ISLAMIC ART AND SPIRITUALITY

D1453776

Islamic Art and Spirituality

SEYYED HOSSEIN NASR

STATE UNIVERSITY OF NEW YORK PRESS

NX
688
.A4
N369
1987

Permission to use the cover painting, *Mantiq-al-Tayr*:
Concourse of the Birds, was given by The Metropolitan
Museum of Art, Fletcher Fund, 1963 (63.210.111)

Cover design by Sushila Blackman

First published in USA by
State University of New York Press
Albany

© Seyyed Hossein Nasr 1987

All rights reserved

No part of this publication may be reproduced
or transmitted, in any form or by any means,
without permission.

For information, address State University of New York Press,
State University Plaza, Albany, N.Y., 12246

Library of Congress
Cataloguing-in-Publication Data

Nasr, Seyyed Hossein
Islamic art and spirituality.

Includes index.
1. Arts, Islamic, I. Title.
NX688.A4N37 1985 700'.917'671 85–14737
ISBN 0–88706–174–5
ISBN 088706–175–3 (pbk.)

<div dir="rtl">

يا كريم

</div>

Yā Karīm

<div dir="rtl">

كتب الله الاحسان على كلّ شئ

</div>

God has inscribed beauty upon all things.

OTHER WORKS BY THE AUTHOR
IN EUROPEAN LANGUAGES

Three Muslim Sages
Ideals and Realities of Islam
An Introduction to Islamic Cosmological Doctrines
Science and Civilization in Islam
Sufi Essays (*also as* Living Sufism)
An Annotated Bibliography of Islamic Science
Man and Nature: The Spiritual Crisis of Modern Man
Islam and the Plight of Modern Man
Islamic Science: An Illustrated Study
The Transcendent Theosophy of Ṣadr al-Dīn Shīrāzī
Islamic Life and Thought
Knowledge and the Sacred
Traditional Islam in the Modern World
Need for a Sacred Science

CONTENTS

LIST OF TRANSLITERATIONS

Arabic characters

ء	'	ف	f	**short vowels**
ب	b	ق	q	◌َ a
ت	t	ك	k	◌ُ u
ث	th	ل	l	◌ِ i
ج	j	م	m	
ح	h	ن	n	
خ	kh	ه	h	**Diphthongs**
د	d	و	w	و◌َ aw
ذ	dh	ى	y	ي◌َ ay (ai)
ر	r	◌	ah ; at (construct state)	◌ِيّ iyy (final form ī)
ز	z	ال	(article) al- and l- (even before the anteropalatals)	◌ُوّ uww (final form ū)
س	s			
ش	sh			
ص	ṣ			
ض	ḍ			
ط	ṭ	**long vowels**		*Persian letters added to the Arabic alphabet*
ظ	ẓ	اى	ā	پ p
ع	ʿ	و	ū	چ ch
غ	gh	ي	ī	ژ zh
				گ g

In the Name of God – Most Merciful, Most Compassionate

PREFACE

ISLAMIC ART has been the subject of study by Western scholars since the nineteenth century and by Western-trained Muslim savants for several decades. It has, moreover, come to receive special attention during the past two or three decades by the larger public as a distinct category of art. Numerous works have appeared in nearly every European language on the history, technical formation, social setting, and other aspects of this art. A few books and articles have been devoted to its spiritual significance and meaning, but these have been few and far between. Except for the writings of T. Burckhardt, which cast special light upon the intellectual, symbolic, and spiritual dimensions of Islamic art, there are very few works which look upon Islamic art as the manifestation in the world of forms of the spiritual realities (*al-ḥaqā'iq*) of the Islamic revelation itself as coloured by its earthly embodiments.

The present work seeks to glance at certain aspects of Islamic art from the point of view of Islamic spirituality and in relation to the principles of the Islamic revelation. It is neither a systematic exposition of the Islamic philosophy of art nor a history of that art. Rather, it is a study of certain important facets of Islamic art, including the literary and the musical as well as the plastic, in the light of the Islamic conception of sacred art and what one might call the Islamic philosophy of art, if philosophy of art is understood in its traditional sense as used by such authorities as A. K. Coomaraswamy. The domain to which the principles in question are applied is mostly, but not wholly, Persian art with which the author is best acquainted because of his own cultural background. Moreover, this art pro-

ix

vides peaks of Islamic art in nearly every field. Persian art of the Islamic period, while being profoundly Persian and in conformity with the sensibility of the Persian people, is also Islamic art in the traditional sense of that term and therefore can serve perfectly to demonstrate the universal rapport between Islamic spirituality and Islamic art.

Several of the chapters of this book have appeared earlier in essay and monograph form and have been revised for this work, while many of the chapters are new. The translations throughout the book are ours unless otherwise indicated. Footnotes have been kept to a minimum; their aim is to guide the reader towards further studies in the field or to elucidate or document a point in the text where necessary. Otherwise, since the book is addressed primarily to the general reader, both Western and Muslim, interested in the relation between Islamic spirituality and Islamic art, rather than only to the specialist of Islamic art, we have not attempted to provide exhaustive scholarly notes as in a technical work addressed to scholars in the field.

We wish to express our gratitude to Miss Katherine O'Brien, whose help in many ways with the preparation of the manuscript has been invaluable.

Wa mā tawfīqī illā bi'Llāh

Seyyed Hossein Nasr
Newton, Massachusetts
October, 1983

INTRODUCTION

I

The Relation between Islamic Art and Islamic Spirituality

I F O N E L O O K S with the eye of discernment upon the extremely varied manifestations of Islamic art over vast expanses of space and time, the question arises as to the source of the unifying principles of this art. What is the origin of this art and the nature of this unifying principle whose dazzling effect can hardly be denied? Whether in the great courtyard of the Delhi Mosque or the Qarawiyyin in Fez, one feels oneself within the same artistic and spiritual universe despite all the local variations in material, structural techniques, and the like. The creation of this artistic universe with its particular genius, distinct characteristics, and formal homogeneity underlying distinctions of a cultural, geographical or temporal nature requires a cause, for no effect of such immense dimensions can be considered as simply a result of chance or the agglomeration of accidental historical factors.

A whole library of works in nearly every European language, to which must now he added not only the Islamic languages themselves but also Chinese and Japanese, have studied the history, description, and material characteristics of this art. But rarely has the basic question of the origin of this supra-individual and sacred art been posed.[1] It is by now well known how Sassanid and Byzantine techniques and models were emulated in early Muslim architecture and Roman ones in city planning and how Sassanid music was adopted by the Abbasid court musicians. But the solution of the problems of links across centuries and cultural boundaries, despite their interest from the point of view of the history of art, does not reveal to us the origin of Islamic art, for Islamic art like any other sacred art,[2] is not simply the materials used but what a particular religious collectivity has done with the material in question. No one

3

would equate a Byzantine church in Greece with a Greek temple even if the actual stone blocks used for the church were taken from a temple. The blocks have become units in an edifice which belongs to a religious universe very distinct from that of the ancient Greeks. In the same way the Umayyad Mosque in Damascus is filled with a presence and reflects a spiritual ambience which are nothing other than Islamic no matter what the historical origins of that building may have been.[3]

The question of the origin of Islamic art and the nature of the forces and principles which brought this art into being must therefore be related to the world view of Islam itself, to the Islamic revelation, one of whose radiations is directly the sacred art of Islam and indirectly the whole of Islamic art. The causal relation between the Islamic revelation and Islamic art, moreover, is borne out by the organic rapport between this art and Islamic worship, between the contemplation of God as recommended in the Quran and the contemplative nature of this art, between the remembrance of God (*dhikrallāh*) which is the final goal of all Islamic worship, and the role played by Islamic art of both a plastic and sonoral nature in the life of individual Muslims and the community or *al-ummah* as a whole. This art could not perform such a spiritual function if it were not related in the most intimate manner to both the form and content of the Islamic revelation.

Some might concede such a relationship but seek the origin of Islamic art in the socio-political conditions created by Islam. This view is a thoroughly modern and non-Islamic one, even if now emulated by certain Muslims, for it sees the origin of the inward in the outward and reduces sacred art with its interiorizing power to simply external, social and, in the case of Marxist historians, economic conditions. It can be easily rejected from the point of view of Islamic metaphysics and theology which see the origin of all forms in God, for He is the Knower of all things, and therefore the essences or forms[4] of all things have their reality in the Divine Intellect. Islamic thought does not allow the reduction of the higher to the lower, of the intellectual to the corporeal or the sacred to the mundane. But even from the non-Islamic point of view the very nature of Islamic art and the sciences and spiritual realization necessary for its

creation would make it evident to any impartial observer—not blinded by the various ideologies which parade as all-consuming world views today in place of traditional religion—that whatever relation exists between Islamic art and the Islamic revelation, it cannot be simply on the plane of socio-political changes brought about by Islam.[5] The answer must be sought in the Islamic religion itself.

Islam consists of a Divine Law (*al-Sharīʿah*), a spiritual path (*al-Ṭarīqah*) and the Truth (*al-Ḥaqīqah*) which is the origin of both the Law and the Way.[6] It also possesses many forms of science of a juridical, theological, philosophical and esoteric nature related to these basic dimensions. When one analyzes Islam in this perspective, one realizes that Islamic art cannot have its origin in the Divine Law which defines the relation between God and man and society on the level of action. The Divine Law plays a very important role in creating the ambience and background for Islamic art, and in setting certain limitations upon some arts while encouraging others. But essentially the Divine Law contains instructions for Muslims on how to act, not how to make things. Its role in art, besides providing the general social background, is in moulding the soul of the artist by imbuing it with certain attitudes and virtues derived from the Quran and the prophetic *Ḥadīth* and *Sunnah*.[7] But it does not provide guidance for the creation of a sacred art such as that of Islam.

Nor can one discover the origins of Islamic art in the juridical sciences and theology, both of which are closely associated with the Divine Law and the question of defining and defending the tenets of the Islamic faith. An individual theologian like al-Ghazzālī may have written on beauty. Authorities on jurisprudence such as Bahāʾ al-Dīn al-ʿĀmilī even built beautiful gardens, but treatises on theology (*kalām*) or jurisprudence (*fiqh*) are not known for casting light upon the questions of Islamic art and aesthetics.[8] Moreover, many of the greatest masterpieces of Islamic art were created before these sciences became fully codified and accepted as the ultimate authoritative works produced in these fields.

It is therefore to the inner dimension of Islam, to the *bāṭin* as contained in the Way and elucidated by the Truth, that one

must turn for the origin of Islamic art. This inner dimension is moreover inextricably related to Islamic spirituality. The term for spirituality in Islamic languages is connected to either the word *rūḥ* denoting spirit or *maʿnā* signifying meaning.[9] In both cases the very terms imply inwardness and interiority. It is within the inner dimension of the Islamic tradition that one must seek the origin of Islamic art and the power which has created and sustained it over the ages while making possible the blinding unity and inebriating interiority which this art possesses.

The twin sources of Islamic spirituality are the Quran, in its inner reality and sacramental presence, and the very substance of the soul of the Prophet which has remained as an invisible presence within the Islamic world, not only through his *Ḥadīth* and *Sunnah*, but also in an intangible way within the hearts of those who have sought and who still seek God as well as in the very air which the invokers of His Blessed Name have breathed and still breathe. The origin of Islamic art must be sought in the inner realities (*ḥaqāʾiq*) of the Quran which are also the principial realities of the cosmos and the spiritual reality of the Prophetic Substance from which flows the 'Muḥammadan grace' (*al-barakat al-muḥammadiyyah*). The Quran provides the doctrine of Unity while the Prophet provides the manifestation of this Unity in multiplicity and the witness to this Unity in His creation. For who would be able to testify to *Lā ilāha illaʾLlāh* if there were no *Muḥammadun rasūl Allāh?*[10] Wherever the Muḥammadan *barakah* has flowed and still flows, there one must seek the origin of the very creative act which has made the sacred art of Islam possible, for only by virtue of this *barakah* has it been possible to crystallize in the world of form, time, and space, the *ḥaqāʾiq* which the Quran contains within its inner dimension. Is it any wonder that the great masters of Islamic art have always displayed a special love and devotion for the Prophet and in the case of Shiʿism for the Prophet and his household, and that in both Sunni and Shiʿite Islam, ʿAlī, who represents more than any other companion the inner dimension of the Islamic message, is considered as the founder of many of the basic arts such as calligraphy and the patron of all the guilds (*aṣnāf* and *futuw-*

6

wāt). The link of Islamic art to the inner dimension of Islam could not be demonstrated to an outsider in a better manner than by pointing to the role played by 'Alī in both the guilds of craftsmen who have produced Islamic art and the Sufi orders which are the main custodians of the esoteric teachings of Islam.

Without the two fountains and sources of the Quran and the Prophetic *barakah* there would be no Islamic art. The art of Islam is Islamic art not only because it was created by Muslims but because it issues forth from the Islamic revelation as do the Divine Law and the Way. This art crystallizes in the world of forms the inner realities of the Islamic revelation and, because it issues from the inner dimension of Islam, leads man to the inner chamber of the Divine Revelation. Islamic art is a fruit of Islamic spirituality from the point of view of its genesis and as an aid, complement and support for the spiritual life from the vantage point of realization or return to the Origin.

Islamic art is the result of the manifestation of Unity upon the plane of multiplicity. It reflects in a blinding manner the Unity of the Divine Principle, the dependence of all multiplicity upon the One, the ephemerality of the world and the positive qualities of cosmic existence or creation about which God asserts in the Quran, 'Our Lord! Thou createst not this in vain.' (III;191) This art makes manifest, in the physical order directly perceivable by the senses, the archetypal realities and acts, therefore, as a ladder for the journey of the soul from the visible and the audible to the Invisible which is also Silence transcending all sound.

Islamic art derives from Islamic spirituality in a direct manner while being also of course moulded by the particular characteristics of the container or vessel of the Quranic revelation, that is, the Semitic and nomadic world whose positive traits Islam universalized.[11] But this link with the form of the Islamic revelation does not detract from the truth that the origin of this art lies in the inner content and spiritual dimension of Islam. Those who have created objects of Islamic art over the ages have done so either by being able to gain a vision of that archetypal world, thanks to the means made available by the Islamic revelation and specifically the Muḥammadan

barakah, or have been instructed by those who have had such a vision. For the supra-individual character of Islamic art cannot have been brought into being by simply individualistic inspiration or creativity. Only the Universal can produce the Universal. If Islamic art leads to the inner chamber of the Islamic tradition, it is because this art is a message from that inner chamber sent to those qualified to harken to its liberating message and also to provide a climate of peace and equilibrium for society as a whole in conformity with the nature of Islam, to create an ambience in which God is remembered wherever one turns. Does not the Quran assert, 'Whithersoever ye turn, there is the Face of God'? (11;109 Arberry trans.)

Islamic art is based upon a knowledge which is itself of a spiritual nature, a knowledge referred to by traditional masters of Islamic art as *ḥikmah* or wisdom.[12] Since in the Islamic tradition with its gnostic mode of spirituality, intellectuality and spirituality are inseparable, being facets of the same reality, the *ḥikmah* upon which Islamic art is based is none other than the sapiential aspect of Islamic spirituality itself. The dictum of St. Thomas, *ars sine scientia nihil*, certainly pertains in a most evident manner to Islamic art. This art is based upon a science of an inner nature which is concerned not with the outward appearance of things, but with their inner reality. Islamic art manifests, with the aid of this science and by virtue of the Muḥammadan *barakah*, the *ḥaqā'iq* of things which reside in the 'Treasury of the Invincible' (*khazā'in al-ghayb*) upon the outward plane of corporeal existence. In beholding the portal of an edifice like the Shah Mosque with its incredible geometric and arabesque patterns one bears witness to this truth as one contemplates the intelligible world in the world of sensible forms; in listening to the melodies of traditional Persian or Arabic music, one hears that pre-eternal melody which enraptured the soul before the brief episode of its earthly journey. The undeniable intellectual character of Islamic art is not the fruit of a kind of rationalism but of an intellectual vision of the archetypes of the terrestrial world, a vision made possible by virtue of Islamic spirituality and the grace flowing from the Islamic tradition. Islamic art does not imitate the outward forms of nature but reflects their principles. It is based upon

8

a science which is not the fruit of either ratiocination or empiricism but a *scientia sacra* which is attainable only by virtue of the means provided by the tradition. It is not accidental that whenever and wherever Islamic art has experienced a peak of its creativity and perfection there has been present the powerful, living intellectual—which also means spiritual—current of the Islamic tradition. And conversely, this causal nexus provides the reason for understanding why whenever there has been a decay or eclipse of the spiritual dimension of Islam the quality of Islamic art has diminished. In the case of the modern world Islamic art itself has been destroyed to the extent that the spirituality and intellectuality which provides its life force have been neglected.

In certain epochs of Islamic history written sources are present to provide evident proof of the relationship between Islamic spirituality and intellectuality on the one hand and art on the other, while in many other cases the oral tradition has left no direct written trace to enable this relationship to be studied in detail from the outside. An example of the first case is Safavid Persia, which marks one of the most creative periods of Islamic art and also of Islamic metaphysics and philosophy. If one studies closely the doctrine of the world of imagination, or rather the imaginal world (*'ālam al-khayāl*),[13] in the writings of such masters as Ṣadr al-Dīn Shīrāzī[14], one sees the correlation between the metaphysical and cosmological doctrines involved and the art of the period including not only the miniature with which we shall deal later in this volume, but also poetry, music, and even landscape architecture.[15] This relation does not imply a departure from the norm but a fortuitous example of a general principle which allows this basic relationship to be understood even in other cases where explicit formulations of the intellectual principles involved are not available. If there are new phases or chapters in Islamic art, that fact does not mean in the light of this rapport a change in Islamic spirituality, but demonstrates the continuous application of principles of a living tradition to different circumstances and conditions.

To illustrate further the direct relation between Islamic art and spirituality one can turn to the case of the performing arts.

Because of the nature of the Islamic religion, which is not based upon the dramatic tension between Heaven and earth or the way of heroic sacrifice and redemption through divine intercession and also because of its non-mythological character, a sacred and religious theatre did not develop in Islam such as one finds in ancient Greece, India, or even medieval Christian Europe. But to the extent that the elements of passion and drama did enter into the Islamic perspective and became an aspect of Islamic spirituality, namely in Shi'ism, a religious theatrical art called the *ta'ziyah* developed reaching elaborate proportions in both Safavid and Qajar Persia and Moghul and post-Moghul India.[16] The creation of such an art form, although not central to Islam, and not being even sacred art but properly speaking religious art,[17] nevertheless points to the nexus between Islamic spirituality and Islamic art not only in the grand manifestations of that art in such domains as calligraphy and architecture but also in more particular and limited branches such as the Shi'ite passion play or *ta'ziyah*, which reflects directly the Shi'ite sense of tragedy.

Islamic sprituality is of course also related to Islamic art through the manner in which the Islamic rites mould the mind and soul of all Muslims including the artist or artisan. The daily prayers which punctuate the day and night and systematically break the strangling hold of daydreaming upon the soul, the proximity to virgin nature which is the primordial mosque that the mosque in Islamic cities and towns only emulate, the continuous references in the Quran to the eschatological realities and the fragility of the world, the constant repetition of Quranic phrases which remould the soul of the Muslim into a mosaic of spiritual attitudes, the emphasis upon the grandeur of God which prevents any kind of Promethean humanism from taking place, and many other factors related to the particular genius of Islam have moulded and continue to mould the mind and soul of every Muslim. In the training and education of man as *homo islamicus* at once the slave and vice-regent of God (*'abdallāh* and *khalīfatallāh* to use the Quranic terminology), Islamic spirituality has influenced Islamic art directly through the inculcation of certain attitudes and the elimination of other possibilities within the mind and soul of those men and women

who have created this art. If a traditional Muslim finds the titanesque statues of a Michaelangelo crushing and Rococo churches stifling, it is because of that sense of submission to God created in his soul by Islamic spirituality and his horror of human self-aggrandizement at the expense of the Divine Presence. It is not that no Muslim could create a titanic and Promethean art as the modern period demonstrates amply, but that no Muslim would do so as long as the imprint of Islamic spirituality upon the soul of the Muslim remained strong.

Only that which comes from the One can lead back to the One. If virgin nature serves as support for recollection or remembrance of God (*dhikr*), it is because it was created by the Divine Artisan, one of God's Names being *al-Ṣāni'*, literally the Divine Artisan or Maker. In the same way, if Islamic art can serve as support for remembrance of the One, it is because, although made by men, it derives from a supra-individual inspiration and a *ḥikmah* which comes ultimately from Him. If the most spiritually gifted among Muslims can fall into spiritual ecstasy through hearing an Arabic or Persian poem, listening to a chant, or contemplating a piece of Arabic calligraphy, it is because of the inner nexus between these forms of art and Islamic spirituality. The powerful support that Islamic art provides for the soul's quest for the world of the spirit could not exist save through the inner link between this art and Islamic spirituality. If any extrinsic proof be needed of the relation of Islamic art to Islamic spirituality, it can be found in the role of support that this art plays in the induction of *ḥāl* or spiritual state, which is itself a grace from Heaven, and in the attitude of those closest to the heart of Islamic spirituality to this art in its manifold manifestations. This relation alone would suffice to reduce to insignificance the arguments of all those who consider Islamic art as merely the product of external historical factors divorced from the principles and spiritual springs of the Islamic revelation.

Finally, in a discussion of the relation between Islamic art and Islamic spirituality something must be said about the patronage of this art because too often the spiritual is understood by Western readers in the context of the dichotomy between the sacred and the secular which characterizes Wes-

tern civilization. Some might ask why, if there is such a relationship between Islamic art and Islamic spirituality, some forms of Islamic art have never received patronage from the religious authorities or the 'mosque' but only from the court, the ruling classes, or the merchant classes which are usually identified with the secular in European history. In answer to this question it must be pointed out first of all that there exists no such dichotomy between the religious and the secular in Islam. The so-called secular powers or elements in traditional Islamic society have always possessed as much religious significance within the all-embracing Divine Law as have the specifically religious elements. Secondly, there is a more subtle relationship to be discovered in the question of the patronage, the use, and the function of the arts, a relationship which is based on the complementarity between what one might call in summary fashion the mosque and the court.

There are certain arts which may be said to have issued from the mosque, in the general sense of its being the centre of religious acvitivity—such arts as Quranic psalmody, sacred architecture, and calligraphy, especially the Kufic which represents the most archaic, formal and religiously significant calligraphic style. There are other arts such as music, poetry, and miniature painting whose most important patronage always came from the court although they also reached society as a whole. Moreover, paradoxically enough, the first type of art represents the more 'masculine' and the second the more 'feminine' types of art. In the case of calligraphy, which also received patronage from the court and the ruling aristocracy, the styles which are more gentle and feminine are again to be associated more with the arts of the court and the more masculine and heraldic with the mosque, the exception being when the court itself patronized the building of mosques and other religious institutions.[18]

There is, however, a third element to consider which alone explains the spiritual quality of the courtly arts, and that is Sufism. Although the Sufis were naturally related to the mosque in their defense of the *Sharī'ah*, many of them being among the *'ulamā'*, they were also profoundly connected to political authority, not in submitting to the power of the world

and its luxury or in composing panegyrics for the powerful, but in providing spiritual guidance and example for those who yielded power. While certain Sufi orders kept aloof from political authority others permitted their members to accept even the highest offices.[19] In any case the Sufi influence was strong in the domain of the arts for which the court acted as patron. It is enough to study the religious background of many miniaturists and musicians of the Safavid, Ottoman and Mogul dynasties to become aware of this fact. The 'feminine' arts supported by the courts are interiorizing by their very nature and of a highly spiritual quality. They possess unmistakable spiritual traits which could not come about except through the presence of the influence of Islamic esoterism. Through an inner complementarity between the mosque and the court, both contributed to the creation of forms of Islamic art which are complementary in nature while sometimes combining in the creation of single works such as the royal mosques, some of which are among the greatest masterpieces of Islamic art.

The more one penetrates into the significance of Islamic art the more one becomes aware of the most profound relationship between this art and Islamic spirituality. Whether sponsored by the mosque or the court, used by the religious scholar, the prince, the merchant, or the peasant, traditional Islamic art was created by an inspiration which issued ultimately from the Muḥammadan *barakah* and with the aid of a *ḥikmah* which resides in the inner dimensions of the Noble Quran. To grasp fully the significance of Islamic art is to become aware that it is an aspect of the Islamic revelation, a casting of the Divine Realities (*ḥaqā'iq*) upon the plane of material manifestation in order to carry man upon the wings of its liberating beauty to his original abode of Divine Proximity.

NOTES

1. One might say that the same holds for Christian or Buddhist art, but in no case is the negligence of the religious and spiritual cause of the art in question as general and widespread as in that of Islam.

2. A distinction must be made between the sacred art of Islam and traditional Islamic art. The sacred art relates directly to the central practices of the religion and the practice of the spiritual life, embracing such arts as calligraphy, mosque architecture, and Quranic psalmody. Traditional Islamic art, however, embraces every form

of the visual and sonoral arts from landscaping to poetry, all of which being traditional also reflect the principles of the Islamic revelation and Islamic spirituality but in a more indirect manner. In a sense sacred art is the heart of traditional art, reflecting in a direct manner the principles and norms which are reflected in a more indirect manner is the whole domain of traditional art.

3. If some people object by pointing to classical motifs in Umayyad palaces or the Byzantine mosaics of the Umayyad Mosque itself, they must remember that first of all for Islam, as for other other religions, a certain amount of time was required in order for the purest forms of the sacred art in question to manifest themselves. Secondly, even in traditional art one may find here and there motifs and forms belonging to an alien world; but these forms remain accidental and not central and do not change the fundamental nature of the art in question.

4. We use form throughout this book in the traditional sense as employed for example by A. K. Coomaraswamy in his numerous studies on traditional art. On the meaning of form see Nasr, *Knowledge and the Sacred*, New York, 1981, pp. 260ff; and L. P. Kollar, *Form*, Sydney, 1980.

5. This does not mean of course that these factors are not of importance in the patronage, encouragement and expansion or on the contrary decay, withering away and dying out of certain arts in different parts of the Islamic world. Without, let us say, Safavid patronage, there would be no Safavid carpets of the quality made by the royal ateliers of Isfahan. But one cannot say that this patronage created this particular art even in its distinct Safavid form.

6. See S. H. Nasr, *Ideals and Realities of Islam*, London, 1985.

7. Meaning respectively the sayings and the manners and mores of the Prophet.

8. This term is used in the sense of the philosophy of art and not limited to its etymological meaning of being related to the senses.

9. In Arabic the most common term for spirituality is *rūḥāniyyah* and in Persian *ma'nawiyyat*. Rūmī always speaks of the outer aspect of an object as its form (*ṣūrat*) and its inner reality as meaning (*ma'nā*). See chapter eight of the present work.

10. The two testimonies of Islam meaning respectively 'There is no divinity but God' and 'Muḥammad is the Messenger of God.'

11. See T. Burckhardt, *The Art of Islam*, trans. P. Hobson, London, 1976, pp. 39ff.

12. See Burckhardt, *op. cit.*, pp. 196ff.

13. The word 'imaginal' would avoid the sense of the illusory which is associated with the term imagination in modern parlance, although the word imagination itself can also be redefined so as to embrace its older meaning as distinct from fantasy.

14. This doctrine has been studied extensively by H. Corbin in his *Spiritual Body and Celestial Earth*, trans. N. Pearson, Princeton, 1977; *Creative Imagination in the Sufism of Ibn 'Arabī*, trans. R. Manheim, Princeton, 1981; and *En Islam iranien*, 4 vols., Paris, 1971–2, especially vol. II, pp. 188ff and vol. IV, pp. 115ff.

15. See J. During, 'Music, Poetry and the Visual Arts in Persia', *World of Music*, vol. XIV, no. 3, 1982, pp. 72–82, pp. 72–86; also his 'The "Imaginal" Dimension and Art of Iran', *World of Music*, vol. XIX, no. 3–4, 1977, pp. 24–34.

16. On the ta'ziyah see P. Chelkowski (ed.). *Ta'ziyeh: Ritual & Drama in Iran*, New York, 1979.

17. It has been in fact been always opposed by the more exoteric of the Shi'ite *'ulamā'*.

18. We do not of course wish to imply a complete dichotomy but rather a tendency towards a complementary, there being many exceptions on both sides.

19. Needless to say, Sufism created its own art independent of both the court and the mosque as can be seen in Sufi poetry, music, and the sacred dance, while it provided, usually through the guilds of craftsmen attached to the orders, both the *ḥikmah* and the Muḥammadan *barakah* which made possible both the art of the court (as well as arts supported by well-to-do merchants) and that of the mosque. In fact through the guilds Sufism influenced the creation of artifacts which were used by all classes within Islamic society.

14

ART AND THE SACRED

II

The Spiritual Message
of Islamic Calligraphy

*The beauty of writing is the tongue of the hand and the
elegance of thought.*

('Alī ibn Abī Ṭālib)

*Handwriting is jewelry fashioned by the hand from the
pure gold of the intellect.*

(Abū Ḥayyān al-Tawḥīdī)

THE PRIMORDIAL creative act was at once the Primordial
Word which is the origin of all sound and of the Noble
Quran as a sonoral universe, and the primal Point which
is the origin of the sacred calligraphy that is the visual embodi-
ment of the Sacred Word. The Primordial Word was not only
the single *kun* or Be! whose echo created the whole Universe
and which is contained in the Noble Quran as sound. It was
also crystallized in the ink with which the Divine Pen (*al-Qalam*)
wrote the realities of all things (*al-ḥaqā'iq*) upon the Guarded
Tablet (*al-Lawḥ al-Maḥfūz*), upon the pages of that archetypal
book that is none other than the Quran as the 'Mother of Books'
(*Umm al-kitāb*), the 'Book' containing the inexhaustible pos-
sibilities of Divine Creativity. The Holy Book itself attests to this
'ink' in the verse, 'If all the trees in the earth were pens, and
if the sea eked out by seven seas more were ink, the Words
of God could not be written out unto their end.' (xxxi; 27—
trans. M. Lings)

In the same way that the psalmody of the Noble Quran as
the sonoral sacred art of Islam *par excellence* is the origin of
the traditional sonoral arts, so is the art of calligraphy, which
reflects on the earthly plane the writing of His Word upon the

17

Guarded Tablet, the origin of the plastic arts. Quranic calligraphy issues at once from the Islamic revelation and represents the response of the soul of the Islamic peoples to the Divine Message. The points traced by the Divine Pen created at once the celestial archetype of Quranic calligraphy as well as the lines and volumes of which the cosmic order is constituted and from which issues not only natural space, but also the space of Islamic architecture. In the mystery of the Point, represented by the diacritical point under the first letter which opens the Noble Quran, namely the letter *bā'*,[1] is to be found the principle of both Islamic calligraphy and Islamic architecture, the principle of both the sonoral and plastic arts, the root of both of which is to be found in the Sacred Book. The points and lines of Islamic calligraphy with their inexhaustible diversity of forms and rhythms are related to that Supreme Divine Precinct at whose centre resides the first Point which is none other than His Exalted Word. The Master of Illumination, Shihāb al-Dīn Suhrawardī, begins one of his prayers with these words: 'O Master of the Supreme Circle from which issue all circles, with which terminate all lines, and from which is manifested the First Point which is Thy Exalted Word cast upon Thy Universal Form.'[2]

The Guarded Tablet contains the archetypes of all earthly forms and more particularly of traditional Quranic calligraphy, all of whose styles are made possible by, and reflect, the sacred character of the Revealed Book. Islamic calligraphy is the visual embodiment of the crystallization of the spiritual realities (*al-ḥaqā'iq*) contained in the Islamic revelation. This calligraphy provides the external dress for the Word of God in the visible world but this art remains wedded to the world of the spirit, for according to the traditional Islamic saying, 'Calligraphy is the geometry of the Spirit'.[3] The letters, words and verses of the Quran are not just elements of a written language but beings or personalities for which the calligraphic form is the physical and visual vessel. Through the writing and reading of these letters, words, and verses, man enters into contact with these beings and talismans which have come ultimately from the far 'other' shore of universal existence to guide man back to the abode of the One. For him who understands the signifi-

cance of the Quran in both its spoken and written form, 'it is easy to understand the capital part played in the life of the Moslem by those sublime words—the verses of the Quran; they are not merely sentences which transmit thoughts, but are in a way, beings, powers or talismans.'[4]

Inasmuch as there resides a Divine Presence in the text of the Quran, calligraphy as the visible embodiment of the Divine Word aids the Muslim in penetrating and being penetrated by that Presence in accordance with the spiritual capabilities of each person. The sacred art of calligraphy aids man to pierce through the veil of material existence so as to be able to gain access to that *barakah* that resides within the Divine Word and to 'taste' the reality of the spiritual world. 'Calligraphy and illumination are as it were compensations for such contingencies as ink and paper, a "step up" which makes it possible, in a flash of wonderment, to approach more nearly and penetrate more deeply the Divine substance of the Quranic text, and thus to receive a "taste", each soul according to its capacity, of the Infinite and the Eternal.'[5]

Although calligraphy has developed in numerous forms and has embraced functions and domains not directly related to the text of the Quran, something of this principial wedding between calligraphy, which began in a purely Quranic context, and the spiritual substance of the Quran has survived within all aspects of traditional Islamic calligraphy. It has come to occupy a position of special privilege in Islam to the extent that it could be called the progenitor of the traditional Islamic visual arts and the most characteristic feature of the visible aspect of Islamic civilization.[6] It has become identified over the centuries with culture itself, good calligraphy being taken as a sign of a cultured man and a disciplined mind and soul as well as hand. Calligraphy has continued to be the central visual art with its numerous applications ranging from architecture to poetry. Calligraphy is the basic art of creation of points and lines in an endless variety of forms and rhythms which never cease to bring about recollection (*tidhkār* or *dhikr*) of the Primordial Act of the Divine Pen for those who are capable of contemplating in forms the trace of the Formless.

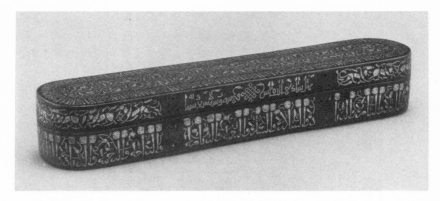

This Pen box made by Shazi for Majd al-Mulk al-Muẓaffar in 607/1210–11 displays the love of the Muslim craftsman for calligraphy used as decoration on objects of everyday life always with the idea of reminding man of the presence of God's Word in all phases of human life.

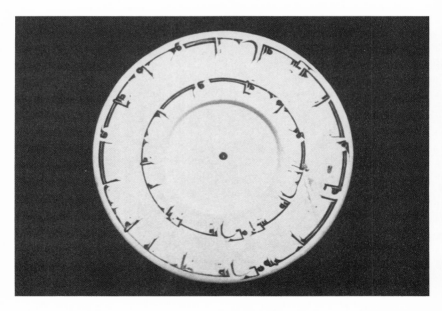

So many utensils such as this 4th/10th century Persian plate from Nayshapur were adorned with Quranic calligraphy reflecting in the plastic arts the life of the users of these utensils in which the use of such a plate for food or other likely activities was usually combined with the recitation of the Names of God and formulas drawn from the Quran.

20

Through the qalam *existence receives God's orders,*
From Him the candle of the qalam *receives its light.*
The qalam *is a cypress in the garden of knowledge,*
The shadow of its order is spread over the dust.[7]

The Pen or *Qalam* is the Active Pole of Divine Creation; it
is none other than the Logos which manifests all the possibili-
ties or Divine Archetypes hidden in the 'Treasury of the Invisible'
by imprinting the Guarded Tablet with the letters and words
which are the *paradigma* of all earthly forms. The calamus with
which the human hand writes is a direct symbol of that Divine
Qalam and the calligraphy it traces on paper or parchment an
image of that Divine Calligraphy which has written the very
reality of all things upon the pages of the cosmic book, leaving
an imprint upon all creatures by virtue of which they reflect
the celestial origin of their existence. For as the sixth/twelfth
century poet Mīr Muʻizzī has stated,

> *Inscribed upon the pages of the earth and sky*
> *The line: 'Therefore take heed, you who have eyes.*

The human calamus is usually a reed and thus evokes not
only the beautiful lines and forms of traditional calligraphy but
also the haunting melody of that sacred music of the lovers
of God which calls them back to their Origin in Divine Proxim-
ity. It is the reed to which Rūmī alludes in that immortal verse
that opens his *Mathnawī:*

> *Harken to this Reed forlorn,*
> *Breathing, ever since 'twas torn*
> *From its rushy bed, a strain*
> *Of impassioned love and pain.*
>
> (R. A. Nicholson's trans.)

The song of the reed is the sonoral counterpart of the letters
and words of the calligrapher. Both are produced by the reed
and harken man back to his spiritual homeland through recol-
lection of the archetypes which both traditional music and cal-
ligraphy reflect in their sonoral and visual forms. From another

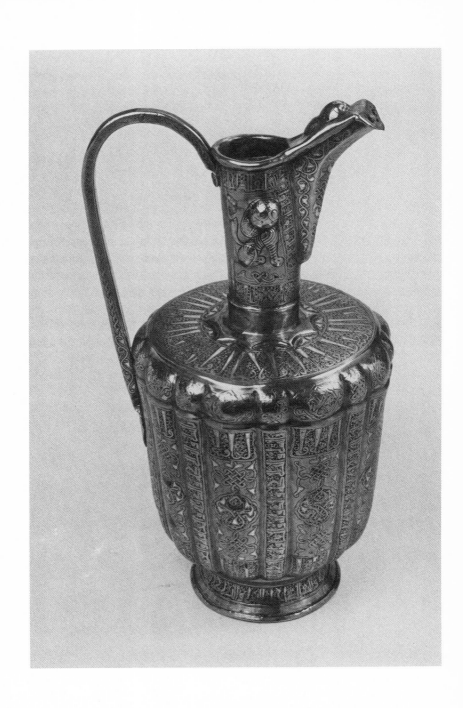

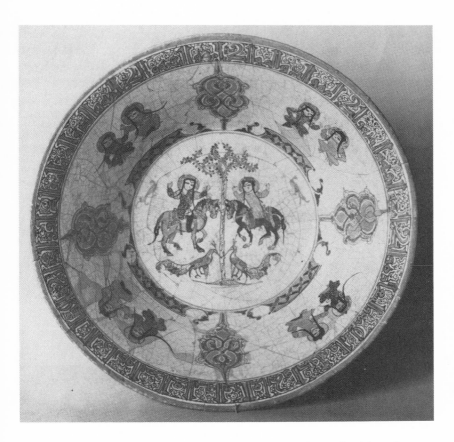

The decoration of the most commonly used objects of everyday life such as this 7th/13th century Persian bowl from Rayy reveals the care with which Islamic art dealt with objects of practical utility, identifying art with the making of objects of everyday life—in fact life itself—rather than a special kind of activity relegated to a distinct and separate domain of life.

LEFT As the use of the ewer for the washing of one's hands and face was usually accompanied with the recitation of certain Quranic formulas, so was this late 7th/13th century Persian brass ewer adorned with verses of Quranic calligraphy.

point of view it might be said that the reed used as the instrument of calligraphy represents more the cosmogonic act, the arc of descent (*al-qaws al-nuzūlī*) of traditional cosmology[8] and the reed as flute the act of return to the Origin, the arc of ascent (*al-qaws al-ṣu'ūdī*). Yet, the reed as both the calamus and the flute creates forms which are related to the very existence of things through that analogy that relates the forms of traditional art to the reality of things by virtue of that correspondence between art and cosmology which is the basis of all traditional art.

The saint has himself become the reed through which the Divine Musician produces the melodies of cosmic existence while he is also the calamus with which God manifests His actions in His creation. By being in perfect surrender to the Divine Will, the saint becomes himself the pen in the hands of the Divine Artist, realizing concretely the Quranic dictum, 'The Hand of God is above their hands'. (XLVIII; 10) He is himself like a pen with which 'he' writes the pages of his life as a masterpiece in both form and content, the saint being himself a work of sacred art. Moreover, when he actually produces calligraphy in such a state, the pen in his hand becomes like his own being an instrument in the 'hand of God'. Through this perfect surrender, concentration, and inner annihilation the art produced by him becomes sacred art. He becomes the instrument through which the celestial forms become manifest in the spatio-temporal matrix, making possible the creation of norms which are then emulated by students and disciples who themselves have not fully realized the truth of the dictum 'the Hand of God is above their hands'. But the sacred art of calligraphy in Islam was created by those who did become themselves a pen in the hand of the Divine Artisan. It is they who established the traditional norms which were then emulated by others. It is not accidental that the style of Kufic, the oldest and most important style of Quranic calligraphy, is said traditionally to have been 'created' by 'Alī who also said, 'The whole of the Quran is contained in the Opening Chapter, the Opening Chapter in the *basmallah*, the *basmalah* in the *bā*', the *bā'* in the diacritical point, and I am that diacritical point'. Only he who possesses inner union with the Original Point of all lines and

with the Centre of all circles of existence could himself act as a calamus in the Divine Hand and an instrument for the creation of the sacred art of Islamic calligraphy, which like all veritable sacred art is of supra-individual origin.

The Quran itself mentions the *qalam* in the very first verses revealed to the Prophet where in the *Sūrat al-'alaq* (The Clot) the Prophet is ordered to 'Read: And thy Lord is the Most Bounteous, Who teacheth by the pen' (xcvi; 3–4, Pickthall translation), while the chapter entitled 'The Pen' (*Sūrat al-qalam*) opens with the letter *nūn* followed by the verse, 'By the pen and that which they write.' (lxviii; 1) The letter *nūn* in Arabic (ن) resembles an ink-pot which 'contains' the ink with which the archetypes of all beings are written upon the Guarded Tablet. This letter also resembles a ship which carries the possibilities of a particular cycle of manifestation upon the 'ocean of non-existence'.[9]

The ninth/fifteenth century Persian Sufi scholar Kamāl al-Dīn Ḥusayn Kāshifī, in his Quranic commentary *Mawāhib-i 'aliyyah*, relates the letter *nūn* to the first letter of light (*al-nūr*) which was the first reality created by God according to the *ḥadīth*, 'the first thing that God created was light', and the last letter of *al-Raḥmān*, the Divine Mercy, by virtue of which all creation was brought forth.[10] The very substance of God's creation is the coagulation of the 'Breath of the Compassionate' (*nafas al-raḥmān*) which, being 'breathed' upon the archetypes (*al-a'yān al-thābitah*), brought forth the world.[11] Kāshifī adds that God first created the *Qalam*, then the Inkpot or *nūn* so that He begins the chapter of 'The Pen' with the lines '*nūn* and the Pen'. According to another *ḥadīth* the *Qalam* symbolizes the tongue and *nūn* the mouth. The Supreme Pen, according to Kāshifī, is light whose 'extension is the distance between heaven and earth'.[12] Kāshifī also states that the letter *nūn* is an allusion to the synthetic Divine Knowledge contained in the All-Comprehensive Essential Unity (*aḥadiyyat-i dhātiyya-yi jam'iyyah*) and the Pen refers to the detailed Divine Knowledge contained in the Celestial Unicity (*wāḥidiyyat-i samā'iyyah*). 'What the Pen has written from the [ink] of the eternal ink-pot are the exalted, simple, Divine Letters as well as the inferior, compound, lordly words'.[13] Kāshifī thus summarizes the meta-

physical foundation of calligraphy based upon the Quranic symbol of the Pen and the Inkpot, of *nūn* and *Qalam*, providing a key for the understanding of the metaphysical principle and spiritual significance of Islamic calligraphy and the role that calligraphy plays in the religious and artistic life of traditional Islam.

The earthly manifestation of the Divine Prototype of Islamic calligraphy, mentioned in the Quranic image of the Pen and the Inkpot, has continued to possess a central spiritual significance. This is revealed first of all by the traditional attribution of the origin of this art to 'Alī, the representative *par excellence* of Islamic esotericism after the Prophet,[14] as well as some of the early pillars of Islamic spirituality who are considered as poles of Sufism in Sunni Islam and as Imams in Shi'ism.[15] Secondly, calligraphy written by human hands has continued to be practiced consciously as a human emulation of the Divine Act, although far removed from its archetypal perfection, for 'the greatest nobility accorded to the art of writing is the fact that it is like the distant shadow of the Divine Act'.[16] Thirdly, traditional calligraphy is based on a precise science of geometric forms and rhythms, each letter being formed from a number of points in a mathematical fashion differing in each major style but all based upon a *scientia* which possesses exact laws of its own. If one can say of all of Islamic art that it is a science as Islamic science is an art, this rapport holds especially true for calligraphy about which one could indeed say categorically *ars sine scientia nihil*. In fact the proportions of calligraphy are the key for the understanding of the proportions of Islamic architecture. Now this *scientia* issues from the Ḥaqīqah at the heart of the Quranic revelation; and by virtue of this science which underlies the rules of various styles of traditional calligraphy, this art unveils certain cosmic correspondences and even reveals through its symbolism realities of a metacosmic nature. This aspect of the calligraphic art, which needs a separate treatment in order to be explained fully, is yet another facet of the profoundly spiritual and sacred character of Islamic calligraphy for the science in question here is sacred science and not simply a knowledge of a profane nature.

There is, however, a temporal separation between the

26

earthly crystallization of Quranic calligraphy and the advent of the Quranic revelation. It might be said that while the Quran as a sonoral universe was the sound of the Divine Word which became engraved upon the heart of the Prophet and later through him the Companions and later generations, calligraphy was the echo of and response to this Divine Sound which could not but come later. It was the response of the soul of Muslims—first Arabs and then Persians and Turks, from among whose ranks rose most of the greater calligraphers of the later centuries—to the Quran as the spoken and heard Word of God. While based on the original inspiration of the great early saints such as 'Alī, the perfect crystallization of this response in the major styles of Islamic calligraphy could not come but at a later period. Moreover, this response was of a distinctly Islamic character since while the pre-Islamic Arabs were as sensitive to language and poetry as the early Arab Muslims, unlike the Muslims they displayed no interest in calligraphy. The same could almost be said about the pre-Islamic Persians who did possess a written scripture and hence calligraphy, but for whom calligraphy was not an art of central importance as it was to become once they embraced Islam. The sudden rise of Arabic and soon thereafter Persian calligraphy is a purely Islamic phenomenon related directly to the response of the heart and soul of the peoples destined to constitute the Islamic *ummah* to the overwhelming presence of the Divine Word revealed in the Quran. The Quranic revelation was sonoral, yet its earthly embodiment could not but be the creation of one of the most remarkable traditions of calligraphic art, namely the Islamic.

Although the prototypes of all the traditional styles of Islamic calligraphy are contained ultimately in the 'Hidden Treasures' in the Divine Order, without which this calligraphy would not be a 'visual sacrament', the earthly crystallization of various styles took place over a period of time in accordance with the laws of manifestation and crystallization whereby a tradition becomes established in the world of time and space. In fact the different styles of calligraphy 'constitute a providentially long-drawn-out demonstration of the Divine qualities of the message'.[17]

These styles doubtless show certain regional variations related to the ethnic genius of a particular segment of the Islamic world. But they also display a universality which carries most of these styles beyond the borders of a particular cultural zone within that world. From the beginning there developed the Kufic, or 'Quranic', script and the *naskhī*, which was less strictly related to the Quranic text although in later centuries some of the finest Qurans were written in *naskhī*. Cursive styles developed soon thereafter so that Ibn Nadīm, who lived in the fourth/tenth century, already mentions twelve scripts and twelve variations upon them.[18] The famous calligrapher, Ibn Muqlah, who lived at the same time, laid down the rules for writing six major styles, the *thuluth, naskh, rayḥān, muḥaqqiq, tawqī,* and *riqā'*, rules which have survived to this day. These styles received their final elaboration in the hand of the celebrated Yāqūt al-Musta'ṣamī in the seventh/ thirteenth century. They signify through their persistence over the ages the immutability of the styles of this central traditional art in Islam in conformity with the nature of Islam itself, which after the normal period of elaboration created a civilization marked by permanence, immutability of principles and sacred forms through which the stream of life has flowed over the centuries.

Islamic calligraphy reflects through the symbolism of its very forms this intertwining between permanence and change that characterize creation itself. The world consists of a continuous flow or becoming, yet becoming is nothing but the reflection of Being and the immutable archetypes contained in the Divine Word or Intellect. Islamic calligraphy recreates this metaphysical reality inasmuch as, in 'embodying' the text of the Quran, it repeats the contours of creation itself. Hence, 'as in weaving, the horizontal movement of the script, which is a rippling movement, corresponds to change and becoming, whereas the vertical represents the dimension of the Essence or the immutable essences'.[19] Or from another point of view it might be said that the vertical symbolizes the Unity of the Principle and the horizontal the multiplicity of manifestation.

All the traditional styles share in combining these two dimensions of verticality and horizontality but each in a dif-

28

ferent manner. Some styles are almost completely static and others almost completely flowing. But in each case some element of each principle must be found no matter how much the other is emphasized.

The Universe can also be symbolized by a tree which according to the Quran has 'its roots firm and its branches spread in the heavens'. The World Tree is one of the most universal symbols of cosmic manifestation. Since the Quran is the prototype of creation and itself the world of multiplicity as issuing from and returning to Unity, Islamic art was bound to combine these two symbols, that of the Word and of the World Tree, in combining calligraphy with stylized plant forms. Many of the mosques and other architectural edifices of the Islamic world from the Cordova mosque to the Minareli school in Anatolia, from the Gawhar Shād mosque in Mashhad to the mausoleums and mosques of Agra, display this intertwining of calligraphy and arabesque forms whose meditation recalls the correspondence between the Quran and the world of nature and also the primordiality of the Quranic revelation throughout which the theme of 'creation-consciousness' is repeated.

Islamic patterns also often combine calligraphy with both stylized plant forms or arabesques and geometric patterns. Here the calligraphy, related directly to the Divine Word, may be said to symbolize the Principle of creation, the geometric element symbolizing the immutable patterns or masculine aspect while the arabesques, related to life and growth, represent the living, changing and maternal aspect of creation. Seen in this light, the calligraphy can be contemplated as the principle from which the two other elements of Islamic patterns, namely the geometric and the arabesque, originate and into which they become integrated as all cosmic dualities become integrated in the unity of the Principle.

Quranic calligraphy is also related to illumination, which became an ever more present element as the tradition drew temporally further away from its Divine Origin. The remarkable Quranic illumination of the later centuries is a compensation from Heaven for this very separation, making visible a spiritual energy which was always present but had not manifested itself in the world of visual forms during the earlier period of proxim-

ity to the historical origin of the Revelation. Quranic illumination 'crystallizes' the flow of the soul towards God and is itself an aid in the reintegration of the soul which results from the sacred presence of God's Word. Illumination makes possible the visualization of the spiritual energy which flows from the reading of the sacred Text; it therefore occupies the margin of the page while the calligraphy comprises the text itself. The illumination is like the halo which surrounds the Sacred Word and the luminosity which is generated by the theurgical presence of the word that is the Word of Light.[20]

Since the verses of the Quran are powers or talismans, the letters and words which make possible the visualization of the Quranic verses also play the role of a talisman and display powers of their own. Putting aside the numerical symbolism and esoteric significance of the letters and phonemes of the Arabic alphabet and language which comprise a vast science of their own,[21] one can turn to the visible forms of the calligraphy as themselves representing 'beings' as well as direct symbols of spiritual realities to the Muslim mind. Each letter has a 'personality' of its own and symbolizes in its visual form a particular Divine Quality since the letters of the sacred alphabet correspond to features and qualities of God as the Divine Scribe.

The letter *alif* (ا) by its very verticality symbolizes the Divine Majesty and the Transcendent Principle from which everything originates. That is why it is the origin of the alphabet and the first letter of the Supreme Name of God, *Allāh*, whose very visual form conveys the whole of the Islamic metaphysical doctrine concerning the nature of Reality for, 'in the written form of the Name *Allāh* in Arabic (الله) we distinguish a horizontal line, that of the very motion of writing, then the upright strokes of the *alif* and the *lām*, and then finally a more or less circular line, symbolically reducible to a circle; these three elements are like indications of three "dimensions": serenity, which is "horizontal" and undifferentiated like the desert or a blanket of snow; majesty, which is "vertical" and motionless like a mountain: and mystery, which extends "in depth" and relates to the Divine Ipseity and to gnosis. The mystery of Ipseity implies that of identity, for the divine nature, which is totality as well as transcendence, includes all possible divine aspects including

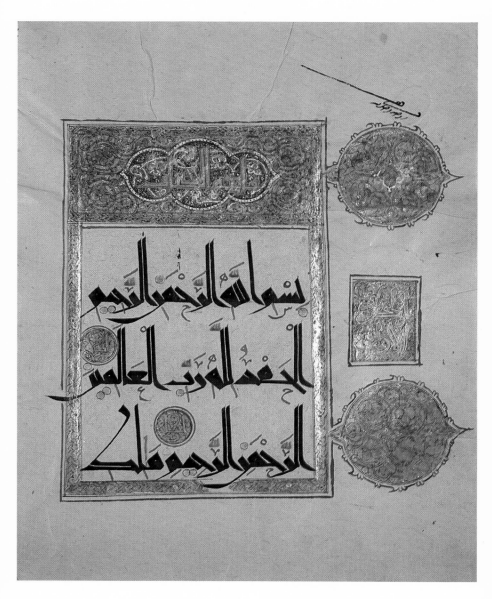

This is the opening chapter of the Quran in the style of Oriental Kufic which is the calligraphic style most closely associated with the Sacred Text and the first in which the Word of God was written in Arabic.

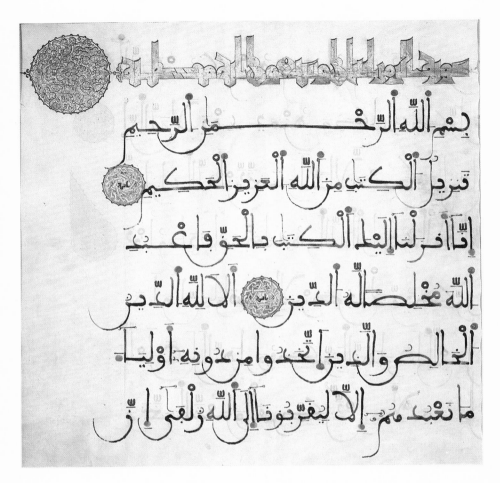

The noble style of the *Maghribī* script developed in the Maghrib and Spain represents one of the peaks of Quranic calligraphy, being a distinct wedding between the spirit of the Quran and the ethnic and artistic genius of the people of the Maghrib.

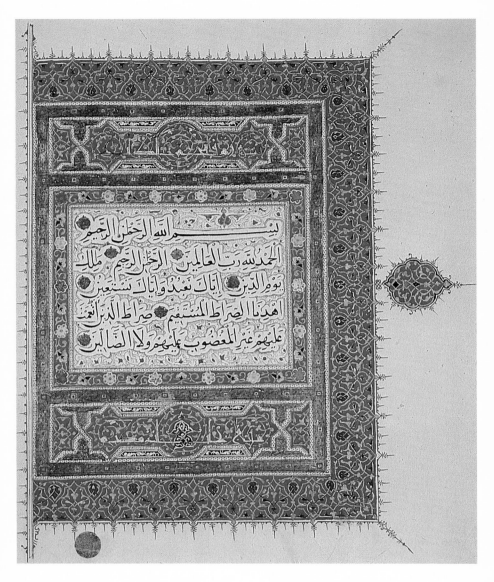

The *naskhī* style flowered as a later form of calligraphy but continued to serve as a vehicle for the writing of the Quran. It is in this medium of sacred art that one finds the most perfect examples of the *naskhī* style often combined with the art of illumination which is like the visualization of the luminous inspiration flowing from the Sacred Text.

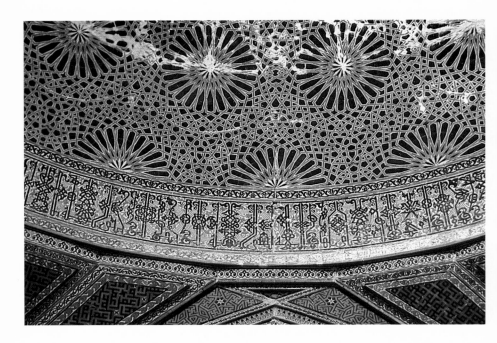

The Karatay *madrasah* in Qonya, a masterpiece of Seljuq architecture, displays the ubiquitous presence of the sacred calligraphy of the Quran intertwined with geometric patterns.

the world with its numberless individualized refractions of the Self'.[22]

He who loves God empties his heart of all but Him; the *alif* of Allah pierces his heart and leaves no room for anything else. That is why Ḥāfiẓ sings in a famous verse,

چکنـم حرف دگـر یاد نداد اسـتـادم نیـسـت بر لوح دلـم جز الـف قامـت دوست

There is no trace upon the tablet of my heart save the alif of the stature of the Friend.
What can I do, my master taught me no other letter.

One need only 'know' this single letter in order to know all that is to be known, for the Divine Name is the key to the Treasury of Divine Mysteries and the path to the Real. It *is* that Reality by virtue of the essential identity of God and His sanctified Name. That is why in Sufism meditation upon the calligraphic form of the Name is used as a spiritual method for realizing the Named.

As for *bā'* (ب), the second letter of the alphabet, its very horizontality symbolizes the receptivity of the maternal and passive principle as well as the dimension of beauty which complements that of majesty. The intersection of the two letters constitutes the point which stands below the *bā'* and which symbolizes the Supreme Centre from which everything issues and to which everything returns. In fact all manifestation is nothing other than that point for how can the One bear otherness to that which would compromise its oneness? That is why the *alif* and *bā'* themselves together with all the letters which follow them in the Arabic alphabet are constituted of that point which, while being one in itself, is seen as many in the mirror of multiplicity.

In his *al-Kahf wa'l-raqīm fī sharḥ bismillāh al-raḥmān al-raḥīm*,[23] the celebrated eighth/fourteenth century Sufi, 'Abd al-Karīm al-Jīlī, writes that the point is the indivisible substance (*al-jawhar al-basīṭ*) while all the letters are compound (*al-jism al-murakkab*). The point symbolizes and refers to the Divine Essence.[24] Hence when added to any letter the point does not have a sound of its own in the same way that the theophany

31

of the Essence appears in each creature according to the possibilities of perfection of that creature.

The point 'creates' the *alif* and the *alif* all other letters, for while the point is the symbol of the Divine Ipseity, *alif* symbolizes the station of Oneness. Al-Jīlī describes a dialogue between the point (*al-nuqṭah*) and the *bā'* in which the point addresses *bā'* as 'O letter, I am thy Principle . . .', while *bā'* answers, 'O Master, it has become certain to me that thou art my Principle'. *Bā'* also asks from where has come to it that truth which belongs to the point. The point responds that all letters and words are in reality a single form which comes from the point.[25] The whole mystery of Divine Union is described by al-Jīlī through the symbolism of the dialogue between the point and the *bā'*.

According to al-Jīlī since the *basmalah* brings all things into being, it is like the Divine Command, 'Be!' (*kun*). But the act itself is symbolized by *alif* while *bā'* is the recipient of the act. The superiority of *alif* to *bā'* is shown by the fact that while the point which is supreme is part of *alif* and internal to it as the written form of *alif* reveals, it is external to *bā'*. The *alif* thus correspond to the Muḥammadan Reality (*al-ḥaqīqat al-muḥammadiyyah*) while *bā'* corresponds to creation. God first created the Muḥammadan Reality and from it the rest of creation.[26] In contemplating the first two letters of the Arabic alphabet, the person who is able to penetrate into their inner meaning contemplates the symbol of both the principial realities and the manifested order.

The Sufi and philosopher Ṣā'in al-Dīn ibn Turkah, who followed al-Jīlī by two generations, writes that letters and words descend from the spiritual world into the physical and possess an inner spiritual substance while putting on the dress of the world of generation and corruption.[27] In his commentary upon the same saying about the point under the *bā'* treated by al-Jīlī, Ibn Turkah mentions that each Quranic letter has three forms: 'the spoken form which descends upon the ear, the written form which becomes manifest to the eye, and the essential and spiritual form whose locus of appearance is the heart'.[28] The calligraphic form is therefore the counterpart of the sonoral

form of the Divine Word and a key, along with the sonoral form, to the inner meaning which resides in the heart.

Over the centuries numerous other Sufis and sages have drawn from the treasury of Islamic wisdom to reveal the spiritual nature of Quranic calligraphy as sacred art and its role in the spiritual life. Some have spoken of the symbolism of letters and words; others of the very forms of the letters. And yet others have expounded the central doctrine of the transcendent unity of Being (*waḥdat al-wujūd*) through the symbolism of the ink and the pen; the points and the letters which are created by it. In yet another commentary upon the saying concerning the point under the *bā'*, the great twentieth century Sufi master Shaykh al-'Alawī writes,

The letters are the signs of the ink; there is not one,
Save what the ink hath anointed; their own colour is pure illusion.
The ink's colour it is that hath come into manifest being.
Yet it cannot be said that the ink hath departed from what it was.
The inwardness of the letters lay in the ink's mystery,
And their outward show is through its self-determination.
They are its determinations, its activities,
And naught is there but it. Understand thou the parable!
They are not it; say not, say not that they are it!
To say so were wrong, and to say 'it is they' were raving madness.
For it was before the letters, when no letter was;
And it remaineth, when no letter at all shall be.
Look well at each letter: thou seest it hath already perished
But for the face of the ink, that is, for the Face of His Essence,
Unto Whom all Glory and Majesty and Exaltation!
Even thus the letters, for all their outward show, are hidden,
Being overwhelmed by the ink, since their show is none other
 than its.
The letter addeth naught to the ink, and taketh naught from it,
But revealeth its integrality in various modes,
Without changing the ink. Do ink and letter together make two?
Realize then the truth of my words: no being is there
Save that of the ink, for him whose understanding is sound;
And wheresoe'er be the letter, there with it is always its ink.
Open thine intellect unto these parables and heed them![29]

The esoteric doctrine concerning the nature of calligraphy combined with the beauty of its immediate presence which touches all who are sensitive to the saving and liberating grace of beauty provide the key for understanding the central position of this art in Islam and the reason for its privileged position in the hierarchy of Islamic art as well as its important role in Islamic spirituality itself.[30] For centuries Muslims have practiced calligraphy not only to cultivate a good handwriting which is a sign of traditional culture (*adab*), but also to discipline the soul. More than one calligrapher has been aware that in drawing a line from right to left, which is the direction of Arabic calligraphy, man is moving from the periphery to the heart which is also located in the left side of the body, and that in concentrating upon the writing of words in beautiful forms man is also bringing back the dispersed elements of his soul to their centre. Muslim men and women have also meditated upon the beauty of calligraphic forms as consorts of the Divine Word which is beautiful because it issues directly from the source of all beauty. The heart and soul of all Muslims have become refreshed by the majesty, harmony, rhythm, and flow of calligraphic forms which have surrounded Muslims living in traditional Islamic society and which have unveiled their beauty upon the pages of Qurans, on walls of mosques and other forms of architecture, on carpets and curtains, and even upon objects of daily use from dress to plates and bowls in which food is taken. Traditional calligraphy as the central sacred art of Islam is a gift from the *Ḥaqīqah* at the heart of the Islamic revelation from which this sacred art derives. It remains so for all Muslims whether they are themselves aware of the *Ḥaqīqah* or whether they remain content with external forms. As for those who follow the Way to the *Ḥaqīqah*, this central art is a major support for contemplation of the One, for every *alif* cannot but remind us that only the *alif* of Allah should occupy our heart and mind while every point brings about the recollection of the truth of the *ḥadīth* that 'God was and there was nothing with Him', and that furthermore, 'He is now even as He was'.

NOTES

1. The chapters of the Quran begin with the heading 'In the Name of God, Most Merciful, Most Compassionate', in Arabic *Bismillāh al-raḥmān al-raḥīm*, the b or Arabic *bā'* being written in Arabic as ﺑ. The point under the b symbolizes the Primordial Point, the first drop of the Divine Pen upon the Guarded Tablet. It is also the symbol of the Divine Essence Itself which stands not only beyond the cosmos symbolized by various letters and words but also beyond the Creative Act.

2. This prayer is among the collection of Suhrawardī's prayers and invocations usually known as *al-Wāridāt wa'l-taqdīsāt*. See M. T. Danechepazhuh, '*Niyāyish-nāmahā-yi Suhrawardī*', in M. Mohaghegh (ed.), *Ārām-nāmah*, Tehran 1361 (A.H. solar), p. 96. On this work and its author see H. Corbin, *En Islam iranien*, vol. 11, Paris, 1971, pp. 126ff.; and S. H. Nasr, *Three Muslim Sages*, Albany (N.Y.), 1975, Chapter 11.

3. See V. Minorsky, *Calligraphers and Painters*, Washington, D.C., 1959, p. 21.

4. F. Schuon, *Understanding Islam*, trans. D. M. Matheson, London, 1963, p. 60.

5. M. Lings, *The Quranic Art of Calligraphy and Illumination*, London, 1976, p. 14.

6. A traditional Muslim authority writes; 'The pen is the beacon of Islam and a necklace of honor with princes, kings and chiefs.' E. Robertson, 'Muḥammad ibn 'Abd ar-Raḥmān on Calligraphy', *Studia Semitica et Orientalia*, 1920, p. 65.

7. Minorsky, *op. cit.* p. 49.

8. On the arcs of descent and ascent see S. H. Nasr, *An Introduction to Islamic Cosmological Doctrines*, London, 1978, chapter XII.

9. On the symbolism of this letter see R. Guénon. 'The Mysteries of the Letter Nun,' in K. Bharatha Iyer (ed.), *Art and Thought*, London, 1947, pp. 166–168.

10. See Kāshifī, *Māwāhib-i 'aliyyah*, edited by S. M. R. Jalālī Nā'īnī, Tehran, 1329 (A.H. solar), vol. IV, pp. 229–230.

11. See T. Burckhardt, *An Introduction to Sufi Doctrine*, trans. D. M. Matheson, London, 1976, Part II.

12. Kāshifī, *op. cit.*, p. 230.

13. *Ibid.* Kāshifī alludes to two levels of manifestation, that of letters (*ḥurūf*) and that of words (*kalimāt*), both of which transcend the world of maternal forms and which together constitute the principle and basis of Quranic calligraphy as the visible embodiment of the Divine Word and by extension as the progenitor of all the traditional arts which issue from within the bosom of the traditional universe created by the revelation of the Word.

14. Referring to 'Alī, Qaḍī Aḥmad, the son of Munshī, says, 'And there exist tracings of the miraculous *qalams* of His Holiness the Shah, the Refuge of Sanctity (i.e. 'Alī) which enlighten the sight of the soul and brighten the tablets of the heart . . . and the most excellent *kūfī* is that which he has traced . . . Masters (of the art) trace the rules of writing and its origin to that Holiness', Minorsky, *op. cit.* pp. 53–54.

15. Especially the fourth Imām Zayn al-'Ābidīn and the eighth Imām 'Ali al-Riḍā.

16. Burckhardt, *The Art of Islam*, p. 51.

17. Lings, *op. cit.* p. 15.

18. See A. M. Schimmel, *Islamic Calligraphy*, Leiden, 1970; and Lings, where fine examples of all the major styles are reproduced. Much attention has been paid to Islamic calligraphy in recent years and many works have appeared with various degrees of success in describing the history and characteristics of various styles of calligraphy, many of them containing a profusion of illustrations. See Nājī Zain al-Dīn, *Atlas of Arabic Calligraphy*, Baghdad, 1968; M. Ziauddin, *Moslem Calligraphy*, Calcutta, 1936; A. Raenber, *Islamische Schönschrift*, Zurich, 1979; Y. M. Safadi, *Islamic Calligraphy*, Boulder (Colorado), 1979; A. Welch, *Calligraphy in the Arts of the Muslim World*, New York, 1979. Since completion of the present work, A. Schimmel's *Calligraphy and Islamic Culture*, New York, 1984 has appeared. It pertains directly to the subject matter of this chapter and needs to be mentioned here as an important reference.

19. Burckhardt, *The Art of Islam*, p. 47.

20. 'It [the palmette] is a reminder that the reading or chanting of the Quran is the virtual starting point of a limitless vibration, a wave that ultimately breaks on the shore of Eternity; and it is above all that source that is signified by the margin, toward which all the movement of the painting—in palmette, finial, crenellation and flow of arabesque—is directed. 'Lings, *op. cit.* p. 74.

21. This subject treated under different Islamic esoteric sciences, especially *al-jafr*, lies outside the scope of our present discussion and needs to be treated separately. Fortunately it has received ample and profound treatment recently in two works of J. Canteins, *Phonèmes et archétypes*, Paris, 1972, especially the introduction; and more directly as far as the Islamic tradition is concerned in *La Voie des lettres, Tradition cachée en Israel et en Islam*, Paris, 1981. See also P. Nwyia, *Exégèse coranique et langage mystique*, Beirut, 1970.

22. Schuon, *Understanding Islam*, p. 64. For an extensive analysis of the symbolism of the letters of the Divine Name see Canteins, *La Voie des lettres*, pp. 106ff.

23. This treatise is a commentary upon the saying attributed to 'Alī that the whole Quran is contained in the opening chapter, that chapter in the *basmalah*, etc.

24. *Al-Kahf. . .*, Hyderabad (Daccan), 1340 A.H. solar), p. 5.

25. *Ibid.*, pp. 10–11.

26. See Ibrāhīm Basyūnī, *Al-Basmalah min ahl al-'ibārah wa ahl al-ishārah*, Cairo, 1972, pp. 103ff, where al-Jīlī's *al-Kahf wa'l-raqīm* is analyzed.

27. See his *al-Risālat al-inzāliyyah*, ed. By S. 'A. Mūsawī Bihbahānī, in M. Mohaghegh and H. Landolt (eds.), *Collected Papers on Islamic Philosophy and Mysticism*, Tehran, 1971, p. 137.

28. See *Aḥwāl wa āthār-i Ṣā'in al-Dīn Turkah Iṣfahānī*, vol. I, Tehran, 1351 (A. H. solar), p. 108.

29. Translated by M. Lings in his *A Sufi Saint of the Twentieth Century*, London, 1971, pp. 150–151.

30. There have been certain sects such as the *ḥurūfīs* which have in fact gone to extremes in their emphasis upon the esoteric significance of letters and thereby left the pale of Islamic orthodoxy. The antidote to such excesses is provided by certain Sufis themselves such as al-Niffarī, and the traditional use of calligraphy as support for spiritual practice must not be confused with the sectarian use of it by such groups as the Ḥurūfīs or Nuqṭawiyān.

III

The Principle of Unity
and the Sacred Architecture of Islam

«جُعلت لى الارض مسجداً و طهوراً.»

The earth was placed for me as a mosque and purifier.

(ḥadīth)

«المؤمن فى المسجد كالشمس في الماء.»

*A person of faith in a mosque is like the sun reflecting
in the water.*

(ḥadīth)

GOD DESIGNATED the whole of virgin nature, that inexhaustible masterpiece of His creative act, as the place of worship for Muslims and distinguished His final messenger by allowing Islam, the primordial religion, to return to primordial nature as its temple. The sacred architecture of Islam *par excellence* is the mosque which is itself but the 're-creation' and 'recapitulation' of the harmony, order, and peace of nature which God chose as the Muslims' enduring house of worship. In praying in a traditional mosque the Muslim in a sense returns to the bosom of nature, not externally but through the inner nexus which relates the mosque to the principles and rhythms of nature and integrates its space into that sacred space of primordial creation which dilated and still dilates, to the extent that virgin nature has survived the onslaughts of Promethean man,[1] in the Divine Presence that at once calms and unifies the soul. Through the Divine Command which placed nature as the Muslim's temple of worship, the sacred architecture of Islam becomes an extension of nature as created by God within the environment constructed by man. It becomes encompassed by and participates in the unity, interrelatedness, harmony, and serenity of nature even within the

environment of the city and town. It becomes in fact a centre from which these qualities emanate to the whole of the urban environment. The spaces and forms of the traditional Muslim town and city are in a sense extensions of the mosque, organically related to it and participating in its sanctifying and unifying character in the same way that the whole city or town participates in the blessedness that emanates from the chanting of the Quran and the call to prayers (*al-adhān*) issuing from the precinct of the mosque. In making the mosque an extension of primordial nature, Islam emphasizes the primordial nature of man himself. This nature it seeks to revive and reaffirm by awakening man from the dream of forgetfulness, arousing within him the consciousness of the reality of the One or the Absolute, a consciousness which constitutes the very substance of primordial man and the *raison d'être* of human existence.[2]

The very word 'mosque' derives from the Arabic *masjid* which means literally the place of *sujūd* or prostration, that is, the third position in the Islamic ritual prayers (*ṣalāt* or *namāz*) in which the forehead of the worshipper touches the ground in the supreme act of submission and surrender to God before Whom, at the beginning of these prayers, the Muslim stands directly as the primordial man, himself his own priest,[3] facing God without an intermediary. The space of the mosque, as the recapitulation and extension of the space of virgin nature, is thus created in accordance with the nature of the most important rite performed in the mosque, namely, the ritual prayers. These prayers are performed by man, not as a fallen being but as God's vicegerent on earth, aware of his theomorphic substance, standing on the vertical axis of cosmic existence and capable of praying to and calling directly upon God.

It is not, however, only the space of the mosque within which the faithful pray to the One that is important. It is also the floor upon which they prostrate themselves that is of crucial significance. The first mosque of Islam was the house of the Blessed Prophet, and it was the house of which the first official mosque, that of the Blessed Prophet in Medina, was in a sense an extension. It was the forehead of the most perfect of God's creatures,

of the Perfect Man[4] himself about whom God has said, 'Were it not for thee I would not have created the heavens',[5] that touched in prayer the floor of the humble room within which he prayed, thereby sanctifying the floor of the mosque and returning this floor to its inviolable purity as the original earth at the dawn of creation. The Blessed Prophet had first prayed before the Divine Throne (*al-'Arsh*) before he prayed upon the ground (which in Arabic and Persian as *farsh* is often contrasted to *'Arsh*) and, by sanctifying the *farsh* over again as the reflection of *'Arsh*, returned the earth to its primordial condition as the mirror and reflection of Heaven. It was this sanctification of the ground by the very act of the *sujūd* of the Blessed Prophet that bestowed a new meaning upon the ground and the carpet covering it. The carpet, whether of simple white colour or full of geometric and arabesque patterns and ornaments, reflects Heaven and enables the traditional Muslim who spends most of his time at home on the carpet to experience the ground upon which he sits as purified and participating in the sacred character of the ground of the mosque upon which he prays.

In revealing the central rite of daily prayers to the Prophet, God allowed not only nature to become once again the temple of worship, as it had been for primordial man, without any danger of naturalism or idolatry, but also permitted the sanctification of the earth itself through the *sujūd* of the Perfect Man. By touching the ground with his forehead the Prophet bestowed a special significance upon the floor of his house, through it upon the first mosque, and through the Medina mosque upon the whole of Islamic architecture as far as the floor and the experience of space from the floor is concerned.

The Quranic revelation brought back to man the awareness of the cosmos as God's revelation and the complement of the 'written Quran' revealed in the Arabic language.[6] This awareness is abetted by the rite of ritual prayer which brings out the primordial nature of man to whom God addresses Himself in Islam while it accentuates the significance of primordial nature as the temple of worship. Furthermore, the Blessed Prophet asserted the reality of the *farsh* as the image of the *'arsh*. He prayed in deserts and mountains, in nature which was still pure and unviolated. He also prayed in his house in Mecca and

later in Medina and finally in the Medina mosque which is the prototype of all later sacred architecture of Islam. In this manner God, through his last prophet, re-established nature as the primary temple of worship and made possible through the founder of Islam the consecration of the space and ground of his domicile as the sacred place within which and upon which the most perfect of men stood directly before God and performed the rites which are central to Islam. If in the Islamic city the home is an extension of the mosque and the floor of the traditional home which is kept ritually clean an extension of the floor of the mosque upon which one stands and prays, it is because the floor of the mosque itself is an extension, through the prototypical Medina mosque, of the floor of the house of the Blessed Prophet wherein the forehead of the Perfect Man touched the earth as a result of a new dispensation from Heaven. This act of touching the earth, among its many functions, stood for the return of both man and nature to the state of primordial purity (*al-fiṭrah*) when Unity manifested itself directly in the hearts of man and was echoed in an unending symphony in that harmony which constitutes virgin nature. The root of the sacred architecture of Islam is to be found in this re-sanctification of nature in relation to man seen as the primordial being who remains aware of his inner nexus both to the One and to His creation,[7] as well as subsequent relationships between architecture and the Islamic cosmos with its cosmological laws and principles described so majestically in the Quran and elucidated and elaborated by generations of sages throughout the history of Islam.[8]

Islamic cosmology, as based on the cosmological verses of the Quran such as the *āyat al-Kursī* (II; 255) and *āyat al-nūr* (XXIV; 35)[9] and many prophetic *ḥadīths*, envisages the Spirit or *al-rūḥ* at the apex and centre of cosmic existence and belonging to the world of Divine Command.[10] Below it stand the archangelic substances identified with the 'perimeter' of the Divine Throne which they uphold, then the Divine Pedestal (*al-Kursī*) and the lower angelic orders descending in a hierarchy to the invisible world. There are many forms of mosque architecture, a fact which has been paraded by many scholars of Islamic art as proof that Islamic architecture is simply an out-

growth of historical accidents. But whether in the classical domed mosque in which the centre of the dome sybolizes the One, and on a lower level the *rūḥ*, while the octagonal belt, upon which the dome usually rests, symbolizes the angelic order and the four-sided base the earth or the material world, or in the earliest mosques in which all the elements of the spiritual universe of Islam are not visually symbolized, there is an inner nexus between Islamic architecture and Islamic cosmology and angelology. The Islamic cosmos is based on the emphasis upon God as the Unique Origin of all beings, on the hierarchy of existence which relies upon the One and is ordered by His Command, on the levels of existence which relate matter to the subtle world, the subtle world to the angelic, the angelic to the archangelic, the archangelic to the Spirit or *al-rūḥ* and the Spirit to God's primordial creative act. This cosmos is based on order and harmony which is more than the result of the direct manifestation of the One in the many. It displays a peace and tranquility which dominate its obviously dynamic character because the patterns of change within nature reflect nevertheless the immutable archetypes which belong to the higher states of universal existence and are ultimately possibilities in the Divine Nature. These and many other features of Islamic cosmology are reflected in Islamic architecture, especially in the sacred architecture of the mosque which is based on a science that cannot but issue from the inner dimension of the Islamic revelation and other forms of wisdom which Islamic esotericism integrated into its world-view in accordance with its own nature and the integrating power of Islam.

The Islamic cosmos is replete with the signs and portents (*āyāt*) of God in accordance with the Quranic verse, 'We shall show them our signs (*āyāt*) upon the horizons and within their souls until it becomes manifest to them that it is the Truth'. (XLI;53) The true Muslim sees every aspect of nature not as phenomena divorced from the noumenal world but as signs of God, the *vestigia Dei*.[11] The mosque also displays the same reality. Its patterns appear to the Muslim eye as *vestigia Dei* while its emptiness, simplicity, and in many cases lack of any designs or patterns also reflect to the Muslim mind the 'signs'

The most primordial sacred architecture of Islam is the Ka'bah, the point where the Heavenly axis pierces the earth. This primordial temple built according to the Islamic tradition by Adam himself and then rebuilt by Abraham is the earthly reflection of that celestial temple which is also reflected in the heart of man. The harmony of dimensions, stability and symmetry of the Ka'bah, the centre of the Islamic cosmos, are to be found in the sacred architecture of the whole of the Islamic world.

LEFT Among the most perfect of grand mosques of Egypt, the Ibn Ṭūlūn Mosque in Cairo reveals in a particularly striking manner the tranquility and peace that characterize Islamic sacred architecture.

43

of God which in this case refer to the ontological status of the world as needy and poor (*al-faqīr*) while God is the self-sufficient and the Rich (*al-Ghanīy*). As for the space, its stillness reflects the pacifying presence of the Divine Word which echoes through it while the rhythmic division of the space by means of arches and columns is the counterpart to the rhythms of cosmic existence which punctuate the phases of the life of man as well as the cosmos both of which come from Him and return to Him in accordance with the Quranic verse, 'Verily we belong to God and to Him we shall return'. (11; 156)

The sacred architecture of Islam reflects the reality of God's creation through the science upon which the structure of both architecture and creation are based, this architecture depending upon the grace or *barakah* issuing from the Quranic revelation which has made the correspondence in Islam between sacred architecture and nature possible. Moreover, the nexus between Islamic architecture and virgin nature must be sought in the spiritual reality of the Blessed Prophet who, as the Perfect Man, *par excellence*, brought to earth that rite which sanctified and continues to sanctify the earth and brought into focus the spiritual reality of that primordial substance and state which both man and nature bear within themselves. The spiritual significance of Islamic architecture must be sought at once in the nature of the Quranic revelation which brought out the 'supernatural' character of both the natural order and of man as well as in the inner nature of the Blessed Prophet, who not only 'sanctified' the earth upon which man stands and prostrates himself, but sanctified the space within which also man lives and orients himself with the goal of reaching that Reality that lies beyond all extension and becoming.

Architecture is of course the art *par excellence* of ordering space, and all sacred architecture achieves its basic goal of placing man in the presence of the Divine through the sacralization of the space which it forms, orders, and orients by means of various architectural techniques. In the case of Islamic architecture this sacralization is achieved most of all by means of the polarization of space through the presence of the Ka'bah which is the centre of the earth around which Muslim pilgrims circumnambulate and towards which all Muslims turn in their

44

daily prayers. But this effect is also achieved by means of the creation of a qualified space in a sense defined by the reverberations of the Divine Word upon the surface and planes within the volumes of the corporeal world which comprises the Islamic edifices and cities. The space of Islamic architecture is not the quantified space of Cartesian geometry but the qualified space related to sacred geometry and given order through the presence of the sacred.[12] The Ka'bah chosen by God as the direction of prayer or *qiblah* of Muslims is in a sense ubiquitous in that it determines and polarizes direction and creates an invisible set of 'lines of force' which attract all points in the periphery toward the Centre. It is not only the direction of the mosque or a whole city that is determined by the *qiblah* but the experience of space itself.

Space is, moreover, sanctified in an esoteric manner through the cosmic amplitude and expansion of the inner reality of the Blessed Prophet, or what the Sufis call *al-ḥaqīqat al-muḥammadiyyah*. As the Universal or Perfect Man, the Blessed Prophet 'fills' the breadth (*'arḍ*) and depth or length (*ṭūl*), of cosmic existence;[13] he 'fills' the space within which the Islamic cosmos functions and in which the Muslim breathes and lives. The Muḥammadan Reality reaches the zenith and the nadir and the four cardinal directions which are thereby qualified and sanctified. The stations of wisdom in Islamic spirituality are related to this aspect of the Muḥammadan Reality[14] who in thus sanctifying space also bestowed upon it once again its primordial spiritual significance.[15] The same being who in praying before the Divine Throne or *'Arsh* and then upon the earth, hallowed the earth by bringing something of the *'Arsh* to the ground or to the *farsh* of human habitation, also sanctified space in an invisible and esoteric manner which is nonetheless decisive in the genesis of the sacred architecture of Islam and in fact all Islamic architecture. In the same way that the soul of the Blessed Prophet is an invisible spring for all Islamic spirituality, something of his soul is also to be found in the sobriety, calm, harmony, outward austerity and inner richness and generosity of the traditional Islamic city and the authentic manifestations of Islamic architecture. The experience of the space of Islamic architecture by a traditional Muslim and there-

fore the discovery of the principles of that architecture which make the Islamic experience of space possible cannot be achieved without paying full attention to the manner whereby, through the Prophet and the rites brought to this world by him as a result of the Divine Command, the earth and nature as a whole were once again made to reflect Heaven and regain their primordial character as the temple created for the worship of the One. Also space was qualified in such a manner as to enable the integration of all points of the periphery within the Centre and to enable experience of the ubiquitous presence of the Divine throughout that space which points to the Centre wherever one happens to be located on the wheel of terrestrial existence.

Although the significance of the void will be dealt with separately in a later chapter, it is necessary to point out here, while discussing the sacralization of space, the central importance of the void in Islamic architecture and art in general. The emptiness of the mosque, even the most richly decorated, is related both to the idea of spiritual poverty (*faqr*) of which the Blessed Prophet said, 'Spiritual poverty is my glory' (*al-faqr^u fakhrī*) and the identification of the invisible and unmanifested with the spiritual in the Muslim mind. The Quran refers often to the invisible and visible worlds, *'ālam al-ghayb wa'l-shahādah*, identifying the first with the spiritual and the second with the corporeal or material world. The emptiness in the mosque, related at once to spiritual poverty and the sense of the presence of the Spirit, is of course also a result of the emphasis of the Islamic revelation upon the doctrine of Divine Unity and hence the aniconic nature of the sacred art of Islam.[16] Together these factors bestow upon emptiness within the space of Islamic architecture a spiritual significance of the greatest importance.

This is to be seen also in interior decoration of not only the mosque but also the home which is its extension. Uncluttered by furniture, with emphasis upon the floor which is kept ritually clean, the interior space of the traditional Muslim house, like that of the mosque, evokes the sense of the sacred through the very emptiness which although non-existent from one point of view, nevertheless manifests the presence of the Spirit in the same manner that the ether, although not visible in itself,

serves as the substratum for the gross elements of traditional cosmology. Air serves as the vehicle for the transmission of the Word of God which resonates periodically throughout the spaces of the Islamic habitat. When one enters a traditional mosque or home the very emptiness of the space draws attention to the Invisible as does the experience of the ground upon which one can only walk after taking off one's shoes. This touching of the ground with one's hands and face in prayer creates the awareness of the hallowedness of the earth by virtue of the act of that most perfect of creatures who, in touching the earth with his forehead in total submission to God, sacralized it for all subsequent generations of Muslims.

There is within Islamic spirituality a special link with qualitative mathematics in the Pythagorean sense, a link which results from the emphasis upon unity and the intellect (*al-'aql*) on the one hand and the primordial nature of Islamic spirituality on the other. It is not that Islam borrowed the spiritual significance of mathematics from Pythagoras, Plato or Nicomachus. These ancient sages provided providentially a sacred science which Islam could easily assimilate into its world view. The truth is that there was already in the Islamic world view before its encounter with Greek science what one might call an 'Abrahamic Pythagoreanism'.[17] Pythagoras was already a Muslim sage in Muslim eyes and therefore could be assimilated easily into the Islamic universe.[18] The mathematical nature of Islamic art and architecture does not derive from external historical influences, Greek or otherwise. It derives from the Quran whose own mathematical structure is bewildering and reveals an amazing rapport between Islamic intellectual and spiritual concerns and mathematics. The mathematical nature of Islamic art is in a sense the externalization of the mathematics hidden in the very structure of the Quran and the numerical symbolism of its letters and words.[19] The Pythagorean philosophy of mathematics provided the language and presented an already elaborated science, itself of a esoteric nature and going back to Egypt and Babylon, for the 'spiritual mathematics' which is so central to Islamic architecture and even the so-called decorative arts. It did not create this art. The use of rigorously defined geometric spaces, precise

47

mathematical proportions, clearly defined lines and volumes relating to exact mathematical laws[20] were means whereby the space of Islamic architecture, as well as its surfaces, were integrated. The principle of Unity was thereby made more manifest and the Islamic space within which Muslims carried out their ordinary lives as well as moments of worship were sacralized. The question of how mathematics as a sacred science is related to Islamic architecture is the subject of a separate treatise which we cannot go into here in any detail. But what does need to be emphasized is the significance of this traditional mathematics, much of it drawn from ancient and Pythagorean sources and integrated into Islamic esotericism as a means of creating a sense of the sacred in Islamic art and architecture. This mathematical character of Islamic art, moreover, derives directly from the nature of Islamic spirituality which remains always closely wedded to the experience of harmony and an archetypical reality which is the reflection of the One and which remains immutable beyond the ever changing patterns of the transient world. There is present something of both the lucidity and perfection of the snowflake and the beauty of a geometrically formed flower in the Islamic paradise which when manifest in Islamic art and architecture re-captures an echo of that paradise and prepares the soul for the experience of that *firdaws* promised in the Quran to the faithful.

While dealing with mathematics, it is noteworthy to mention a point neglected by most students of Islamic architecture. The surfaces of many buildings which can be characterized as sacred architecture, such as mosques and mausoleums of saints, are often covered by very elaborate mathematical patterns. This characteristic is to be seen especially in later Islamic architecture in such buildings as the Shaykh Luṭfallāh and the Shāh Mosques of Isfahan[21] and the tomb of Shāh Ni'matallāh Walī in Mahan. What can be the significance of such complicated geometric patterns on the surface of walls of mosques and mausoleums? Besides directing attention to the Centre which is everywhere and nowhere, untying the knots of the soul and preventing subjectivism, these patterns also have another significance of a remarkable nature. Although 'on the

48

surface' of things, they represent the interior structure of corporeal existence or matter as this term is understood in its general sense. Recent research by several scientists has revealed extraordinary similarities between these geometric figures and configurations and the 'inner' structure of material objects both animate and inanimate discovered through the electronic microscope and other modern techniques.[21]

It seems as if these patterns serve as a key for the understanding of the material with which the architect deals while unravelling also the structure of the cosmos before the eyes of the beholder. But these patterns do not originate from an analysis of matter in the manner of modern physics. They are the results of the vision of the archetypal world by seers and contemplatives who then taught craftsmen to draw them upon the surfaces of tiles or alabaster. These patterns do not prove that physics leads naturally to metaphysics, especially physics of the modern variety. Rather, they are an illustration of the Hermetic principle that 'that which is lowest symbolizes that which is highest'. They also illustrate an important aspect of the Islamic revelation, which is to bring out the reality of the cosmos itself as God's primordial revelation. If in the sacred architecture of Islam built to celebrate God, mathematical patterns, which correspond to the inner structure of the natural world, serve as ornaments upon the various façades, it is because nature herself participated in the Quranic revelation and was re-sacralized by it in the eyes of that segment of humanity which came to accept the revelation brought by the Blessed Prophet. The role of mathematics in the sacralization of architecture in Islam is inseparable from the nature of the Quranic revelation and its emphasis on the one hand upon the supernatural character of the intellect within man and, on the other, the sacredness of virgin nature whose laws and structures are related to the mathematical world.

One must also of course consider the specific symbolism of various geometric forms associated with Islamic architecture which relates outward forms to inner meaning and architectural utility to spiritual significance. The dome, while creating a ceiling which protects from both heat and cold, is also the symbol of the heavenly vault and its centre the *axis mundi*

which relates all levels of cosmic existence to the One.[22] The octagonal base of the dome symbolizes the Throne and Pedestal and also the angelic world, the square or rectangular base the corporeal world on the earth. The stalactite or *muqarnas* structures represent reflection here below of the supernal archetypes, the descent of the heavenly abode towards the earth and the crystallization of the celestial substance or ether in terrestrial forms. The external form of the dome symbolizes the aspect of Divine Beauty or *jamāl* and the vertical minaret Divine Majesty or *jalāl*. The Persian arch moves upward like a flame towards Heaven and the Transcendent and the Maghribi arch inwardly toward the heart which symbolizes the same Principle in its aspect of immanence.[23] Consideration of the symbolic aspect of these forms, not all of which are necessarily employed in all types of traditional Islamic architecture, is of course essential for an understanding of the spiritual significance of this architecture, for they are the means whereby Unity penetrates into the world of architectural forms to create a sacred quality whereby earthly forms come to signify realities beyond the earthly realm.

'God is the Light of the Heavens and the Earth', the Quran asserts and a prophetic saying adds a cosmogonic and cosmological dimension to this verse by adding, 'The first being created by God was light'. This important reality of the Islamic universe manifests itself not only in the luminous skies and clear light which characterize most of the heartland of the Islamic world where classical Islamic architecture grew, but also in this architecture itself. The great masterpieces of Islamic architecture, such as the Alhambra, the *īwāns*, and the courtyards of so many Persian mosques and the Tāj Mahal, are like crystallizations of light, limpid and lucid, illuminating and illuminated,[24] where the space of Islamic architecture is defined by light. While the traditional architect seeks to protect the inner spaces of a building from the great heat of the outside; and while coolness and shade are associated in the Muslim mind with divine blessing, the soul of the Muslim, and in fact the primal man in every man, yearns for light which is ultimately a symbol of Divine Presence, the Light which shines

upon the whole cosmos from the central *axis mundi* that is neither of the East nor of the West.[25] Throughout the centuries Sufis have sung and written of the significance of light as a spiritual substance.[26] A special school of Islamic philosophy, the school of *ishrāq* or illumination, based specifically upon the symbolism of light was founded by the Persian theosopher and Sufi, Suhrawardī, and developed over the centuries by such later masters as Shams al-Din Shahrazūrī, Quṭb al-Dīn Shīrāzī, Ibn Turkah, and Mullā Ṣadrā.[27] Arabic and Persian literature, and even everyday language, are replete with expressions which identify light with joy of the soul and correct functioning of the intellect while even old tales told to small children are often based on the primal symbolism of light as truth and felicity, a symbolism which is so powerfully reconfirmed in the Islamic tradition and of course also asserted by many other older religions, especially Mazdaeism.

This identification of light with the spiritual principle that at once creates, orders, and liberates is a determining factor in the sacralization of architecture in Islam, complementing the above-mentioned factors and principles. Moreover, this light is ultimately the same as the Word, for according to another *ḥadīth* the first being created by God was the Word (*al-kalimah*) hence the principial identity of Light and the Word *al-nur* and *al-kalimah*. It is certainly not accidental that the place in the mosque from which the Word of God in the form of the call to prayer reaches the community, namely the minaret, is called in Arabic *al-manārah*, literally the place of light. Even if, according to certain historians of architecture, the architectural features of a minaret are derived from a lighthouse (a point which is itself debatable since a raised platform was already in use as a minaret in the Medina Mosque), the very name of the minaret in Islamic language identifies the Light of God with His Word. This confirms the Quran's own description of itself as Guidance (*al-hudā*) upon the path to God, hence a light which shines upon the otherwise dark path of human existence in this world. The light which defines the spaces of Islamic architecture and brings out its geometric clarity and intellectual lucidity is inseparable from that Word which in the form of the Quran reverberates within those spaces and brings

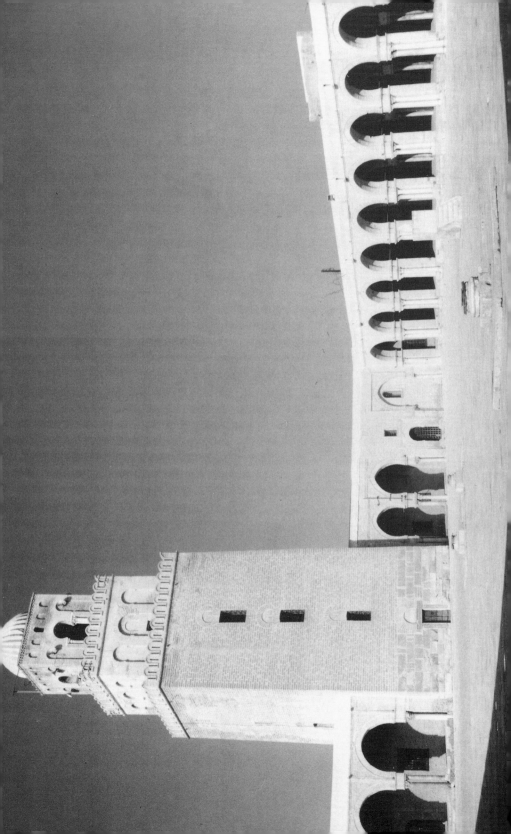

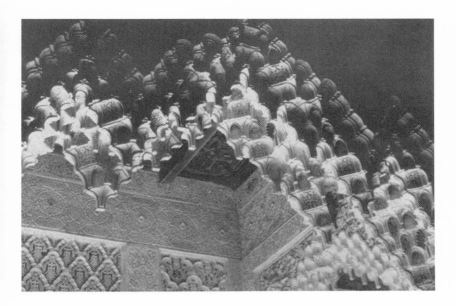

These stalactites from the Court of Lions in Alhambra do not only serve the practical function of supporting the roof, but also symbolize the descent of light into the world of material forms. They are like rays of light cast from the world of the supernal Sun toward the abode of earthly opacity.

LEFT Among the earliest mosques built in the Islamic world, the great Mosque of Kairouan in Tunisia already possesses in fullness that inner peace and harmony that characterize the masterpieces of Islamic architecture.

those who harken to its echo before the Divine Presence. Both the reverberations of Word and Light sacralize the spaces and forms of Islamic architecture and create a sense of the presence of the One wherever man turns his face for as the Quran asserts, 'Whithersoever ye turn, there is the face of God'. (Arberry trans.)

Not only does light define the spaces of Islamic architecture, but it also plays a central role in making possible both the use of intensely white, structures which reflect the purity of the desert and the levelling of all multiplicity before the One according to *Lā ilāha illa'Llāh*, and the use of intensely coloured edifices which appear as an earthly reflection of the paradisal states. If white symbolizes the unity of undifferentiated reality, colours which result from the polarization of light symbolize the manifestation of the One in the many and dependence of the many upon the One. Each colour symbolizes a state and is itself light, without light being limited to that particular colour. If colours can be said to symbolize states and levels of cosmic existence, white is the symbol of Being which is the origin of all existence. As for black, which plays an eminent role in Islam in that, along with green, it is the colour of the family of the Blessed Prophet and is even important architecturally as the colour of the cloth (the *kiswah*) which covers the Ka'bah, it may be said to symbolize the supra-ontological Principle transcending even Being as usually understood. It symbolizes the Supreme Principle to which the Ka'bah is of course related in that it is in a sense the principle of all sacred architecture in Islam.[28]

If the white or earthen-coloured mosques remind man of his poverty before Divine Unity and correspond both to the spiritual poverty of the Blessed Prophet and to the aspect of his soul as related to submission, peace, serenity, and sepulchral beatitude, the intensely coloured mosques symbolize the richness of God's creation and the other aspect of the soul of the Blessed Prophet which is a theophany and reflection of the infinite richness of that Divine Treasury which creates at every moment without ever exhausting its infinite possibilities. As for individual colours employed in different edifices ranging from the green dome of the Medina Mosque, symbolizing the

colour of Islam[29] to the azure blue mosques of Timūrid and Safavid Persia as well as certain regions of Ottoman Turkey and Mogul India, they all possess a symbolic significance based both on *hadīth* literature and oral tradition and are far from being *ad hoc* and simply arbitrary.[30] But in any case, whether light shines upon a white surface, or polarizes into numerous colours, whether it penetrates directly into the spaces of a mosque from ceilings or indirectly through side portals, it is related to the Divine Presence and the cosmic intelligence which also shines within man and is the means by virtue of which man is able to realize the One. Through the ingenious use of light the Islamic architectural spaces are integrated with each other and into a unity which transcends the experience of ordinary and 'profane' space.

The *shahādah*, *Lā ilāha illa'Llāh*, contains the principial knowledge about the nature of Reality and in accordance with its truth, which lies at the heart of the Islamic revelation, Islam itself is based on the nature of Reality. It is profoundly 'realist' in the traditional and not the modern sense of the word. It is realist in that it emphasizes that God is God and man is man, that the material world is the material world and the angelic world the angelic. It refuses to confuse one level or reality with another or to address itself to a would-be ideal that is not in the nature of the being in question.[31] This characteristic of Islam could not but manifest itself in architecture which always preserves its realism and refuses to create the illusion of an ideal which is not in the nature of the material and the space with which it is concerned. There are no created tensions, no upward pull to a heavenly ideal in Islamic architecture as one finds in Gothic cathedrals which are based on another spiritual perspective than that of Islam. The space of the sacred structures of Islam rests serenely and nobly in a stillness which conforms to the inner nature of things here and now rather than seeking to participate in an ideal which belongs to another level of existence and is contrary to the nature of the material at hand.

Likewise, Islamic architecture ennobles matter not by making stone appear to be light and flying upwards but, by means of geometric and arabesque patterns which make material

objects become transparent before their spiritual archetypes, reflecting these archetypes on the level of existence proper to those objects. In this way the nobility of material objects is brought out by remaining faithful to the nature of each object which, being created by God, reflects on its own level a particular spiritual quality. The traditional Muslim architect and builder, like all traditional craftsmen, had a profound sense of the nature of the materials with which he dealt. Stone was always treated as stone and brick as brick. At no time did such a builder seek to make a particular object appear to be something other than itself. Whether dealing with stone, brick, mud, or wood in whatever region of the Islamic world and depending upon ecological and economic factors, Muslim architects were able to create masterpieces of Islamic architecture because they had a mastery both of the science involved in building and of the materials they used thereby integrating them into a whole reflecting the ethos of Islamic art. They had a sense and awareness of Islamic spirituality which enabled them to create unmistakably Islamic buildings whether using mud in Mali or wood in Malaysia. In contrast to many modern architects who have lost the sense of direct knowledge of the nature of materials, the traditional Muslim architect had direct experience of the reality of the materials he was using,[32] possessing at once an intuitive and empirical knowledge of things. This knowledge included many dimensions of the reality of material objects left out of the world-view of both classical and modern physics despite their claim to being based on empiricism.

This sense of realism and remaining faithful to the nature of things, which is of course inseparable from the resacralization of the cosmic order by the Quranic revelation, also manifests itself in the ecological equilibrium of the traditional Islamic building and of the whole urban environment. Islamic architecture makes full use of light and shade, and their heat and coolness, of wind and its aerodynamics, of water and its cooling effect, of the earth and its insulating features as well as its protective properties in face of the elements. Far from being an attempt to stand in opposition and defiance against nature and its rhythms, Islamic architecture remains always in harmony with the environment. It always uses the lightest

touch possible in creating a human ambience, avoiding that titanic rebellion against the created order that characterizes Promethean man and his artistic creations. The Islamic town rises gently from the earth, makes maximum use of nature's own resources and when abandoned usually returns again gently to the bosom of the earth. This architecture not only participates in the rhythms and forces of nature but also in her blinding harmony and unity. Moreover, this ecological harmony of traditional Islamic architecture is not simply the result of sane ecological and even economic thinking in the modern sense of these terms,[33] but is a consequence of the nature of Islamic spirituality. A small fountain in a traditional courtyard of a mosque or a private house, which cools the air as well as pleases the eye with very little waste of a precious natural resource, is seen by the Muslim in religious and not only 'practical' or economic terms. The very physical experience of the cooling effect of the wind tower on a hot summer afternoon in a traditional house in Kashan or Yazd possesses an unmistakable spiritual component. This intermingling with the qualities, forces, and flow of the elements, the movement of the heavens, and the ever repeating rhythms of light and darkness, all of which traditional Islamic architecture heightens and reveals rather than hides, serves only to remind the Muslim of that other revelation of God, that is, nature, which remains truly *muslim* or submitted to the Divine Will by obeying its own nature and the laws which each domain of the natural order was created to obey.

The unity of Islamic architecture is related of course not only to the unity of the cosmos and beyond that realm to the Unity of the Divine Principle Itself, but also to the unity of the life of the individual and the community which the Divine Law (*al-Sharī'ah*) makes possible. By refusing to distinguish between the sacred and the profane, by intergrating religion into all facets of life and life itself into the rhythms of rites and patterns of values determined by religion, Islam creates a wholeness which is reflected in its architecture.[34] The mosque in a traditional Islamic city is not only the centre of religious activity but of all community life, embracing the cultural, social and political as well as, to a certain extent, economic activities. It

is therefore related organically to the bazaar or centre of economic life, the palace or seat of political power, schools where intellectual activity takes place, etc. Private homes are always nearby and in the same way that work, leisure, prayer and care of the family are integrated and not totally separate in the traditonal Islamic pattern of life, the architectural spaces related to these activities are also intertwined. Even within the home, a single room is often used for several functions including eating, sleeping, socializing and praying, while prayers can take place in shops in the bazaar, transactions in the mosque, and teaching in both the mosque and the home.

When one looks at the traditional Islamic city, one observes that this unity and inter-relatedness are reflected directly in the architecture. At the centre there is always the mosque or tomb of a saint with the city growing in an organic manner around it.[35] Moreover, the city seems to be covered by a single roof emanating from the sacred centre. In a profound sense therefore, the sacred architecture of Islam casts its light and influences the whole of traditional Islamic architecture, bestowing upon it the character of reflecting sacred presence. It seems that in the same way that the floor of the mosque, sacralized by the Blessed Prophet, stretches into the floor of every home in which one prays, the roof of the traditional city emanates from and is an extension of the roof of the sacred structure at its heart. The space of the whole city is purified and sacralized by the presence of the Divine Word which fills it periodically every day through the chanting of the call to prayers and the text of the Quran recited from the minarets of the mosques in various parts of the city. The unity of the sacred architecture of Islam thereby spreads to the whole of traditional Islamic architecture and this architecture partici-pates, albeit in a more peripheral manner, in that crystalliza-tion of Divine Presence which fills the spaces of the sacred architecture of Islam and places man as God's vice-gerent directly before the Majesty of the One.

All the factors mentioned above, from the unitarian charac-teristic of the Islamic revelation, the cosmic dimension of this revelation and the nature of the Quran as the Word of God addressed to what is primordial in man, the sacralization of

the earth by the Blessed Prophet through the institutionaliza-
tion of the rite of *ṣalāt*, an esoteric science of geometry and pro-
portions related to architecture and many other elements, have
made possible the creation of the sacred architecture which is
one of the central arts of Islam. This sacred art came into being
as a result not of simple accretion of various elements but of
a creation which is inseparable from the spirit and form of the
Islamic revelation and is the direct effect of this revelation
without which it could not exist.[36] The principles of this archi-
tecture and the manner of its relation to the Islamic revelation
may not have been elucidated in old texts because there was
no need for such an elucidation, not because such a relation-
ship did not exist. It is only now, when much of the oral tradi-
tion is forgotten and many Muslims themselves have become
oblivious to this relationship, that it is necessary to assert cate-
gorically the Islamic nature of Islamic architecture. In fact it
needs to be underlined that the sacred architecture of Islam
is a crystallization of Islamic spirituality and a key for the
understanding of this spirituality. The spaces it has created pro-
vide a haven in which man can savour, by grace of this very
spirituality, the peace and harmony of not only virgin nature
but also paradise of which virgin nature herself is a reflection,
this paradise which man carries at the depth and centre of his
being where the Divine Presence reverberates, for the heart of
the faithful is the Throne of the Compassionate.

NOTES

1. By Promethean man we mean the anti-traditional man in rebellion against
Heaven and in quest of playing the role of divinity on earth without submitting himself
to the Will of Heaven. See Nasr, *Knowledge and the Sacred*, Chapter 5.

2. On the Islamic conception of man and his primordial nature see F. Schuon,
Understanding Islam, pp. 13ff; Nasr, *Ideals and Realities of Islam*, pp. 16ff; and G. Eaton,
King of the Castle, London 1977, Chapter v.

3. This truth holds as much true for women as it does for men since both men
and women perform their ritual prayers in standing directly before God.

4. The Blessed Prophet is of course for Muslims the Universal or Perfect Man
(*al-insān al-kāmil*) *par excellence* containing within himself the perfections of all hori-
zontal and vertical dimensions of universal existence. On the doctrine of Universal
Man see 'Abd al-Karīm al-Jīlī, *Universal Man*, trans. T. Burckhardt, Sherborne, 1983.

5. The famous 'sacred *ḥadīth*', *wa law lāk^a wa mā khalaqtu'aflāk^a*.

6. Later Muslim metaphysicians and Quranic commentators distinguished between the 'written or composed Quran' (*al-Qur'ān al-tadwīnī*) and the 'cosmic Quran' (*al-Qur'ān al-takwīnī*) which is the cosmos itself.

7. The *ḥadīth* about the man of faith (*mu'min*) in the mosque being like the reflection of the sun in the water quoted at the beginning of this chapter refers to the spiritual significance of the mosque as the reflection of the inner reality of primordial man who is the microcosmic counterpart of cosmic reality. Whether it be the exquisite and elaborate patterns of the Gawharshād mosque of Mashhad in Persia, where this *ḥadīth* is written on the wall, or the simple white walls of an Ibn Ṭulūn mosque, the traditional mosque reflects the reality of both primordial nature and man. It reflects that 'sun' which is none other than that *fiṭrah* which Islam came to re-assert both within man and in the cosmic order.

8. All traditional architecture is in fact connected to the cosmology of the tradition in question and this relation is not unique to Islam. What is strange, however, is that in the case of Islam most modern scholars, including not only Westerners but also many Muslims, have failed to pay any attention and in many cases have even denied any relationship between Islamic architecture and Islamic cosmology. Unfortunately, not all the different forms of Islamic cosmology have been studied and made available in a contemporary language. Even if their details are not known, however, it can be said with certainty that they are all based on revealing the inter-relation of the many to the One and the manner by which, through the multiple states of being and the hierarchy of existence, the visible cosmos which surrounds us is manifested. See Nasr, *An Introduction to Islamic Cosmological Doctrines*.

9. The texts of the *āyat al-kursī* (The Throne Verse) and the *āyat al-nūr* (The Light Verse) are respectively as follows:

'Allah! There is not God save Him, the Alive, the Eternal. Neither slumber nor sleep overtaketh Him. Unto him belongeth whatsoever is in the heavens and whatsoever is in the earth. Who is he that intercedeth with Him save by His leave? He knoweth that which is in front of them and that which is behind them, while they encompass nothing of His knowledge save what He will. His throne includeth the heavens and the earth, and He is never weary of preserving them. He is the Sublime, the Tremendous.' (trans. M. Pickthall)

> God is the light of the Heavens and the Earth;
> the likeness of His Light is as a niche wherein is a lamp,
> the lamp is a crystal,
> the crystal as it were a shining star;
> lighted it is from a blessed tree,
> an olive, neither of the East nor of the West,
> whose oil would well-nigh flare
> though fire touch it not;
> Light upon Light;
> God guideth to His Light whom He will,
> for God coineth parables for men,
> and God is All-knowing of all things.

(trans. P. Hobson)

10. In accordance with the Quranic verse, *al-rūḥ min amrᵢ rabbī*, 'The Spirit is from the command of my Lord'. (XVII; 85)

11. We have dealt with this central theme of Islamic science in several previous works including *Man and Nature*, London, 1976, pp. 75ff.

12. On sacred geometry especially in its relation to Islamic architecture see the works of K. Critchlow such as *Islamic Patterns*, London, 1976.

13. It is significant to note that the terms *'arḍ* and *ṭūl* are used in both Islamic metaphysics and geometry and architecture. On their metaphysical significance see R. Guénon, *The Symbolism of the Cross*, trans. A. MacNab, London, 1975, and al-Jīlī, *op cit*.

14. 'Sérénité, recueillement, ferveur, certitude; cette quaternité, qui résume la substance mohammedienne . . . se déploie, nous l'avons dit, entre deux pôles, la Vérité du Transcendent et le Coeur en tant que siège de l'Immanent. C'est ainsi que dans l'espace les quatre points cardinaux se situent entre le Zénith et le Nadir; ce n'est pas, à rigoureusement parler, la substance du Logos humain qui retrace les linéaments de l'order cosmique, c'est celui-ci qui en réalité témoigne de la nature' suréminent' et universelle de l'Homme-Logos.' F. Schuon, *Approches du Phénomène religieux*, Paris, 1984, p. 173.

15. It is of great significance to note that because of its primordial nature, Islam shares certain striking features with the primal religions of the North American Indians, especially those which have preserved best their primordial character. These features include not only emphasis upon geometric patterns in art but also the metaphysical and cosmological significance of the cardinal directions of space. See F. Schuon, *Language of the Self*, Trans. M. Pallis and D. M. Matheson, Madras, 1959, pp. 209ff.

16. This aniconism derives at once from the emphasis upon the supreme transcendent Divinity before whose Majesty all manifested orders from the archangelic to the material are reduced to 'nothingness' ('All things perish save the Face of God' as the Quran asserts), and the nomadic and Semitic spirituality which it characterizes in its formal aspects. See T. Burckhardt, *The Art of Islam*, Chapter III.

17. This is an expression first used by F. Schuon.

18. See Nasr, *An Introduction to Islamic Cosmological Doctrines*, pp. 47ff.

19. See J. Canteins, *La Voie des Lettres*.

20. This is of course not unique to Islam but exists in all sacred architecture which is always based on a cosmology derived from the roots of the tradition in question and a sacred geometry. But it is especially emphasized in Islam where all definitions of architectural space become much more mathematically precise and clearly defined.

21. K. Critchlow has carried out a series of studies in which this remarkable relationship has been brought out.

22. This effect is accentuated in many mosques such as those of Isfahan or the Dome of the Rock in Jerusalem bringing all lines of complicated arabesques and geometric patterns back to the centre of the vault so that wherever the eye casts its glance it is ultimately led to the centre. There are also some domes such as that of the Friday mosque of Yazd in which stars are used as ornament so that when one looks up at the dome one sees a replica of the visible heavens and is strongly reminded of the heavenly symbolism of the dome which of course does not symbolize merely the visible heavens but the invisible, spiritual heavens of which the visible heavens themselves are a reflection. These star studded domes make one feel also as if the stars and the sky had descended to the earth with the stars cast about in this world like fire flies during a summer night glimmering in the dark woods as a terrestrial reflection of the heavenly stars.

23. The symbolism of various features of Islamic art and architecture have been dealt with in great depth by Burckhardt. See especially his *The Art of Islam*, Chapter IV.

24. Concerning the Alhambra, Burckhardt writes, 'Among the examples of Islamic architecture under the sway of the sovereignty of light, the Alhambra at Granada occupies the first rank. The Court of Lions in particular sets the example of stone transformed into a vibration of light; the lambrequins of the arcades, the friezes in *muqarnas*, the delicacy of the columns which seem to defy gravity, the scintillation of the roofs in green tilework and even the water-jets of the fountain, all contribute to this impression . . . By analogy one can say of Muslim architecture that it transforms stone into light which, in its turn, is transformed into crystals'. *op. cit.*. pp. 79–80.

25. As stated in the *āyat al-nūr*, quoted already in note 9. In this verse it is the Blessed Olive Tree which symbolizes the world axis and which is therefore neither of the East nor of the West (*lā sharqiyyᵃⁿ wa lā gharbiyyᵃⁿ*) because of its central position in the cosmic order.

26. See for example the treatise on illumination of Abu'l-Mawāhib al-Shādhilī, edited by E. J. Jurji, *Illumination in Islamic Mysticism*, Princeton, 1938.

27. On the school of *ishrāq* whose significance for the understanding of many facets of Islamic art has rarely been appreciated see H. Corbin, *En Islam iranien*, vol. II, Paris, 1971; Nasr, *Three Muslim Sages*, Albany, N.Y. 1975; and Nasr, 'Shihāb al-Dīn Suhrawardi, Maqtūl', in M. M. Sharif, *A History of Muslim Philosophy*, vol. I, 1963, pp. 372–398.

28. The geometry, form and proportions of the Ka'bah all play a crucial role in the rise of Islamic architecture and need to be treated in any full study of the sacred architecture of Islam. See Burckhardt, *The Art of Islam* where he writes, 'If it [the Ka'ba] is not a work of art in the proper sense of the term—being no more than a simple cube of masonry—it belongs rather to what might be termed "proto-art", whose spiritual dimension corresponds to myth or revelation, depending on the point of view. This means that the inherent symbolism of the Ka'ba, in its shape and the rites associated with it, contains in embryo everything expressed by the sacred art of Islam'. p. 3. Concerning the harmonics of the proportions of the Ka'bah so central to the auditory revelation of the Quran on the one hand and later sacred architecture of Islam on the other, see E. McClain, 'The Ka'ba as Archetypal Ark', *Sophia Perennis*, vol. IV, no. I, Spring 1978, pp. 59–74; also his *Meditations Through The Quran*, New York, 1981, pp. 73ff.

29. According to tradition, the horizon would be covered by green light when revelation descended while during the Nocturnal Ascent (*al-mi'rāj*) the Blessed Prophet was pulled up for the very last stage of the journey to the Divine Presence by a green cloth (*rafraf*) which descended from above. In his Quranic commentary Abu'l-Futūḥ Rāzī writes, 'They carried me from veil to veil until I had traversed seventy veils the width of each of which was five hundred years' journey. There, a green cloth (*rafraf*) descended whose light was stronger than that of the sun and dazzled my eyes. They placed me upon that *rafraf* and I reached the Divine Throne (*al-'arsh*)'. *Tafsīr* of Abu'l-Futūḥ Rāzī, Tehran, 1315 (A.H.), vol. III, pp. 321–322.

As for prophetic *hadīth* Ibn Ḥātim accounts, 'God created the throne (*al-'arsh*) of green emeralds and He created four columns for it made of red rubies'.

There are also many sayings of the Shi'ite Imams concerning the significance of the colour green as well as other colours. For example, the Tenth Imam 'Alī al-Naqī has said, 'God created this belt from emerald green. From this green the sky gains its green colour. It is the veil, but beyond this veil God possesses seventy thousand worlds with inhabitants more numerous than the number of men and genies'.

30. On the significance of colour schemes in Islamic architecture see N. Ardalan and L. Bakhtiar, *The Sense of Unity—The Sufi Tradition in Persian Architecture*, Chicago, 1973, pp. 47ff.

31. This theme is treated extensively in many writings of F. Schuon on Islam especially his *Understanding Islam*, London, 1963 Chapter I.

32. This difference can be easily observed even today between traditional and modern architects in such countries as Egypt, Persia and Morocco where traditional master builders and craftsmen still survive.

33. The whole modern attempt to separate the ecological crisis from its spiritual causes by separating living in peace with nature from living in peace with God is certainly totally alien to the traditional Islamic perspective. In *Man and Nature*, based on the 1964 Rockefeller Lectures at the University of Chicago, which was one of the first works to predict the ecological crisis and make the theme popular, We spoke of the spiritual roots of this crisis. Since then, despite the works of E. F. Schumacher and T. Roszak, there has been a constant attempt to sever the relation between the ecological crisis and the rebellion against Heaven by post-medieval Western man which constitutes the underlying cause of the crisis. There is certainly a 'forgotten dimension' to the ecological crisis which causes many modern students of Islamic urban design to neglect completely the spiritual significance of living in harmony with nature for Islam.

34. See 'Islamic Architecture and Contemporary Urban Problems', in my *Traditional Islam in the Modern World*, London, 1986, where I have dealt fully with this subject.

35. This pattern is described in great detail and depth by T. Burckhardt in his *Fes, Stadt des Islam*, Olten, 1960.

36. By this assertion we do not mean that Islamic architecture did not make use of various techniques and methods of Sassanid and Byzantine architecture. The important question is not whether Islamic architecture did make use of previously existing materials and techniques or not but what it did with these materials and techniques.

IV
Sacred Art in Persian Culture

HROUGHOUT the long centuries of Islamic history, one
of the major *foci* of Islamic civilization and especially art
has been Persia, where the principles of the sacred art of
Islam in relation to spirituality can be demonstrated amply in
many fields and domains of art, both plastic and sonoral. Per-
sian art, at once deeply Persian and Islamic, represents a
culmination of Islamic art and one of its indisputable peaks.
The highly artistic nature of Persians and their love for beauty,
refinement, and delicacy enabled them not only to create one
of the great schools of art in the ancient world associated with
the Achaemenians, Parthians and Sassanids, but also to absorb
and apply the principles of the Islamic revelation in the creation
of numerous outstanding works of Islamic art. Both because
of its richness, variety, and depth of expression, Persian Islamic
art presents an ideal field for the study of the sacred art of Islam
in relation to Islamic spirituality on the one hand and to the
ethos and genius of a particular people and culture on the
other.[1]

Some of the principles of sacred art have already been dis-
cussed in earlier chapters but they need to be reasserted due
to the confusion which reigns in the modern world as far as
the nature of sacred and traditional art, as distinct from profane
art, is concerned.[2] To understand sacred art we must under-
stand the meaning of the sacred and also the meaning of art,
which today has become divorced from human life and rele-
gated mostly to a few buildings called museums. To understand
the sacred we must in turn comprehend the traditional view
of reality, both cosmic and metacosmic, within whose confines
men have lived and still continue to live in many Oriental
countries.

Now, in the traditional view of the Universe in general and the Islamic universe in particular, reality is multi-structured, that is, it possesses several levels of existence. It issues forth from the Origin or the One, from God, and it consists of many levels which, as mentioned in the previous chapter, in conjunction with Islamic cosmology, can be summarized as the angelic, psychic and physical worlds. Man lives in the material world but is at the same time surrounded by all of the higher levels of existence above it. Traditional man lives in the awareness of this reality even if its metaphysical and cosmological knowledge is beyond the ken of the 'ordinary believer' and reserved for the intellectual elite.

The sacred marks an eruption of the higher worlds within the psychic and material planes of existence, of eternity in the temporal order, of the Centre in the periphery. All that comes directly from the spiritual world—which stands above the psychic world and must never be confused with it, the one being *rūḥ* (spirit), and the other *nafs* (soul) in Islamic parlance— is sacred, as is all that serves as a vehicle for the return of man to the spiritual world. But this possibility, namely return to the realms beyond, is inseparable from the reality of the descent from above, because essentially only that which comes from the spiritual world can act as the vehicle to return to that world. The sacred, then, marks the 'miraculous' presence of the spiritual in the material, of Heaven on earth. It is an echo from Heaven to remind earthly man of his heavenly origin.

Although we have already mentioned the distinction between 'traditional' and 'sacred', it is necessary to return to this point in order to understand more clearly the role of sacred art in Persian culture in distinction from traditional Persian art. It must first of all be remembered that 'traditional' and 'sacred' are inseparable, but not identical. The quality termed 'traditional' pertains to all the manifestations of a traditional civilization reflecting the spiritual principles of that civilization both directly and indirectly. 'Sacred', however, especially as used in the case of art, must be reserved for those traditional manifestations which are directly connected with the spiritual principles in question, hence with religious and initiatic rites and acts possessing a sacred subject and a symbolism of a

spiritual character. Opposed to the sacred stands the profane and opposed to the traditional, the anti-traditional.

Because a tradition embraces all of man's life and activities, in a traditional society it is possible to have an art that has a quality of apparent 'worldliness' or 'mundaneness' and is yet traditional. But it is not possible to have an example of mundane sacred art. There is finally the possibility of a religious art which is not sacred art because its forms and means of execution are not traditional. Only it has chosen for its subject a religious theme. To such a category belong the religious paintings and architecture of the West since the Renaissance and also some of the popular religious paintings executed in the East during the past century or two under the influence of European art. Such religious art must be clearly distinguished from real sacred art.

To distinguish between religious and sacred art, an exercise which is of interest mostly in the case of Western art, is relatively easy. But to understand the finer distinction between sacred and traditional art which is also of importance for Islamic art in general and Persian art in particular may be more difficult. Let us take an extreme example: a genuine medieval sword, whether Islamic or Christian, is a work of traditional art in that it reflects the principles and forms of Islamic or Christian art and its 'decorations' are symbols of Islamic or Christian origin. But it is not directly connected with an initiatic rite or religious practice. The Shinto sword at the Shrine of Ise in Japan, however, belongs to the category of sacred art because it is a ritual object of high significance in the Shinto religion, connected with the very revelation of that religion. Likewise, in Persia, Quranic calligraphy is sacred art, but the miniature is traditional art reflecting the principles of Islam in a more indirect manner.

As for liturgical art, it must be considered as a branch of sacred art usually of a less direct and essential character, representing the extension of sacred art in the domain of the audible. In certain religions such as Christianity it can have a more central role, but even there the icon must be considered as the most central form of sacred art. In other religions such as Islam the liturgical art is none other than the sacred art

of chanting the Divine Book, in this case the Quran. In Islam only among certain ethnic groups including the Persians have forms of religious chanting other than Quranic psalmody developed which in a sense can be almost called liturgical, but in this case they do not play the same essential role as does the chanting of the Quran. The use of the terms 'liturgical art', and 'liturgical language', is particularly pertinent in the case of Christianity, and has become prevalent among certain circles even in Iran in recent decades only by reason of its pertinence in the West. It would therefore be better to deal with the more fundamental categories of sacred and traditional art in discussing Islamic art in general and Persian art in particular.

In Persian culture the very words used for art reveal its universality and its organic bond with all aspects of life itself. The words by which art is known in Persian are *fann, hunar*, and sometimes *ṣan'at*. Both *fann* and *hunar*, even as used according to their contemporary meaning, imply having the capability of doing or making something correctly. One often says that each thing has its *fann*, that is, the correct manner of doing or making that thing; or that to perform a particular act *hunar* is needed, that is, a particular skill or art is necessary. In fact the use of the word *hunar* to translate the modern European concept of 'art' is a very recent phenomenon. The more classical authors of the Persian language such as Firdawsī have used *hunar* in the widest sense, as both culture and art as well as artisanship. As for the word *ṣan'at*, which is now used to mean also technology, it refers to the crafts, which are identical with art or more precisely the plastic arts in the Persian and Islamic contexts. There are no arts 'and' crafts; the two are one and the same. To make a beautiful plate or pot is as much art as to paint a miniature. The word *ṣan'at*, therefore, confirms once again through the very breadth of its meaning the unity of art and life which has characterized Persian culture, like every other authentic traditional culture, throughout history. This unity is particularly evident among the Persians because they are among the most creative and artistic of peoples, the delicacy of their artistic taste running through all aspects of traditional Persian life, from architecture and gardening to cooking and even to smoking the water pipe.

67

This universal meaning of art in its traditonal sense must not of course obliterate the distinction made earlier between sacred art and that aspect of traditional art which is a less direct reflection of spiritual principles. The life of traditional man in all its aspects, from working to eating and sleeping, has a spiritual significance, but rites and specific religious acts nevertheless exist in a distinct manner within the rhythm of daily life and reflect in a more direct fashion the principles which govern all life. In the same manner although sacred art is a part of traditional art which is combined with the whole of traditional life, it is concerned especially with those acts of making and doing that are directly connected with spiritual and religious rites and symbols. Because of this fact, it is sacred art whose survival is most directly connected with the survival of a religion, even after the structure of traditional society has been weakened or destroyed as we have seen in so many parts of the globe in modern times.

Before discussing the particular forms of sacred art in Persian culture throughout its history, it is necessary to elucidate further the relation between sacred art and a particular religious form, and the link between art and the initiatic organizations such as the Sufi orders. Because sacred art is the bridge between the material and the spiritual worlds, it is inseparable from the particular religion to which it is connected. There is no sacred or liturgical art possible in a vacuum any more than it is possible to 'write' a sacred scripture without a revelation from Heaven. There is Hindu, Buddhist, and Islamic sacred art but not an Indian sacred art if by India we mean a land and a people. It is true that the genius of the ethnic group in question plays a role in the style and manner of execution of sacred art, as we see in the difference between the Buddhist art of Japan and that of Sri Lanka but all these differences are within the limits of the principles established by both the spirit and the form of the religion in question. Sacred art derives from the spirit of a particular religion and shares its genius. It also makes use of a symbolism which is related to the form of the religion in question. And it is these elements which dominate. How different are the Hindu temple of Dasavatara and the Delhi Mosque, both of which stand in India; or the naturalistic

Roman temples and the other-wordly Romanesque churches both located in Italy.

It is true that a religion can adopt certain forms and even artistic symbols of a previous religion, but in such a case the forms and symbols are completely transformed by the spirit of the new revelation, which gives a new life to them within its own universe of meaning. The techniques and forms of Roman architecture were adopted by Christian architecture to produce works of a very different spiritual quality. As we have already seen, Islam, and before it Byzantine Christianity, adopted Sassanid techniques of dome construction and produced domed structures which, however, reflect different types of art. In Persia itself Islamic art adopted many art motifs of pre-Islamic Persia with its immensely rich artistic heritage as well as those of Central Asia, but they became transformed by the spirit of Islam and served as building blocks in structures whose design was completely Islamic. The same could be said in fact about the Zoroastrian art of the Achaemenian Period which adopted certain Babylonian and Urartu techniques and forms but certainly transformed them into something distinctly Zoroastrian.

To understand sacred art and its efficacy in any context it is far from sufficient to search out the historical borrowing of forms. What is important is what forms and symbols mean within the traditional universe under consideration. And this question is unanswerable unless one has recourse to the religion which has brought the traditional civilization and sacred art into being. One could not understand, not to speak of create, works of sacred art without penetrating deeply into the religion which has produced these works. The attempt of some modern artists in both East and West to do so can be compared to trying to split the atom by copying the forms of mathematical signs found in books of physics. But as far as the result is concerned, it is the opposite, for any attempt to create such a so-called 'sacred art' must have severe repercussions in human terms.

Throughout Persian history an intimate relation has existed between art and the spiritual discipline deriving from the religion then dominant in Persia. Since little is known of the details of social organization in pre-Islamic Persia, the exact institutional link between the artisans and craftsmen and the priestly

class is difficult to delineate. But the results are there to prove that such a link clearly existed. Nearly all important remnants of the art of that period are either religious or royal in character. And since the royalty was of a definite religious character, the royal art was in turn intimately connected with the Zoroastrian world-view. Even Persepolis, as has been suggested by A. U. Pope, seems to have been constructed as a palace for religious ceremonies rather than for the purely political activity of ruling over the empire.[3] Moreover, the architectural forms and the gardens have a definite traditional and symbolic character, the garden being a form of mandala which closes upon an inner centre and serves as a 'reminder' and 'copy' of paradise. It must not be forgotten that the word paradise itself, in European languages, as well as *firdaws* in Arabic, derive from the Avestan *pairi-daeza*, meaning garden, which itself was the terrestrial image of the celestial garden of paradise.

In connection with other ancient Iranian religions, such as Mithraism and Manichaeism, there is even less evidence to enable us to understand clearly how the sacred art was related through specific institutions to the religions in question. Suffice it to say, however, that in the case of Mani, painting was considered as the particular 'miraculous' gift of the founder of the religious movement himself.

The connection between art and spiritual methods is more firmly established and clear during the Islamic period. In the Islamic cities which throughout the ages have produced most of the objects of Islamic art, the craftsmen organized early into guilds (*aṣnāf* and *futuwwāt*) which, through their close relation with Sufism and the personality of 'Alī himself, derived direct spiritual inspiration from the very heart of the Islamic message. The famous saying, 'There is no man of chivalry but 'Alī and no sword but the sword of 'Alī (*Dhu'l-fiqār*)' bears testimony to the basic link between the *futuwwāt* and the Sufi orders, the vast majority of both of which derive their initiatic chain (*silsilah*) from 'Alī. Through this spiritual and institutional link, which still survives in many Persian cities such as Yazd and Kashan, the masters of the guilds become initiated into the mysteries of Sufism and learn the metaphysical and cosmological doctrines which underlie the symbolism of Islamic art. The rest

of the members of the guild in question emulate the methods, techniques and symbols involved without necessarily understanding all of the more profound levels of its meaning, although on their own level of understanding the work does have meaning for them. They can use all their creative energy in making the objects of art and are far from mere imitators of something they do not understand. The sense of joy that emanates from authentic traditional works of art is the best proof of the original creative joy of the artist. It is, moreover, because of this depth of expression innate to the symbols and images transmitted from the master to the craftsmen who study and work with him that often a work produced by a so-called uneducated craftsman has more profundity and intelligence than what many a so-called educated onlooker has the capability to understand.

This same intimate relationship exists between Islam in general and Sufism in particular and the other forms of art. It is not accidental that the vast majority of the great musicians of Persia were connected in one way or another with Sufism or that the most universal poetry of the Persian language is Sufi poetry. Likewise in calligraphy, as already noted, the number of men associated in one way or another with the esoteric dimension of Islam who were masters of the art is great indeed.

As far as the plastic arts are concerned, in Persia, as in certain other civilizations such as the Christian West, the Hermetic sciences and particularly alchemy played an intermediary role between the purely metaphysical and cosmological doctrines of the religion and the making of things. The function of art, according to its Islamic conception, is to ennoble matter. Alchemy, likewise, is a symbolic science of material objects, of minerals and metals in their connection with the psychic and spiritual worlds. It is not, as so many have thought, a proto-chemistry.[4] It is basically a science of the transformation of the soul based upon the symbolism of the mineral kingdom. For this very reason it is also a way of ennobling matter; of turning base metal into gold. The relation between alchemy and art in Persia as in Islamic art in general, has been profound. As already noted, the colours used in so many works of art, far from being accidental, are related to their alchemical symbol-

71

ism as well as the symbolism derived from the Quranic revelation and *Ḥadīth*. Through alchemy and similar cosmological sciences Islam was able to create an ambience that was Islamic in both form and content, one in which the religious and spiritual principles were imprinted upon that matter, that surrounds man in his daily life and has such a profound effect upon the attitude of his mind and soul.

As far as the actual expressions of sacred art in the course of Persian history are concerned, through the definition given above it becomes clear that we can only speak of a Zoroastrian, Mithraic, Manichaean or Islamic sacred art in the context of Persian culture. Even if a particular work of a sacred character of the Zoroastrian period has influenced in its techniques certain works of the Islamic period, only the original work can be considered as sacred art and then solely in the light of the Zoroastrian religion. Despite the possible existence of a continuity of techniques or forms between the pre-Islamic and the Islamic period, a work bearing the mark of such a continuity or 'influence' could not be classified strictly as Islamic sacred art. For example, certain building techniques of Zoroastrian fire-temples were adopted for private houses during the Islamic period. Such an architectural form would be an aspect of Zoroastrian sacred art but not of Islamic sacred art, despite all the resemblances in technique. Conversely, the technique of constructing a cupola on squinches was developed by Sassanid architects and used in many kinds of buildings, not all of a strictly religious character. But when these techniques were integrated into mosque and church architecture by the Muslims and Byzantines, they became a part of Islamic and Christian sacred art. The determining factor in all cases is not a particular form or technique but the spiritual principles derived from the particular tradition in question, principles which integrate and mould forms into a whole that reflects directly the world view of the tradition involved.

In pre-Islamic Persia, as far as Zoroastrianism is concerned, the forms of art that most likely must be classified as sacred art include the architecture of the fire-temple, the music and poetry accompanying the Zoroastrian rites—remembering here that the parts of the Avesta that are most definitely by

the historical Zoroaster are the Gathas, which are songs—and certainly the sacerdotal dress, of which some images have survived. Perhaps also the original gardens in the shape of squares looking inwardly toward the Centre were also of a sacred character. Certainly they are among the most important forms of the pre-Islamic traditional art of Persia, possessing a direct initiatic symbolism and serving as models for the later Persian, and through them, Spanish and Mogul gardens. Rugs also must be classified with gardens in the same category of traditional art, for they too were earthly images of paradise. Also, certainly of traditional nature and associated with royal initiation and the 'lesser mysteries', are the heraldic symbols found in many different forms and shapes and resembling in character and significance the heraldic art of other Oriental civilizations and the medieval West.

It is of some importance to note that Zoroastrianism, like Islam which succeeded it in Persia, did not have religious idols like these found in other Indo-European religions such as Hinduism and the religion of ancient Greece. Hence, there is no sacred art in the form of sculpture to be found in Zoroastrian Persia. One would have to go to the pre-Zoroastrian religions of Iran to find sacred images, properly speaking, in the form of statues. Even Mithraism, which arose from a Zoroastrian background and left many statues outside of Persia and especially in Europe, did not leave any statuary in Persia itself. The image of Ahura-Mazda represented by two wings is the art form closest to a sacred statuary in Zoroastrianism. But even such images were carved on large pieces of stone or on mountainsides; separate statues were not made from them. The Zoroastrian angels, which would correspond to the 'divinities' or 'gods' of other Indo-European religions, were spiritualized entities whose representation in concrete forms and images corresponded much more to the Christian icons of Christ and the Virgin Mary than to the statues of divinities in other religions. In this domain Zoroastrianism manifested an 'iconoclasm' that resembles the spiritual perspective of Islam.

As far as the sacred art of Islam is concerned, it has been already shown that it is related in both form and spirit to the Divine Word as revealed in the Quran. The Word having been

revealed as a book, rather than as a human being as is the case with Christianity, the sacred art concerns the manifestation of the letters and sounds of the Holy Book rather than the iconography of a man who is himself the Logos. The sacred art of Islam in the domain of the plastic arts therefore is more than anything else calligraphy and architecture with which we were concerned in the two previous chapters. This fact is as true for Persian Islamic art as it is for Islamic art in general. It might only be added that in Persia in addition to both architecture and calligraphy reaching their peak of perfection, there developed the highly decorated mosque architecture so typical of the tiled mosques of the Il-Khānīd and Safavid periods in which the two basic forms of sacred art, architecture and calligraphy, join hands to create a multi-faceted crystal in which is reflected a ray of the light of Heaven amidst the darkness of material existence.

One of the remarkable features of Islamic architecture, almost unique in the history of art, is that it reached a peak early in its career and has preserved it to our own times. A traditional style of architecture results not from that false deity of modern times called 'a period' or 'the times', but from the encounter of the spiritual style of a particular religion and the ethnic genius of a particular people who embrace that religion. That is why the style remains valid as long as that religion and the people in question survive. Persian Islamic architecture presents a perfect example of this principle. From the Damghan mosque to the contemporary traditional mosques there are certainly variations, but always upon the basis of a permanence and continuity that is too evident to need elucidation. Traditional Persians were too little concerned with 'their times' to produce a local style that, because of its belonging to a particular date, would also soon become out-of-date. They produced an art that was atemporal, that breathed of the eternal and hence was valid for all ages.

Those modern Persians who want to change the style of sacred art, especially mosque architecture, should ponder over the question as to why their 'times' or 'period' should be any different or more important than any other 'times' or 'period' which continued to propagate the traditional styles of Islamic

74

architecture. A profound analysis would reveal that the desire to change the style of mosque architecture issues in most cases not from the so-called exigencies of 'our times,' but from the fact that most of the people who want to carry out such changes have themselves fallen out of the Islamic tradition and have even become alienated from the ethnic genius of the Persian people. Honesty would demand that one not label one's own shortcomings with such epithets as 'necessities of the times', and that one not have the audacity to seek to create a new form of sacred architecture when one has no notion of either the spirit or the form of the religion which has brought the architecture in question into being, or even of the deeper roots of the culture of one's own people who have nurtured this architectural style over the centuries. The catastrophe brought about in any religion by the destruction of its sacred art is no less than that brought about by the weakening of its moral and spiritual teachings and the negation of the injunctions contained in its Divine Law.

In the realm of the plastic arts, Islamic Persia created other important forms of traditional art which are connected with the forms of sacred art and are directly related to its religious rites and doctrines. In the realm of architecture, the general principles elucidated in the previous chapter all find their concrete applications and examples in Persia. The traditional Persian home is a kind of extension of the mosque in the sense that it perpetuates its purity and simplicity. The carpets over which one does not walk with shoes, their ritual cleanliness which enables man to pray upon them like the carpets of the mosque, the 'emptiness' of the traditional rooms devoid of furniture, and many other elements all connect the house in spirit to the mosque. On a larger scale the whole of city planning is related to the mosque not only through the central role of the mosque in all traditional Persian cities but also in a much more subtle way through the domination of the principle of unity and integration over the whole of the city, from the private home to the city as a totality. Isfahan, Yazd, and Kashan still afford excellent examples of this principle.

Other traditional plastic arts related to the sacred arts include the so-called 'minor arts', which are of extreme importance

because they surround man in his daily life and hence influence him deeply. In this realm the 'seal of the sacred' is to be observed even in the most common everyday objects. The rug is a recapitulation and reflection of paradise, bound by a frame and looking inward toward the centre like the courtyard and the Persian garden. The traditional dress, in all its forms, not only facilitates the Islamic rites but also reveals the theomorphic nature of man rather than hiding it.

The miniature, which is intimately bound with book illustrations, is an 'extension' of calligraphy and again a 'depiction' with the aim of aiding remembrance of the states of paradise. Based on the wholeness of life which characterizes traditional Persian culture, all of the different forms of art are inter-related through the traditional principles which have introduced into them something of the sacred as well as the spiritual principles dominating all aspects of the life of traditional man.

In the realm of the audible, the sacred art *par excellence* in Islam is of course the chanting and recitation of the Quran, which is the spiritual force behind the poetry and music of all Islamic peoples. The Persian language as we know it today was born during the early Islamic period and hence had a greater degree of freedom to be moulded by the spirit and form of the Quran that even Arabic, which at least in the realm of poetry was already formed at the time of the Quranic revelation. This fact, added to the poetic genius of the Persians, is the reason for the remarkable richness of religious and mystical poetry in Persian. Persian poetry is not sacred art in a direct sense, but it is an inspired traditional art of an elevated order connected intimately with the Quran. This is true especially of Persian Sufi poetry. It can be said, in fact, that if Arabic is the language of the 'Word'—the language of God as He spoke through Gabriel to the Prophet of Islam—Persian is the language of the angels. It is the language of paradise, and the beauty of Persian poetry is a reminiscence of paradisal joy. The rhyme and rhythm of Persian poetry reflects a 'spiritual style' that relates it to the form of the Quran as the message of this poetry is related to the content of the Quranic revelation.

In its suddenness, revelation is like lightning. But it can also be compared to the dropping of a stone in a pool of water that

76

causes ripples to move out as concentric circles from the centre. The descent of the Quran with its poetic structure based on sharply defined rhythms and a very subtle rhyming pattern caused ripples in the soul of the Islamic peoples, and brought about the flowering of this genius for rhyme and rhythm in Islamic literature, of which, after Arabic, the most important is certainly Persian, itself the mother of several other Islamic languages. Persian poetry in its rhyme and rhythm reflects the echo of the Sacred Book in the minds of men and women who created this poetry. In its turn this poetry causes a reminiscence of this echo in the minds and souls of the men who read it, and returns them to a state in which they participate in its paradisal joy and beauty. Herein lies its alchemical effect. The person who enjoys this poetry or can create such poetry is still living potentially in the paradise which it creates through the grace issuing from the Quran. To appreciate Ḥāfiẓ fully is to be already in the proximity of the Divine.

Those who no longer appreciate Persian poetry, or who try to break its metres and rhyme patterns through what is called 'new poetry,' (*shi'r-i naw*) have already fallen out of this paradise. They have experienced a 'spiritual' fall which is the hidden cause of their insistence upon destroying the classical forms of Persian poetry. Those who claim that this style was fine for Ḥāfiẓ and his 'period', but not for this 'period', again mistake their own subjective fall outside the spiritual universe of their tradition for a so-called objective state of the world, an interpretation which simply does not exist outside that individual and collective subjectivism that seeks to turn the fall of the soul from grace into a necessary condition of human existence in the contemporary world. One wonders again, as is the case with architecture, why from Rūdakī to Bahār and still among many leading poets today, it has been possible to preserve and develop the classical forms of Persian poetry, and why suddenly these forms now no longer correspond to the 'realities of the times' for a certain number of people. One wonders why such people still allow themselves to breathe air, seeing that this air has been breathed throughout all ages and belongs to 'outmoded' periods of history.

Be that as it may, it is essential to remember that classical

Persian poetry, especially in its Sufi form, is a traditional art of the highest value and of a spiritual and even therapeutic nature, and that its destruction by the 'new poetry' is no less than the destruction of a poetry of celestial quality by a poetry that is purely terrestrial and often unintelligible. Some of the talented younger poets have written 'new poetry' which has some earthly beauty, but this pales into insignificance before the suprapersonal, heavenly beauty which the very forms of classical poetry, not to speak of its symbolism and content, make possible.

As for music, the music of Persia, although influenced by different musical traditions especially the ancient Egyptian, has its origins in the music of the ancient Aryan peoples and is akin to the Greek music heard by Pythagoras. But during the Islamic period it grew in a distinct manner and in a more con-templative direction, not in spite of but because of Islam as we shall have occasion to discuss more fully later. By banning the social aspect of music, especially in cities where the inciting of passions caused by music can always lead to greater moral degradation than in the countryside, Islam turned classical music in an inward direction, as a contemplative art. The spiritual states evoked by classical Persian music are closely related to the spiritual states (*aḥwāl*) of the Sufis, and through Sufism to the spirit of the Quran. In both its purely musical content, as well as in the Sufi poetry with which it has always been intimately connected, Persian music represents a spiritual art of a high order, a powerful aid in the attainment of the contemplative states of Sufism. It is not accidental that the Sufis have cultivated the mystical sessions of music and even dance (*samā'*), and that one of the greatest Sufi masters and revealers of the esoteric meaning of the Quran, Mawlānā Jalāl al-Dīn Rūmī, who founded a Sufi order known for its music and danc-ing (the Mawlawīs), could say:

> The musician began to play before the drunken Turk.
> Behind the veil of melody the mysteries of the eternal
> covenant between God and Man.

Nor is it accidental that throughout the centuries most of the performers of Persian music, and also of the music of Turkey

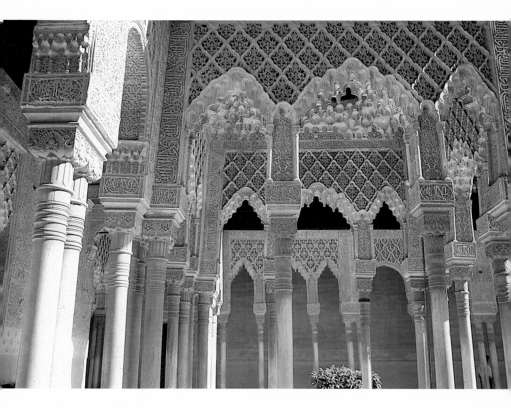

While water dominates the whole architecture and landscaping of the Alhambra, it is light that defines its spaces and forms. The forms of the Alhambra are like light congealed transmuted by an alchemy which turns material forms into so many crystallizations of light.

OVERLEAF Standing before the Shaykh Luṭfallāh mosque belonging to Safavid Isfahan, one is confronted by a symphony of colours, geometric forms and arabesques all dominated by the calligraphy of the Sacred Word, for here is the entrance to the earthly reflection of the paradisal abode.

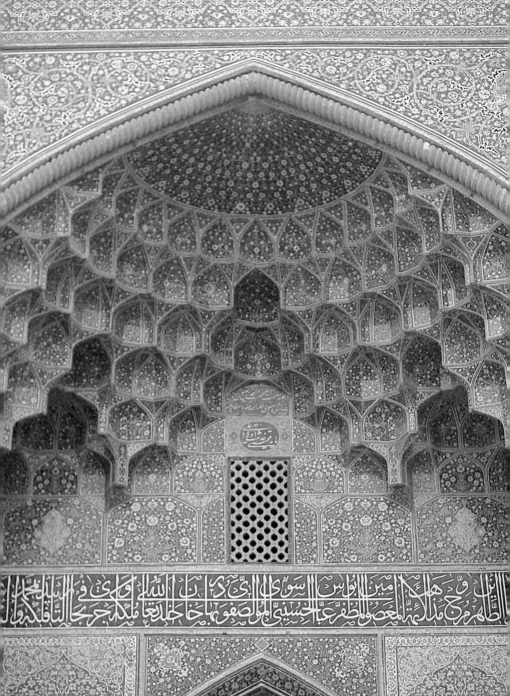
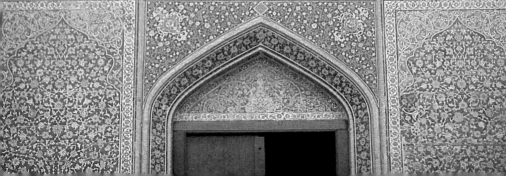

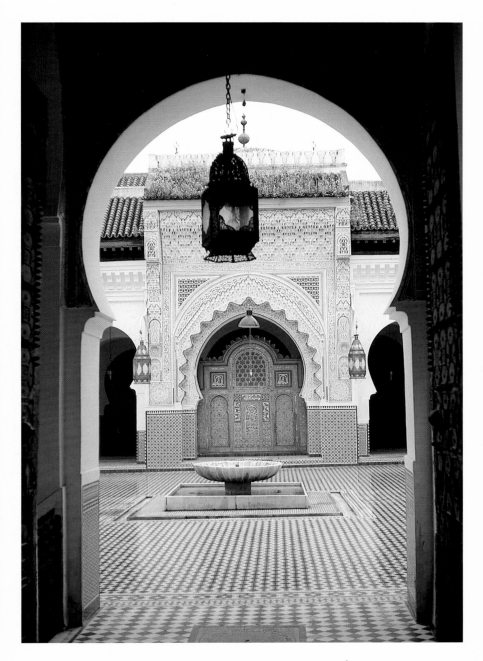

The Maghribī arch opens inwardly onto the centre which is the heart. Here it also opens onto an inner courtyard which with its serenity and interiority reflects the peace and harmony that resides at the centre of man's being.

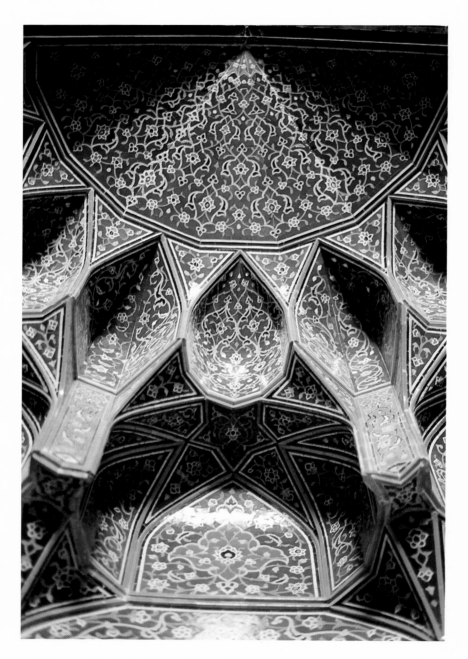

The greatest care has been taken in the construction and decoration of this *miḥrāb* of the Shaykh Luṭfallāh mosque for it is from the *miḥrāb* that the Divine Word resonates filling the whole space of the mosque with sacred presence.

and northern India, have been associated with Sufism. It is in fact by reason of the inexhaustible richness and depth of Persian music, that only the qualified can appreciate it. Only those with some inner depth of their own can penetrate into its depths. Only those with a contemplative dimension can benefit from the liberating power of this music which cuts man from the fetters of material existence and enables the bird of the human soul to fly with joy and freedom in the infinite horizons of the 'sky' of the spiritual world.

A type of traditional art that is peculiar to Shī'ism and found in Persia as well as adjacent regions of Anatolia, Iraq and the Indo-Pakistani subcontinent is the passion play or *ta'ziyah* usually depicting different scenes and events of the tragedy of Karbalā', although other themes have also been treated. This religious theatre is the closest art form in Islam to the liturgical and sacred theatre of other traditions.[5] Sacred theatre is closely related to the mythological point of view, in which different divine powers become personified and engage in dramas of cosmic significance. The 'abstract' character of Islam excludes such a possibility, and thus, theatre could not develop in the Islamic tradition as a sacred art.[6] Nevertheless the *ta'ziyah* did develop as a religious art of power and beauty which has fulfilled certain religious needs of Shī'ism without its being essential to the ritual practices of Islam.

An important character of the *ta'ziyah* that must always be remembered is that it can have efficacy and meaning only in the traditional context for which it was meant. The audience is as much a part of the play as the actors, and both participate with all their body and soul in the events of sacred history that are retold on the stage. A sceptical audience, which because of lack of faith cannot participate wholeheartedly in the tragedy of Imam Ḥusayn and his companions, already destroys through its presence the drama's spiritual climate. In an almost magical way the presence of an incongruent audience, one which no longer believes in the religious truths in question, destroys that unity between performer and onlooker that belongs to the very essence of the *ta'ziyah*. How much more would this climate be destroyed by directors and actors whose interest in these matters is purely external, people who have

79

sufficiently fallen out of their own tradition to consider it as 'interesting'.

The same can be said for the spiritual concert of the Sufis, the *samā'*. The *samā'* must be performed with a 'closed' audience where the members participate in the spiritual ambience created through the power of their own inner forces. To be a mere onlooker without faith and spiritual discipline a session of *samā'* would turn into something else.

In both cases we are faced with an important and basic principle related to the sacred; that is, to understand and fully appreciate the sacred in all its manifestations, including the artistic, man must believe in the sacred and participate in it. Otherwise the sacred hides itself behind an impenetrable veil which is in reality the veil that man's carnal soul—the *nafs* of the Sufis—draws around the immortal core of man's being, thus cutting it off from the vision of the sacred. In both the *ta'ziyah* and the *samā'* the ideal performance must of necessity include both the performers and the 'audience', who through the art are integrated in a union which transcends both of them, a union whose attainment is the goal of all sacred and traditional art. The level of *samā'* and *ta'ziyah* are, however, different. Whereas the *ta'ziyah* enables man to participate in the religious universe of Shī'ite piety and even in the blessing which issues from the supreme sacrifice of the Imam, *samā'* in both its incantory and dance aspects is an esoteric sacred art which seeks to enable man to experience spiritual union and integration into the supreme Centre.[7] Moreover, whereas there is an 'audience' in the *ta'ziyah*, in the *samā'* everyone participates directly in one way or another.

Persian traditional art in general and sacred art in particular have left a heritage of unbelievable richness for the Persian people. Through their artistic talent and refined taste the Persians have been able to create an art that is at once spiritual and sensuous, disclosing the beauty of this world as well as its fleeting nature, and revealing through the theophany of God in beautiful forms the transcendent nature of the source of this theophany. It is a heritage which, despite being endangered, is still a living reality for the vast majority of Persians and which is of universal value to the whole world at a time when ugliness

threatens to stifle the Spirit itself. The duty of the contemporary Persian is to know and understand this art as well as the principles that underly it, and then to make them known to others. As for those who, because of a loss of understanding of these principles and for lack of a faith in the world-view that has created this art, can no longer follow its traditional forms and methods, it is encumbent upon them to realize at least their own shortcomings and not to hide their ignorance by a pride which seeks to destroy all that one does not understand. Honesty, of which everyone speaks today, demands that one not destroy for others through either one's ignorance of the full reality of the Islamic tradition or one's 'artistic' creations something which one has lost oneself. The Persian or more generally Muslim artist with real talent and integrity will be one who, instead of identifying himself completely with the West (with its fads and even its illnesses such as nihilism) will try to understand his own artistic personality, which means also his own tradition and culture. Such an artist does not lose sight of the spiritual significance of Islamic art because of prevalent interpretations of certain circles which would limit Islam to only its most outward aspects so as to make him totally indifferent to the chasm which separates beauty from ugliness. He will be one who realizes in humility the grandeur of the tradition which alone can provide for him a centre and an orientation. In surrendering himself and his talents to this tradition, he receives much more than he gives. A speck of dust and a moment of life are transformed through tradition into a star in the firmament, blessed with permanence and reflecting the eternity of God. The creative power of such an artist, far from being stifled, is freed from the fetters and limitations of his own subjective self, gaining a universality and power which would be impossible otherwise.

For the contemporary Persian artist who is placed today in such an exceptional situation, for the Muslim artist in general, and for all other elements of the classes that mould and give direction to Islamic society, the paramount task is one of attaining self-knowledge in order to cure this abominable inferiority complex *vis-à-vis* the West and to overcome the lack of awareness of the full import and significance of the Islamic tradition

in all its dimensions, especially in its spiritual and artistic aspects. The vastly rich and fecund traditional and sacred art of Persia and in fact Islamic art as a whole, is one of the major means for bringing about a cure of this ignorance and for providing a centre and direction for life, artistic and otherwise. Without it the effort of the artist will either be stifled or it will be yet more noise added to the clamour and disorder which characterize our times. With it the creative power of the artist as well as the scholar and 'thinker' can become like the ray of the sun which dispels the fog, a light which establishes order and elucidates what would otherwise be opaque. With awareness of traditional and sacred art, the work of the true artist, as well as scholar, can become like the song of the bird, heard above the sound and clamor that fatigues and sickens the soul of man. It can become the means to remind man of the peace, tranquillity, and joy for which he was created and which he seeks at all times—knowingly or unknowingly—but which he can only find when he gains an awareness of the sacred and accepts that he must surrender himself to the Will of Heaven.

<div align="center">NOTES</div>

1. There is another reason for my having chosen Persia as a case study. Being Persian, I am naturally better acquainted with the diverse aspects of Persian art than that of other Islamic countries. The relation between sacred art in Islamic Persia and Islamic spirituality, however, is of a universal nature and applies *mutadis mutandis* to other areas of the Islamic world.

2. Fortunately, in the West during the past half century the writings of the traditional authors such as René Guénon, Frithjof Schuon, Ananda K. Coomaraswamy and Titus Burckhardt, as well as a number of historians and scholars inspired directly or indirectly by these authors, such as S. Kramrisch, H. Zimmer, M. Eliade, B. Rowland, A. Moreno, and H. Sedlmayer in the West, as well as K. B. Iyer in India, have brought back to light with blinding evidence the nature, meaning, and function of sacred and traditional art. In their writings, especially those of Schuon, Burckhardt, and Coomaraswamy, to which we have already referred, can be found a wealth of incomparable knowledge about this subject, and we could only present a poor imitation or summary were we to attempt here to survey again the whole subject of sacred art. Our goal, therefore, is to present in this essay something of the principles and nature of sacred and more generally traditional art in its applications to the Persian scene both past and present. The audience we have in mind is the Western student and admirer of Persian art and culture who looks upon Iran with more than a passing interest in its rich artistic life but who has not been able to acquire the necessary metaphysical and scholarly background to make intelligible Persian art, whose principles, like those of all traditional art, are so diametrically opposed to modern Western aesthetics.

<div align="center">82</div>

3. See A. U. Pope, 'Mythical and Ritual Elements in the Architecture and Ornament of Persepolis', *Survey of Persian Art*, ed. by A. U. Pope and Ph. Ackerman, vol. xiv, Ashiya (Japan), 1981, pp. 3011–3016.

4. On the relation of alchemy to art see Burckhardt, *The Art of Islam*, pp. 76ff; also his *Alchemy—Science of the Cosmos, Science of the Soul*, trans. W. Stoddart, London, 1967.

5. See P. Chelkowski (ed.), *Taziyeh: Ritual and Drama in Iran*, New York, 1979.

6. In the Indonesian-Malay world also one can observe the survival of a theatre of Hindu-Buddhist origin which has been integrated into the Islamic culture of the region. But this type of theatre is less directly connected to the sacred history of Islam than the *ta'ziyah*.

7. This subject will be dealt with later more fully. See also the extensive and profound treating of the subject by J. L. Michon, 'Sacred Music and Dance in Islam', *World Spirituality: An Encylopedic History of the Religious Quest*, vol. 20 (ed. S. H. Nasr), in press.

LITERATURE

V

Metaphysics,
Logic and Poetry in the Orient

Dichten heisst, hinter Worten das Urwort erklingen lassen.
Gerhardt Hauptmann

LITERATURE provides an all important field for the under-
standing of the relation between Islamic art and spirit-
uality. Because the Islamic revelation is based upon the
Word that has been revealed as a sacred book, literature
occupies an eminent and privileged position among the arts
of nearly all the Islamic peoples. In later chapters the examples
of such supreme masters of Islamic literature as 'Aṭṭār and
Rūmī, both saints and great artists, will be considered with
others again drawn mostly from those Persian sources familiar
to the author. However, it is important to discuss first the rap-
port between literature and intellectuality in general and to
deal with a subject which is central to an understanding of
not only the literature of the Islamic peoples but of the Orient
as a whole as well as the literature of the traditional West.

As a result of the continuous parting of ways between art
and thought, intellectuality and sensuality, and logic and
poetry which has taken place in the West since the Renais-
sance, the traditional doctrine according to which poetry and
logic refer to a single Reality that binds and yet transcends them
has been almost completely forgotten. Yet the traditional doc-
trine, which is still to be found living within the various Orien-
tal civilizations and in such literatures as Persian and Arabic,
was not always limited to the Orient alone. What this tradi-
tional doctrine teaches can also be found fully elaborated by a
Plato or a Dante, and so cannot be called solely Oriental in the
geographical sense of the term. Rather, it belongs to the Orient
of universal existence, or, if we may use the terminology of

Suhrawardī, to the land of the Orient of Light (*ishrāq*), which is at once the celestial part of the cosmic and universal hierarchy and the source of illumination.[1] But in our present world it is mostly in the Orient that the traditional doctrines can still be found operative, and therefore it is to this Orient that the following discussion of the rapport between logic and poetry will limit itself. In this Orient, embracing essentially the three regions of the Far East, the Indian world, and the Islamic world, there are naturally diverse applications of the teachings in question, but there is remarkable unanimity concerning fundamental doctrines.

The definitions given in Oriental civilizations for logic and poetry would be easily understood by Western students of these subjects well versed in the knowledge of Western culture and its roots, whether these definitions came from a Nagārjuna on the one hand, or an Ibn Sīnā (Avicenna) on the other. Logic in Eastern doctrines deals with the laws governing the movement of the human mind in its journey from the known to the unknown, whatever might be the epistemological foundations which make the attainment of logical certitude possible, and whatever differences may exist between let us say *Nyāya* logic and Aristotelian logic. As for poetry, it deals with human language as moulded by the principles of harmony and rhythm, which also govern the cosmos. These two disciplines or activities of the human mind and soul have parted ways nearly completely in the modern West, while they have preserved their complementarity and close association in theory and practice wherever the Oriental traditions still survive. There has always been in the Orient a logical aspect to poetry and a poetic aspect to the great expressions of logical thought. Even today in many Oriental languages, works of a logical nature are studied in a poetic form which facilitates their mastery.[2] Traditional poetry is innately logical to the extent that it is often used instead of a prosaic argument to prove a point.

The traditional doctrine of poetry needs further elucidation, since the correspondence between cosmic realities and human languages has been eclipsed in an age given much more to the quantitative study of nature and linguistic analysis than to the qualitative study of the cosmos and poetic synthesis. According

to the traditional doctrine, the inner reality of the cosmos, which unveils itself to the inner eye or to intellectual vision—for which the inner eye is the instrument of perception—is based upon a harmony which imposes itself even upon the corporeal domain. This harmony is, moreover, reflected in the world of language, which is itself a reflection of both the soul of man and of the cosmos. In the domain of language, it is the word, the substance of language which replaces the material substance of the external world, and bears the imprint of the cosmic harmony. To quote from the Hindu tradition, 'The universe itself, properly viewed by the Intellect, the "eye of the heart", as it is often called, is the result of the marriage of harmony (*sāman*) and the word (*ṛc*)'.[3]

In the macrocosm, the harmony of the Universe is more manifest in higher planes of reality and becomes dimmer and less evident as one descends towards the lower extremities of the cosmos. At the same time this harmony lies at the heart of the traditional plastic arts and is the foundation of traditional architecture and other arts dealing with material forms. In language, the same principle is to be observed. Harmony is always present but as its imprint upon the word or substance of language becomes more marked and profound, poetry comes into being; poetry which through its re-echoing of the fundamental harmony of things is able to aid man to return to the higher states of being and consciousness.

This doctrine of the imposition of harmony upon the substance of language is to be found in the Far East expressed in terms of the Yin-Yang polarization, and in Islamic sources in the distinction between form (*ṣūrah*) and meaning (*ma'nā*)[4] which lies at the heart of the metaphysical teachings of such masters of Sufi poetry as Jalāl al-Dīn Rūmī.[5] According to this doctrine, everything in the macrocosmic world consists of both an external form (*ṣūrah*) and an inner meaning (*ma'nā*). This is also true of human language which has come into being as a result of the imposition of *ma'nā* upon the very substance of language or its *ṣūrah*. As this impression of *ma'nā* upon *ṣūrah* increases, the external form becomes more transparent and reveals more readily its inner meaning. With poetry or poetic language in general, this process reaches a higher degree of

intensity until, in the case of inspired poetry, *ma'nā* dominates totally over *ṣūrah* and remoulds the outward form completely from within (without, of course, destroying the poetic canons). In such cases one might say, using the traditional language of Aristotelian and Thomistic metaphysics, that the substance of language becomes completely in-formed and hence in a state of complete actualization of all its possibilities.

According to Oriental doctrines, then, poetry is the result of the imposition of the Spiritual and Intellectual Principle[6] upon the matter or substance of language. This Principle is also inextricably related to Universal Harmony and its concomitant rhythm which is to be found throughout cosmic manifestation. The rhythmic patterns of traditional poetry, therefore, possess a cosmic reality and are far from being simple man-made contrivances. They are profoundly related to the Intellectual Principle and bring about within the soul of man a transformation which makes possible, with the help of traditional methods of spiritual realization, the recovery of man's primordial relation with the Spiritual and Intellectual Principle of things.

The rhythm which in-forms traditional poetry is, needless to say, to be found at the heart of all incantatory spiritual practices based upon the traditional science of sounds (*mantra* in Sanskrit) and is related to sacred languages sanctified by a particular revelation. Hence in such techniques as *dhikr* in Sufism, *japa* in Hinduism and the *nembutsu* in Pure Land Buddhism, the reception of certain sacred formulas is dependent at once upon the spiritual grace present in the formula when practiced under strictly traditional conditions and the harmony and rhythm which accompany this form of practice. In fact, a great deal of traditional poetry may be considered as a kind of prolongation of the fundamental spiritual practices of the tradition in question. In the case of Islam, for example, one can refer to the case of Rūmī, who composed much of his poetry after sessions in which ritual practices of *dhikr*, or invocation, were held, and much of the rhythm of various litanies and invocations is reflected in his Sufi poems, especially those of the *Dīwān-i Shams-i Tabrīzī*.

The relation between traditional poetry and logic is to be found precisely in this metaphysical nexus which binds them

together. Logic is obviously related to logos and from the traditional point of view is the process followed by the mind in its discovery of the truth. This process is made possible because the logical power of the mind is an extension of the Intellectual Principle, itself none other than the reflection of the Divine Intellect or Logos upon the mind. This same Principle is the ontological cause of the cosmic reality, hence the correspondence between the mental processes of man and external reality, and the possibility for the logical faculties of the mind to discover truths which correspond to external reality. This Principle is also that which infuses the substance of language with meaning and makes possible the creation of poetry. Therefore, according to traditional doctrines, logic and poetry have a common source, the Intellect, and far from being contradictory are essentially complementary. Logic becomes opposed to poetry only if respect for logic becomes transformed into rationalism, and poetry, rather than being a vehicle for the expression of a truly intellectual knowledge, becomes reduced to sentimentalism or a means of expressing individual idiosyncrasies and forms of subjectivism. But in a traditional context in which logic is itself a ladder for ascent towards the transcendent,[7] and poetry, whether explicitly didactic or otherwise, bears an intellectual and spiritual message, logic and poetry complement each other and point to a Reality which encompasses both of them. It is of some importance to mention in this context that the original title of one of the greatest masterpieces of Persian Sufi poetry is *Manṭiq al-ṭayr* (*Conference of the Birds* of Farīd al-Dīn ʿAṭṭār, which is discussed in the next chapter), the word *manṭiq* meaning literally logic in both Arabic and Persian. Referring to this same doctrine, the Persian Sufi poet ʿAbd al-Raḥmān Jāmī wrote:

What is poetry? The song of the bird of the Intellect.
What is poetry? The similitude of the world of eternity.
The value of the bird becomes evident through it,
And one discovers whether it comes from the oven of a
 bath house or a rose garden.
It composes poetry from the Divine rose garden;
It draws its power and sustenance from that sacred precinct.[8]

That which encompasses both logic and poetry is the nature of Ultimate Reality as revealed in various traditional metaphysical doctrines according to which this Reality is neither simply a logical abstraction, nor of a purely mathematical nature, nor is it devoid of the 'mathematical' dimension. Rather it is at once logical and poetic, mathematical and musical. God is at once the supreme geometer, and one might say, musician and poet. A complete metaphysics must therefore possess at once logical and mathematical rigour on the one hand and a poetical and musical aspect on the other, as in fact one of the great metaphysical traditions of the Occident, the Pythagorean, has always emphasized. It is because of the very nature of Reality, and therefore of the metaphysical knowledge which is related to it, that in Oriental traditions the most rigourous intellectual and metaphysical expositions have been expressed in either poetry or poetical language and some of the most logical and systematic metaphysicians have also composed poetry.

It is necessary to mention, however, that there is an element in poetry which corresponds to the feminine rather than the masculine aspect of the Divine Reality. If the Intellect can be said to correspond symbolically to the masculine principle, the Logos itself being usually symbolized in such a way, poetry then corresponds to the feminine pole which is at once an extrusion of the masculine and its passive and substantial complement. There is, therefore, in poetry, as in femininity, an aspect which allures and one which interiorizes, an aspect corresponding to Eve and another to Mary; or in Hindu terms it might be said that poetry possesses two characteristics corresponding to the two natures or aspects of Sītā, the escort of Rāma, one which causes dissipation and separation and the other interiorization and union, like *māyā* itself which at once veils and reveals *Ātma*.[9] But in any case, traditional poetry remains wed to the Intellect and bears its imprint. It is in fact inseparable from the total expression of the Truth, which of necessity encompasses both the masculine and feminine principles.

Of course, such a conception of poetry is far removed from all profane theories of literature in the same way that traditional poetry is distinct from profane poetry. In the great works of Oriental poetry, as in such masterpieces of Western literature

as *The Divine Comedy* of Dante, poetry is not the expression of the subjective experiences of the separated ego of the poet, but the fruit of a vision of a reality which transcends the being of the poet, and for which the poet must become the expositor and guide.[10] Such poetry is a vehicle of principial knowledge through both its content and form, through the words as well as the rhythm and the music.

To cite from the Hindu tradition we remember that the *Rāmāyana* was composed by Vālmīki by order of Brahmā, who commanded the poet to use a new metre to record a vision granted to the poet. According to the traditional account:

'Then Vālmīki, dwelling in the hermitage amongst his disciples, set himself to make the great Rāmāyan, that bestows on all who hear it righteousness and wealth and fulfilment of desire, as well as the severing of ties. He sought deeper insight into the story he had heard from Nārada, and thereto took his seat according to yoga ritual and addressed himself to ponder on that subject and no other. Then by his yoga-powers he beheld Rāma and Sītā, Lakshman, and Dasharatha with his wives in his kingdom, laughing and talking, bearing and forbearing, doing and undoing, as in real life, as clearly as one might see a fruit held in the palm of the hand. He perceived not only what had been, but what was to come. Then only, after concentrated meditation, when the whole story lay like a picture in his mind, he began to shape it into shlokas.'[11]

In Sufism also, poetry is considered to be the fruit of vision and almost a 'secondary' result of the expression of spiritual truth, from one who has experienced this truth and who possesses a harmonious nature (*ṭab'-i mawzūn*), expounded for those who also possess such a nature. Shaykh Maḥmūd Shabistarī, the author of the *Gulshan-i rāz* (*The Secret Rose Garden*), which is one of the greatest masterpieces of Persian Sufi poetry, writes:

> *Everyone knows that during all my life, I have never*
> *intended to compose poetry.*
> *Although my temperament was capable of it, rarely did*
> *I choose to write poems.*[12]

Yet in spite of himself, Shabistarī, in a period of a few days, and through direct inspiration (*ilhām*) composed one of the most enduring and widely read poetical masterpieces of Oriental literature. Moreover, he composed in perfect rhyming couplets and the *mathnawī* metre while remaining oblivious to the canons of prosody as contained in the classical works on the subject.[13]

The same holds true for Jalāl al-Dīn Rūmī, the author of the monumental *Mathnawī*, which is at once a treatise on pure metaphysics and a poetic work of art of the highest order. In many places in this and his other works, Rūmī insists upon the fact that he is not a poet and composes poetry in spite of himself. It is the vision of the spiritual world, and the rhapsody created in the being of the poet that cause his utterances to flow out in poetic stanzas. These then convey the imprint of the Universal Harmony upon the substance of language in the same manner that this Harmony dominates the mind and soul of the poet and seer.[14] In his *Mathnawī*, Rūmī writes:

> *I think of poetic rhyme while my Beloved* (God)
> *Tells me to think of Him and nothing else.*
> *What are words that thou shouldst think about them,*
> *What are words but thorns of the wall of the vineyard?*
> *I shall put aside expressions, words and sounds,*
> *So that without all three I carry out an intimate*
> *discourse with Thee.*

It is precisely because such poetry is the fruit of spiritual vision that it is able to convey an intellectual message, as well as to cause what might be called an 'alchemical transformation' in the human soul. Such a poetry has the effect of causing consent to the truth within the human soul, a consent that is related to certitude and complements the consent which results from the exercise of man's logical faculties. It might be said that in logic words have the power of both denotation and connotation while in poetry they also have the power of suggestion and awakening of an already existing possibility for intuitive knowledge in the soul; an awakening which corresponds to a transformation of the state of the soul.[15]

Poetry, then, is similar to logic in that it is a means and vehicle for the expression of Truth, and it complements logic in that it deals with forms of knowledge which are not accessible to the unaided logical faculties of 'fallen man'. Also, poetry brings about a transformation of the soul and its sensibilities in a manner which is not possible for a purely logical work. Traditional poetry causes an assent in the soul of man, so that it is possible to speak of a 'logic of poetry' which convinces and often clinches an argument in those regions of the world where poetry has been able to preserve even today its alchemical quality, and where the psyche of the people is still sensitive to the power of poetry and its manner of expressing the Truth and ability to induce certain states in the human soul.[16] In Oriental doctrines in general,[17] there has not existed that antagonism between logic and poetry of the type which has been observable in the West during the past few centuries. Logic itself has been regarded as a ladder of ascent to the spiritual world, the world of gnosis and metaphysical enlightenment,[18] while poetry has remained a vehicle for the expression not merely of sentiments, but of knowledge of the principial order. This is especially true in Islamic civilization where no either-or alternatives between logic and spirituality have ever been drawn. Even if certain criticisms have been made of logic in the name of Divine Love (*'ishq*), it has been with the aim of preventing not only logic from becoming a limitation rather than an aid, but also knowledge from remaining merely theoretical rather than becoming a 'tasted' fruit which is digested and which transforms one's being.

Ultimately the only common ground between logic and poetry, as understood traditionally, is that gnosis which lies at the heart of the Oriental traditions. In as much as Reality is at once the source of that which is logical and that which is poetical, gnosis or traditional metaphysics, which is knowledge of this Reality, cannot but be the common ground where logic and poetry meet and where Truth unveils itself in epiphanies which are at once logical and poetical, like virgin nature, that other grand theophany of the Truth which likewise possesses its own logic and poetry, its own unimpeachable laws and interiorizing harmonies. The wedding between logic

and poetry, so clearly observable in Islamic literature, cannot take place save through the rediscovery of that gnosis or metaphysics which always has been and always will be, and which makes itself accessible to those competent of receiving its message, whether they be of the Orient or the Occident.

NOTES

1. Concerning the meaning and symbolism of *ishrāq* in Islamic philosophy, associated with the name of Suhrawardī, see H. Corbin, *En Islam iranien*; S. H. Nasr, *Three Muslim Sages*; Corbin (ed.), Suhrawardī, *Opera Metaphysic et Mystica*, vol. I and II, Tehran–Paris, 1976–77, prolegomenas.

2. This is particularly evident in Islamic civilization where to this day many scientific disciplines are first taught as poems, for example the *al-Urjūzah fi'l-ṭibb* of Ibn Sīnā in medicine, the *Alfiyyah* of Ibn Mālik in grammar, and *al-Sharḥ al-manẓūmah* of Hājjī Mullā Hādī Sabziwārī in logic and metaphysics. There are even treatises in Arabic written completely in poetry on the movement of the planets and other aspects of astronomy not to speak of astrology.

3. *Aitareya Brāhmaṇa*, VIII; 27, quoted in R. Livingstone, *The Traditional Theory of Literature*, Minnesota, 1962, p. 77.

4. The use of the term *ṣūrah* in this context and in opposition to *ma'nā* should not in any way be confused with the use of the same term *ṣūrah* when contrasted with matter (*māddah* or *hayūlā*) in the language of hylomorphism used by many Islamic philosophers and following Aristotelian teachings. In the first case it is *ma'nā* which corresponds to the essence or principle and *ṣūrah* to the substantial, receptive and 'material' aspect of things; while in the second *ṣūrah* is used as form in its Aristotelian and Thomistic sense, therefore as the essential and principial in contrast to the material pole.

5. On Rūmī's teachings concerning *ṣūrah* and *ma'nā*, see chapter VI.

6. It is perhaps necessary to add that by intellectual we do not mean rational, but literally that which pertains to the intellect in its original sense as *intellectus* or *nous*. See Nasr, *Knowledge and the Sacred*, pp. 146ff.

7. On this basic theme see F. Schuon, *Logic and Transcendence*, trans. P. Townsend, New York, 1975.

8. From Jāmī's *Silsilat al-dhahab*:

9. See F. Schuon, 'The Mystery of the Veil', in his *Esoterism as Principle and as Way*, trans. W. Stoddart, Bedfont, 1981, pp. 47ff.

10. Likewise, Milton in his *Paradise Lost* prays to the Holy Spirit to be given a vision of the invisible world which would then be translated into poetry.

> *And chiefly thou O Spirit, that dost prefer*
> *Before all Temples th' upright heart and pure,*
> *Instruct me, for thou know'st:*
> *. . .*
> *So much the rather thou celestial light*
> *Shine inward, and the mind through all her powers*

Irradiate, there plant eyes, all mist from thence
Purge and disperse, that I may see and tell
Of things invisible to mortal sight.

11. Quoted in A. K. Coomaraswamy and Sister Nivedita. *Myths of the Hindus and Buddhists*, New York, 1914, pp. 23–24.

12.

<div dir="rtl">

نکــرده هیــچ قصــد گفتــن شعـر همــه داننـد کاین کس در همـه عمـر

ولـی گفتــن نبــود الا بنـادر بر آن طبــعـم اگــرچــه بود قادر

</div>

13. This point is discussed in the commentary of Muḥammad Lāhījī upon the above poems in this *Sharḥ-i gulshan-i rāz*, Tehran, 1337, (A. H. Solar), p. 41.

14. It is worthwhile to recall here the Platonic doctrine concerning harmony. 'What Plato says is that "we are endowed by the Gods with vision and hearing, and harmony was given by the muses to him that can use them intellectually (Κατά νουυ), not as an aid to irrational pleasure (ἡσουή ἄλογος) as is nowadays supposed, but to assist the soul's interior revolution, to restore it to order and concord with itself".' From the *Timaeus* 80B, translated and quoted by A. K. Coomaraswamy in his *Figures of Speech or Figures of Thought*, London, 1946, p. 13.

15. This power of suggestion is called *dhvani* in the so-called 'School of Manifestation' in Hinduism. See A. K. Coomaraswamy. *The Transformation of Nature in Art*, Cambridge, Mass, 1935, p. 53.

16. Many Western people who travel to Islamic countries are amazed by the role that citing a poem can play in deciding an argument in everyday situations where a logical proof would seem to be called for.

17. Such schools as Zen, where elliptical expressions in the forms of *koans* are employed as a means of removing the limitative powers of the mind, appear to be an exception, but even in such a case the method must not be mistaken for the metaphysical doctrine involved. In any case the Zen perspective must not be confused with an opposition to logic which falls below logic, while Zen seeks to free man from above from the limitations of ratiocination. Zen inspired art, whether it be poetry or landscaping, is in no way antagonistic to logic in the manner of the irrationalist and sentimental art of the modern West.

18. This principle is particularly emphasized in the school of *ishrāq* or illumination of Shihāb al-Dīn Suhrawardī. See H. Corbin op. cit. and Nasr, *Three Muslim Sages*, Chapter 11.

VI

The Flight of Birds to Union: Meditations upon 'Aṭṭār's Manṭiq al-ṭayr'

«وَوَرِثَ سُلَیْمانُ دَاوُدَ وَ قالَ یا اَیُّهاالنّاس عُلِّمنا مَنْطِقَ الطَّیْرِ.»

And Solomon was David's heir. And he said: 'O mankind!
Lo! we have been taught the language of the birds
(Manṭiq al-ṭayr).

<div align="right">(Quran, xxvii; 16)</div>

مقـامـات طیــور ما چنــانــســت که مرغ عشــق را معــراج جان است

Our 'Stations of the Birds' (maqāmāt-i ṭuyūr) is such,
that it is the nocturnal ascent of the soul for the
bird of love.

<div align="right">('Aṭṭār, Khusraw-nāmah)</div>

ALL THOSE who are not completely at home in this world of fleeting shadows and who yearn for their origin in the paradisal abode belong to the family of birds, for their soul possesses wings no matter how inexperienced they might be in actually flying towards the space of Divine Presence. The *Manṭiq al-ṭayr* of Farīd al-Dīn 'Aṭṭār, that peerless poet, gnostic and lover of God, is an ode composed for this family of beings with wings, this family which in the human species corresponds to the seekers among whom many are called but few are chosen. The Shaykh himself called his rhyming couplets of some 4458 verses *Zabān-i murghān*, literally, the *Language of the Birds* or *Maqāmāt-i ṭuyūr*, the *Stations of the Birds*[1] in reference to the language of the birds (*Manṭiq al-ṭayr*) which, according to the Noble Quran, God taught to Solomon. And

it is by this Quranic title that the immortal work of 'Aṭṭār finally became known to the world. This Sufi masterpiece, in accordance with the inner meaning of the Solomonic knowledge of the language of the birds, does not only penetrate into the meaning of alien forms of discourse,[2] but is specifically concerned with the types and classes of beings in spiritual quest, for it treats not the language of just any species of animals but those birds whose wings symbolize directly the archetypal reality of flight, and of ascension in opposition to all the debasing and downgrading forces of this world, leading finally to escape from the confinement of earthly limitation.

As 'Aṭṭār himself states.

> *I have recited for you the language of the birds,*
> * one by one.*
> *Understand it then, O uninformed one!*
> *Among the lovers, those birds become free,*
> *Who escape from the cage, before the moment of death.*
> *They all possess another account and description,*
> *For birds possess another tongue.*
> *Before the Sīmurgh that person can make the elixir,*
> *Who knows the language of all the birds.*[3]

The title of *Manṭiq al-ṭayr* is at one and the same time a reference to the language of the birds or spiritual beings, their conference or union[4] and to that esoteric knowledge which is the fruit of the spiritual journey. In fact the word *manṭiq* itself implies both language and meaning including the categories of logic which, as can be seen from the previous chapter, are far from being opposed to the spiritual since they derive ultimately from the Divine Word as the source of all certitude and meaning. The Logos is the ultimate source of logic.

'Aṭṭār was not the first to write of the birds and their language, of their nostalgia for the royal court of the Divine Beloved, of their hardships and suffering in undertaking that journey which is in reality none other than *the* journey, and of finally reaching their goal. Ibn Sīnā had already written his *Risālat al-ṭayr* (*Treatise on the Bird*) over two centuries before, to be followed by Abū Ḥāmid Muḥammad al-Ghazzālī, the celebrated

theologian, whose treatise on the same subject is among his lesser known writings.[5] But 'Aṭṭār's treatment, while drawing from the works of his illustrious predecessors, is of another order. While Ibn Sīnā deals with the intellectual vision which allows the soul to return to its celestial family and al-Ghazzālī with the suffering and helplessness of the seeker who is saved solely through grace and Divine Love, 'Aṭṭār deals with the supreme spiritual and mystical experience of Union. He uses the Ghazzālian theme of suffering through which the birds are finally able to enter the court of the celestial King. But he passes beyond that stage through the highest initiatic station whereby the self becomes annihilated and rises in subsistence in the Self, whereby each bird is able to realize who he is and finally to know him-Self, for did not the Blessed Prophet state, 'He who knoweth himself, knoweth the Lord'?[6] In gaining a vision of the Sīmurgh, the birds not only encounter the beauty of Her Presence,[7] but also see themselves as they really are, mirrored in the Self which is the Self of every self.

The *Manṭiq al-ṭayr* begins with an *alpha* which is already the mirror of the *omega* of the spiritual life for in its preludium is contained an account of the Divine Reality, an account which cannot but be the fruit of the beatific vision by the bird of the soul of the Sīmurgh. Through a rhapsodic crescendo the master poet proceeds in his praise of the One until he reaches the stage wherein he utters:

> *O thou who through thy manifestation hath become*
> * invisible,*
> *The whole universe is Thee, but none hath beheld Thy*
> * face.*
> *The soul is hidden in the body and Thou in the soul,*
> *O Thou hidden in the hidden, O Soul of soul!*
> *Although Thou art hidden in the heart and the soul,*
> *Thou art manifest to both the heart and the soul.*
> *I see the whole Universe manifest by Thee,*
> *Yet I see no sign of Thee in the world.*[8]

In his rhapsodic commentary upon the first *shahādah*, 'there is no divinity but the Divine' (*Lā ilāha illa'Llāh*) 'Aṭṭār does not

only speak of God's Names and Qualities. His concern is not with only a theological exposition whether it be cataphatic or apophatic. Rather, he leads the enraptured reader through the symbolic language of gnosis (*ma'rifah*) permeated with the fire of Divine Love to that knowledge of Unity which on the highest level is none other than the 'Transcendent Unity of Being' (*waḥdat al-wujūd*),[9] a knowledge which cannot be attained operatively save by passing through the hardships of the cosmic journey, passing through the gate of annihilation and reaching that vision of the Sīmurgh which both consumes and sanctifies.

Chants of glory of the One lead 'Aṭṭār to the praise of the Prophet as the Perfect Man, the Logos, the first created of God in whom God contemplates all His creation and for whom the created order is brought into being. If the sapiential understanding of *Lā ilāha illa'Llāh* is *waḥdat al-wujūd*, that of the second testimony of Islam, *Muḥammadun rasūl Allāh*, is not only that Muḥammad is the messenger of God, but that all manifestation, all that is positive in the cosmic order comes from God. The second testimony is no less an assertion of unity (*al-tawḥīd*) than the first and in fact follows from it. 'Aṭṭār's vision of the Sīmurgh could not but make him aware that the Blessed Prophet is

> *The Master of the Nocturnal Ascent and foremost*
> *among creatures,*
> *The shadow of the Truth and the Sun of the Divine*
> *Essence,*
> *The Master of the two worlds and the king of all,*
> *The sun of the soul and the faith of all beings,*
> *His light was the purpose of creatures;*
> *He was the principle of all existants and non-existants.*
> *When the Truth saw that absolute light present,*
> *It created a hundred oceans of light from his light.*
> *It created that pure soul for Itself,*
> *Then created the creatures of the world for him.*[10]

With his intoxicating poems in praise of God and His Prophet, poems which already contain the profoundest metaphysical truths and bear the fruit of the tree of gnosis, 'Aṭṭār sets out

upon the journey of the birds, a journey whose *omega* point is already contained in the *alpha* of the mystical epic. He returns the reader to the realm of terrestrial existence and the bondage of the soul of the profane man who has become entangled in the prism of passions, to the state of the birds ensnared and trapped far away from their abode of Origin. The preludium serves to remind the reader that the poem itself is the fruit of the supreme vision and that the guide, who describes the perilous journey of the birds to the presence of the Sīmurgh, has himself already undertaken the journey and is to be trusted as a veritable guide. The opening verses of the *Manṭiq al-ṭayr*, being among the greatest masterpieces of Sufi poetry, reveal the nature and degree of inspiration of their author and enable the seeker to surrender himself to the work, to be led with the certitude that the guide is not simply an imitator of heresay but one who has already undertaken the journey towards the One, the *only* journey worthy of undertaking in this fleeting life.

The story of the *Manṭiq al-ṭayr* is in itself a simple one. The birds assemble to select a king for they believe that they cannot live happily and in harmony without a king. Among them the hoopoe rises and introduces himself as the ambassador sent by Solomon to the Queen of Sheba. He considers the Sīmurgh as the One worthy to become their monarch. Each bird brings up a pretext and an excuse in order to avoid having to make that crucial decision of embarking upon the path and questions the hoopoe about the whereabouts of the Sīmurgh. The hoopoe answers each bird satisfactorily, removing its doubts and finally succeeding in having the birds prepare for the journey to meet the Sīmurgh. The hoopoe is chosen as leader and describes to them the stages of the journey to be undertaken. Having overcome these difficulties and responding again to the questions of the birds, the hoopoe and the other birds complete their preparation for the dangerous journey. They traverse the seven valleys of the cosmic mountain *Qāf* on whose peak resides the Celestial Monarch. The seven valleys leading to that peak which touches the void are those of quest (*ṭalab*), love (*'ishq*), gnosis (*ma'rifat*), contentment (*istighnā'*), unity (*tawḥīd*), wonder (*ḥayrat*), poverty (*faqr*), and annihilation (*fanā'*).[11]

These stages of the path are also the valleys and dales of the cosmos interiorized within the soul of the initiate.[12] Finally, the birds reach the abode of the Sīmurgh and after an initiatic transformation behold Her Presence as the mirror in which each bird sees it-Self, for the thirty birds (sī murgh in Persian) see the Sīmurgh at once utterly other than themselves and none other than the Self of their selves.

At the beginning of the journey each bird is addressed separately according to its characteristics, what it symbolizes as a distinct human type, and as a particular power of the soul. In reality each bird is at once an aspect or tendency of the human soul and a particular type of soul in which the characteristics in question are predominant. The birds addressed include the hoopoe, the wagtail, the parrot, the partridge, the falcon, the francolin, the nightingale, the peacock, the cock pheasant, the turtle-dove, the ring-dove, the gold-finch, and the white falcon. In their description one discovers at once their special qualifications and gifts and their limitative and inhibiting characteristics.

Thus the birds assemble to prepare themselves for the flight to the cosmic mountain (Qāf). Their debates and discussions reflect those between the master and his disciples within Sufi orders and contain some of the most profound and subtle descriptions of the problems and questions which confront those who actually undertake the journey upon the path of spiritual realization. Each bird speaks of itself in a manner reminiscent of other classical Muslim works on animals such as the Rasā'il of the Ikhwān al-Ṣafā'.[13] That the hoopoe becomes the guide upon the path, the symbol of the Sufi shaykh, murshid, or pīr, is due to its association with Solomon and the court of the Queen of Sheba and that it was already the ambassador of the King, for only one familiar with the King can guide others to His presence.[14]

The hoopoe describes the Sīmurgh as gnostics 'describe' God. One feather from Her wing fell upon China during the darkness of the night, for according to ḥadīth 'God created the world in darkness,' and from beholding this single feather all of the people of China fell into the state of excitement.

How strange that at the beginning, the Sīmurgh
Manifested Herself in the middle of the night in China.
One of her feathers fell in the middle of China,
Of necessity excitement and agitation filled the whole
* country.*
That feather is now in the museum of that land.
That is why it is said, 'Seek knowledge even in China'.[15]

If one feather of the Sīmurgh caused a whole nation to enter into a state of agitation and ecstasy, what must it be to behold Her Face! The birds become excited at hearing the account of Her Presence and prepare to undertake the journey. But the gravitational pull within the soul is not to be so easily overcome. The passionate soul makes a thousand excuses to avoid being consumed by the fire of purification. Each bird, therefore, begins to find an excuse. The nightingale, which symbolizes the love of external and distracting beauty rather than the interiorizing beauty which unites,[16] makes the pretext that its love is the rose whose vision solves all its difficulties and problems. The hoopoe replies that the rose withers away and its beauty does not endure. The wise should seek a beauty which does not perish.

The parrot, which symbolizes the love of earthly existence and its prolongation, seeks the water of life to make the life of this world enduring and would be satisfied with such a goal. To this excuse, the hoopoe replies that the soul was created to be sacrificed to God, this sacrifice being its entelechy and *raison d'être*, hence its final joy and beatitude.

The peacock, which resided originally in paradise but which fell on earth because it aided Satan in alluring Adam away from his edenic innocence and perfection, seeks the perfections of formal paradise and claims that it cannot endure the vision of the Sīmurgh. It is like many exoterists who seek the pleasures of paradise in themselves rather than in relation to God not to speak of God Him-Self, who seek the house rather than the 'Master of the house'; to quote 'Aṭṭār.

The other birds follow suit in a similar vein, each providing an excuse in accordance with the limitation of its perspective or particular passion that dominates it. The duck which spends

its lifetime washing, symbolizing only external observance of religious rites without penetrating into their meaning, does not want to leave the water which it loves. The partridge which loves stones, symbolizing men and women tied to wealth and the possession of precious jewels, does not want to abandon the stone upon which it sits. The bearded griffon, symbolizing worldly and political power, does not want to relinquish its hold upon people of position and power in this world. The falcon, symbolizing those who seek the proximity of the earthly king and worldly power, does not want to forgo its position of favour at court. The heron, symbolizing states of sadness and depression in the soul, does not wish to leave behind this continuous change of psychic states which are like the ever changing waves of the sea. The owl, symbolizing miserliness, does not want to leave the corner of solitude it has chosen. The finch, symbolizing human weakness, makes the excuse that human beings are simply too weak to be able to have a vision of the Sīmurgh. In each case the hoopoe answers the birds and refutes the excuses they are trying to provide in order not to embark upon the path through the cosmic mountain to the presence of the Sīmurgh. He acts much like the spiritual master who removes from the path of the disciples all the infirmities of the soul which manifest themselves as obstacles upon the way. Having heard the secrets of the path and responses to their inner doubts and problems, the birds finally assemble to actually begin their sojourn.

It is at this stage, in the twentieth section of the *Manṭiq al-ṭayr*, that 'Aṭṭār introduces the incredible story of Shaykh-i Ṣanʿān, whose treatment marks one of the peaks of Sufi literature. Most likely based on the early stories of Muslim caliphs or other notables visiting Christian monasteries usually located in far away places of great natural beauty,[17] the story of 'Aṭṭār deals with the tale of a celebrated and venerated Sufi master who, after fifty years of spiritual practice and with hundreds of disciples, falls in love with a young Christian woman. He forgoes his fame, reputation, spiritual function, and even religion for the sake of this love. He wears the girdle of Christian monks, drinks wine and even takes care of a herd of pigs while he burns for the love of the Christian maiden. He faces every

form of rebuke but no force in the world can alter his love which burns and consumes his being. He sings,

I have passed many a night in ascetic practices,
But no one has revealed such nights as these.
Whoever has been granted one night such as this,
His day and night is spent in burning passion.
On the day when they were moulding my destiny,
They were preparing me for such a night.
O Lord what are these signs tonight?
Is tonight the Day of Judgement?
Reason, patience, the friend have departed,
What kind of love, what kind of pain, what kind of affair
 is this?[18]

All the means that the disciples use to bring the Shaykh back are of no avail. Finally only by an intervention of the Prophet who appears in the imaginal world of dreams does the Shaykh awaken to his original faith, make the ablution and enter Islam again, whereupon the Christian maiden, observing the transformation that has overcome Shaykh-i Ṣanʿān, also embraces Islam. All the lessons of the power of love, the inner and outer nature of men, the importance for disciples to be steadfast in their obedience of their master, the danger of pride caused by self-righteousness in the religious life and many other elements of the spiritual path are depicted in colours of unparalleled brilliance by ʿAṭṭār in this tale. No page of Persian literature is more moving than the description of the love of the venerable Sufi master for the beautiful Christian maiden.

There is, however, another pearl of wisdom of the greatest import hidden in the words of this literary masterpiece. This pearl concerns esotericism as such. The Shaykh's attraction to a Christian woman in such a shocking manner alludes obviously to the 'iconoclastic' and 'scandalous' character of all that concerns the supraformal Essence *vis-à-vis* the world of forms. But it also indicates clearly the crossing of religious boundaries through esotericism. Here, the maiden is not just the symbol of love, even of a 'scandalous' kind, but as a Christian she represents a being belonging to a different religious

universe. Through the attraction of love—which here represents realized gnosis—the Sufi master is not only carried from the world of forms to that of the Essence, but is also transported across religious frontiers. In 'Aṭṭār's incomparable story is to be found not only a highly poetic treatment of the theme of the love which attracts, consumes and transforms but also a powerful statement of the role of esotericism in making possible the crossing of the frontiers of religious universes. It is as if 'Aṭṭār wanted to state in the classical language of Sufi poetry that veritable ecumenism is essentially of an esoteric nature and that it is only through the esoteric that man is able to penetrate into the meaning of other formal universes.[19]

At this stage of the Epic, and after this long preparation the birds set out toward the Sīmurgh. Having realized the necessity of having a guide, they choose the hoopoe as their master and promise to obey him. Their first glance upon the valley before them causes deep fear. They are also surprised that there are no other birds upon the path. The hoopoe explains that the very majesty of the King prevents just anyone from approaching Him. The seeker must be qualified and the qualified are always few in number.

The hoopoe explains the difficulties of the journey ahead and, when asked why it is necessary to have a guide at all, provides the traditional answer for the necessity of the prophet and the spiritual master who is his representative on the esoteric plane. The prophet is chosen by God and the spiritual authority of the shaykh is also bestowed from on high. Without the seal of approval of that prophetic authority which is possessed by the human embodiments of the Logos alone, no initiatic function and spiritual authority of an authentic kind are possible.

Another bird complains to the hoopoe of the difficulties of the path and lack of certainty of ever reaching the end. He is answered that since the goal is the Truth Itself, even if one were to lose one's life on this path, it would be worthwhile. As for all the apparent difficulties, they are most of all due to the fact that the roots of the soul are sunk in the creaturely world of multiplicity and that man is too dispersed and diverted by creatures to be able to concentrate his mind and soul upon the Creator.

One bird is ashamed of the sins he has committed and is reassured of the infinite mercy of God, and another of the fact that he is prone to a constant change of moods and states and is answered that through spiritual practice this weakness can be slowly cured. One of the birds complains of the snares of the passionate soul and is told that the lower soul must be conquered. Another fears the temptations of the Devil and the hoopoe answers that the Devil has power only as long as man is attached to worldliness. Once the world is overcome, so is the power of the adversary. Likewise, the hoopoe asserts that the attachment to houses and mansions is an obstacle to the path as is the love of external forms which perish. Only the 'beauty of the Invisible' is worthy of being loved. In a similar manner other important questions which usually lurk upon the path of those in whom there is already a dissatisfaction with where they are, who they are and who have therefore a need to seek and to find, are answered in a masterly fashion by the hoopoe who, being the symbol of the spiritual master, answers the birds as a Sufi master would his disciples.

Finally, the hoopoe enumerates the seven valleys to be traversed and describes each valley beginning with the valley of quest (*wādī-yi ṭalab*) and ending with the valley of annihilation (*wādī-yi fanā'*) which cannot but lead to subsistence (*baqā'*) in God.

> *Release from thee whatever thou hast, one by one,*
> *Then begin a spiritual retreat by thyself.*
> *When thy inner being becomes unified in selflessness,*
> *Thou shalt transcend good and evil.*
> *When good and evil pass, thou shalt become a lover,*
> *Thou shalt become worthy of annihilation.*[20]

Having heard the description of the seven valleys, the birds fly into the first valley to accomplish their journey of destiny. For years they traverse the ups and downs of the cosmic mountain. Many lose their lives; others become entrenched within some intermediate station. Of the many birds who commence the journey only a few finally reach the presence of the

Sīmurgh. Many are called but few are chosen. But as for the few who do reach the Presence of Divine Majesty,

> *They observed a Presence without qualification and*
> *description,*
> *Beyond perception, reason and understanding.*
> *If the spark of His Self-Plenitude were to be cast,*
> *A hundred worlds would burn in one moment.*
> *A hundred thousand esteemed suns,*
> *A hundred thousand moons and stars, even more.*
> *They observed them all in wonder,*
> *Coming like atoms in a dance.*[21]

The birds begin to tremble before such majesty and lose hope of being able to gaze upon the Countenance of the King. The herald of the Court of Majesty discourages them from advancing any further, stating that the lightning of Divine Majesty would burn them all to cinders. But the birds insist that among thousands who set out only thirty have reached this stage and they will not leave. Rather, they would prefer to cast themselves moth-like upon the fire of the Presence of Majesty. Here, the story of Joseph mentioned in the Noble Quran is presented to them and they become aware that they had sold their celestial Self into 'slavery' by betraying it, as had the brothers of Joseph. When would each bird recognize Joseph as king? When would he recognize him to be what he is?

The very agony of this realization transforms each bird inwardly to such an extent that suddenly the self realizes the Self. The thirty birds (*sī murgh*) realize that they are the Sīmurgh.

'At that moment, in the reflection of their countenance, the Sī-murgh (*thirty* birds) saw the face of the eternal Sīmurgh. They looked: it was veritably that Sīmurgh, without any doubt, *that* Sīmurgh was veritably *these* Sī-murgh. Then amazement struck them into a daze. They saw themselves Sī-murgh in all; and Sīmurgh was in all Sī-murgh. When they turned their eyes to the Sīmurgh, it was veritably *that* Sīmurgh which was there in that place. When they looked at themselves, here too it was Sī-murgh. And when they looked both ways at once, Sīmurgh

and Sī-murgh were one and the same Sīmurgh. There was Sīmurgh twice, and yet there was only one; yes, one alone, and yet many. This one was that one; that one was this one. In the whole universe none understood such a thing. All were sunk in amazement; they remained in a state of meditation outside of meditation.

'As they understood nothing whatever of their state, they questioned the Sīmurgh, without using language. They implored it to unveil the great Mystery, to solve the riddle of this reality-of-the-*us* and this reality-of-the-*thou*. Without the aid of language too, this answer came from Her Majesty: My sunlike Majesty is a Mirror. He who comes sees himself in that mirror: body and soul, soul and body, he sees himself entirely in it. Since you came as *Sī-murgh* (thirty birds), you appeared as *thirty* (*sī*) in that mirror. If forty birds, or fifty, come, the veil will likewise be lifted before them. Had you become a multitude, you would yourself have looked and you would have seen yourselves . . . I am far, far above Sī-murgh (*thirty* birds), for I am the essential and eternal Sīmurgh. Therefore, engulf yourselves in me, that ye may find yourselves again in me . . .'.[22]

> To be consumed by the light of the presence of the
> Sīmurgh is to realize that,
> I know not whether I am thee or thou art I;
> I have disappeared in Thee and duality hath perished.[23]

But such a state cannot be reached until man tastes the annihilation of himself through the realization of his-Self.

> Become nothing so that thy being will become
> established;
> As long as thou art, how can Being establish Itself in
> Thee?[24]

Through his incredible poetic art combined with the highest stages of spiritual realization, 'Aṭṭār depicts in inebriating beauty that final goal of human existence whose attainment is possible only through the actual journey of the bird of the

soul to the peak of the cosmic mountain and beyond but whose anticipated vision is made possible by a work of sacred inspiration such as the poem of 'Aṭṭār. In the *Manṭiq al-ṭayr* the Sufi sage of Nayshapur, at once gnostic and artist, has created a work of Islamic art which, like other masterpieces of traditional literature—and art in general—has an alchemical effect upon the soul, radiating a beauty which both melts and rends asunder, even if it be for a moment, the limited confines of earthly existence. It presents, as if by anticipation, a glimpse of that goal which is the end of all wayfaring and the entelechy of human existence.

NOTES

1. See B. Forouzanfar, *Sharḥ-i aḥwāl wa naqd wa taḥlīl-i āthār-i Shaykh Farīd al-Dīn Muḥammad-i 'Aṭṭār-i Nayshābūrī*, Tehran, 1340, (A.H. solar), p. 313. This excellent study of 'Aṭṭār contains a thorough analysis of the *Manṭiq al-ṭayr* on pp. 313–394.

On the life and works of this 6th/12th century Sufi master and poet see also S. Naficy, *Justujū dar aḥwāl wa ātār-i Farīd al-Dīn 'Aṭṭār-i Nayshāpūrī*, Tehran, 1320, (A.H. solar); H. Ritter, *Philologika X, Der Islam*, vol. 25, 1939, pp. 134–173; H. Ritter, *Das Meer der Seele*, Leiden, 1955; and *Colloquio Italo-Iranianio sul Poeta Mistico Fariduddin 'Aṭṭār*, Accademia Nazionale dei Lincei, Rome, 1978.

2. In Sufism the art of mastery over the language of the birds, a science taught to Solomon, implies both the power to penetrate into the meaning of alien forms and the capability to know the meaning of the spiritual states and stations through which the seeker of the Truth must journey.

3. *Manṭiq al-ṭayr*, edited by M. J. Mashkur, Tehran, 1337, (A.H. solar), p. 316. The translation from 'Aṭṭār throughout this chapter is our own unless otherwise stated. Henceforth, all reference to this work will be to this edition which is accepted by the scholarly public as the most exact printed so far. For the translation of the *Manṭiq al-ṭayr* in European languages see M. Garcia de Tassy, *Mantic Uttair, ou Le Langages des oiseaux*, Paris, 1863; Edward Fitzgerald, *Bird Parliament*, 1889, reprinted in *Fitzgerald, Selected Works*, London, 1962; G. M. Abid Shaikh, *Translation of Mantik ut-Tair*, Ahmedabad, 1911; *The Conference of the Birds*, trans. R. Masani, Mangalore, 1924; *The Conference of the Birds*, trans. from Garcia de Tassy's French by S. C. Nott, London, 1954; and *The Conference of the Birds*, translated with and Introduction by Af khan Darbani and Dick Davies, Harmondsworth, 1984.

4. In Persian as in Arabic *manṭiq* itself means logic or meaning while *nuṭq*, from the same root, means speech as well as language. As already mentioned, in Islamic thought, logic, far from being opposed to spirituality, has been seen as the first step in the attainment of sapience and is treated as such by many figures such as Suhrawardī in his *Ḥikmat al-ishrāq* and even Ibn Sīnā, the master of Peripatetics who wrote *Manṭiq al-mashriqiyyīn* (*The Logic of the Orientals*). See H. Corbin, *Avicenna and the Visionary Recital*, trans. W. R. Trask, New York, 1960; Corbin, *En Islam iranien*, vol 11; and Nasr, *An Introduction to Islamic Cosmological Doctrines*, Part 111.

On the relation between logic and realized knowledge, which is attainable through the intellect in its original and not modern sense, see F. Schuon, *Logic and Trancendence*; Schuon, *From the Divine to the Human*, trans. G. Polit and D. Lambert, Bloomington (Indiana), 1982; Nasr, *Knowledge and the Sacred*.

5. On these treatises see Corbin *Avicenna* . . . pp. 193ff. Al-Ghazzālī's brother, the celebrated Sufi master Aḥmad al-Ghazzālī, is also the author of a treatise on the birds of great literary beauty which is more or less the translation of his brother's Arabic work.

6. *Man 'arafa nafsahᵘ faqad 'arafa rabbahᵘ.* This initiatic *ḥadīth* has many meanings of which one of the most profound characterizes the goal and end of the 'Aṭṭārian epic.

7. Although modern Persian has no gender, the word *Sīmurgh* can be referred to in the feminine because first of all its Avestan origin *saēna meregha* is feminine; secondly, the Arabic term for *sīmurgh*, namely *al-'anqā'*, is feminine; and finally, the Sīmurgh on the highest level as understood by 'Aṭṭār refers to the Divine Essence (*al-Dhāt*) which in Sufi literature is referred to as the female Beloved. Moreover, the word *al-dhāt* itself is feminine in Arabic reflecting the metaphysical truth that the internal dimension of the Divinity which is identified with Beauty and Infinity is the prototype of femininity and is 'feminine' in the highest sense of this reality. In order to remain faithful to the original text, however, when 'Aṭṭār refers to the Sīmurgh as *shāh*, the term king rather than queen has been used, and also he rather than she.

8. *Manṭiq al-ṭayr*, p. 6.

9. The numerous errors concerning the meaning of *waḥdat al-wujūd* bear witness indirectly to the esoteric nature of the doctrine in question. *Waḥdat al-wujūd* is nothing more than unity (*al-tawḥīd*) as understood at its highest level, an understanding which, however, cannot be attained by either philological expertise or the best of fideist intentions nor by the sharpest analytical tools of reason. As Rūmī has said, one needs a deep sea diver to fetch the pearl from the bottom of the sea. Only the eye of the heart can grasp the sense of *waḥdat al-wujūd* without either denying Divine Transcendence or positing an independent reality for 'that which is other than God' (*mā siwa'Llāh*), an assertion which is a hidden form of polytheism. On the meaning of *waḥdat al-wujūd* and its distinction from pantheism as usually undertood see T. Burckhardt, *An Introduction to Sufi Doctrine*, trans. D. M. Matheson, Wellingborough, 1976, pp. 28–30.

10. *Manṭiq al-ṭayr*, pp. 18–19.

11. *Ibid.*, pp. 227–291. The Sīmurgh in reality symbolizes both the Divine Essence which stands above the created order and the Divinity as Creator and principle of manifestation. The point on top of Mount Qāf is at once in the infinite expanse of the sky and the principle of generation of the whole cosmic mountain below it. Moreover, it is the point where the two orders, namely, the created and the uncreated, meet. Under this aspect, the abode of the Sīmurgh corresponds to the Logos or Intellect which is both created and uncreated depending upon how it is envisaged.

12. On the states and stations of Sufism see S. H. Nasr, *Sufi Essays*, London, 1972, chapter v; on the interiorization of the cosmos by the gnostic see Nasr, *An Introduction to the Islamic Cosmological Doctrines*, chapter xv.

13. See Ikhwān al-Ṣafā', *Dispute between Man and the Animals*, trans. J. Platts, London, 1869; and L. Goodman, *The Case of the Animals versus Man Before the King of the Jinn*, Boston, 1980.

14. 'Aṭṭār is re-asserting the perennial truth, currently forgotten in so many circles, that only the human embodiment of the Logos, that is the prophet, however that function is understood in various religions, can guide men to God. There is no authentic and complete spiritual realization without tradition. Only the ambassadorial background of the hoopoe qualified him to lead the birds to the presence of the King.

15. In reference to the famous *ḥadīth*.

16. In reality all beauty is interiorizing and liberating if only the beholder were to see in every form of beauty the reflection of the Beauty of the Face of the Beloved.

17. See Forouzanfar, *op. cit.* pp. 320ff. More specifically Forouzanfar relates 'Aṭṭār's story of Shaykh-i Ṣan'ān to a very similar tale in Persian found in a manuscript in *Aya Sophia*, number 2910, in a treatise entitled *Tuḥfat al-mulūk* and attributed to Abū Ḥāmid Muḥammad al-Ghazzālī.

18. *Manṭiq al-ṭayr*, pp. 85 et. seq.

19. On this fundamental and very timely subject see F. Schuon, *Esoterism, as Principle and as Way*, and *L'Islam/Christianisme-Visions d'Oecuménisme ésotérique*, Milan, 1981.

20. *Manṭiq al-ṭayr*, p. 284.

21. *Ibid,*, p. 293.

22. Corbin, *Avicenna* . . . pp. 201–202.

23. *Manṭiq al-ṭayr*, p. 267.

24. *Ibid*, p. 304.

VII
Jalāl al-Dīn Rūmī:
Supreme Persian Poet and Sage

PART I : LIFE AND WORKS

پس حکیمـان گفتـه‌انـد این لحنهـا از دوار چرخ بگـرفـتـیـم ما

مؤمـنـان گویـنـد آثـار بهـشـت نغـز گردانـیـد هر آواز زشـت

ما همـه اجـزای آدم بوده‌ایـم در بهـشـت آن لحنـهـا بشـنـوده‌ایـم

گرچـه بر ما ریـخـت آب و گل شکی یادمـان آمـد از آنـهـا چیـزکـی

پس غذای عاشـقـان آمـد سمـاع که درو باشـد خیـال اجـتـمـاع

آتش عشـق از نواهـا گشـت تیـز آنـچـنـانـك آتش آن جوزریـز

The sages have said that these melodies,
We have acquired from the rolling spheres,
The faithful say that the effects of paradise,
Turn into sweetness every ugly sound.
We were all parts of Adam
And had heard these melodies in paradise.
Although water and clay have cast doubt upon us,
Some echo of them lingers in our memory.
Oh, music is the nourishment of lovers,
Who harbour in their mind the thought of union.
The fire of love becomes intensified through
* these melodies,*
Much like the fire generated by small nuts.

(*Mathnawī*, IV, 733)[1]

ALREADY in 'Aṭṭār one observes an outstanding example of the rapport between Islamic art in the form of literature and Islamic spirituality. At once a poet of the highest order and a saint revered throughout Khurasan, in his own day 'Aṭṭār created an extensive literary corpus

114

in which the knowledge of Divine Unity and love of the Blessed Prophet as well as nearly all the other facets of Islamic spirituality were treated in a highly artistic form. But it is most of all in the person and writings of Jalāl al-Dīn Rūmī that the perfect wedding between Islamic literature and also music and Islamic spirituality can be found. The study of the life, works and teachings of this incomparable master of the spiritual path as well as of the poetic and musical expression of the doctrines and mysteries pertaining to the path to Divine Unity affords a unique opportunity to gain deeper insight into the relation between Islamic art and spirituality. Not only do the works of Rūmī and the ideas contained in them provide the most complete exposition of the Islamic 'philosophy of art' and an example of the relation and rapport between literature and spirituality, but the life of the poet and saint is itself a key to the understanding of this essential rapport. Rūmī's life was a great work of art enclosed from the beginning within the world of Islamic spirituality and producing in the form of poems, and also the music and sacred dance of the Mawlawī Order, masterpieces of art which have vibrated over the centuries with spiritual presence and continue to enrich the spiritual life of Muslims and even non-Muslims to this day.

That unique orchestrator of the music of the heavens and revealer of the Divine Mysteries in the language of the angels, Jalāl al-Dīn Rūmī, was born in Balkh on the 6th of Rabī' al-awwal 604 A.H. corresponding to the 30th of September, 1207. His proper name was Muḥammad, his title Jalāl al-Dīn and later 'Khudāwandagār' or 'lord'. In poetry he used the pen-name 'Khāmūsh' (meaning 'silent') and from the ninth/fifteenth century came to be known as Mawlawī, the term deriving from his earlier title of Mullā-yi Rūm, 'the learned master of Anatolia'. His disciples such as Aḥmad Aflākī, called him 'The Greatest Mystery of God' (*sirr Allāh al-a'ẓam*), while the Persian speaking world usually refers to him as Mawlānā. In the West, where his fame has spread steadily since the last century, he is usually known as Rūmī, Rum referring to Asia Minor where he spent most of his life.[2]

Jalāl al-Dīn was born in a major centre of Persian culture, Balkh, from Persian speaking parents and was the product of

that Islamic Persian culture which in the seventh/thirteenth century dominated the whole of the eastern lands of Islam and to which present day Persians as well as Turks, Afghans, Central Asian Muslims and the Muslims of the Indo-Pakistani subcontinent are heir. And it is precisely in this world that the sun of his spiritual legacy has shone most brilliantly during the past seven centuries.

The father of Jalāl al-Dīn, Muḥammad ibn Ḥusayn Khaṭībī, known as Bahā' al-Dīn Walad and entitled Sulṭān al-'ulamā', was an outstanding Sufi in Balkh connected to the spiritual lineage of Najm al-Dīn Kubrā. He is the author of the *Ma'ārif*, a masterpiece of Sufism which left its indelible mark upon Rūmī's *Mathnawī*³ It was in the bosom of a family devoted to learning and imbued with spirituality that Jalāl al-Dīn was born and where he received his earliest education. And it was in the company of his father that Rūmī left his city of birth forever when he was about twelve or thirteen years old.

It is not known with certainty why Bahā' al-Dīn Walad left the eastern provinces of Persia and moved westward. Two reasons have been put forward: the Mongol invasion and internal political pressures. Some historians defend the thesis that Muḥammad Khwārazmshāh, the powerful ruler of Balkh and other regions of Khurasan at that time, was opposed to the Kubrawiyyah Order to which Bahā' al-Dīn Walad belonged and that he was encouraged in his opposition to the Sufis by the well-known theologian Fakhr al-Dīn Rāzī who is known to have spoken against the Kubrawiyyah. Others have mentioned the imminent danger of the Mongol onslaught which forced Bahā' al-Dīn Walad to flee westward. Although it is difficult to determine definitely which of the two theses is historically true, we believe that the danger of the Mongol invasion was a more likely cause considering that Bahā' al-Dīn was highly revered in Balkh at the time of his departure and probably could have remained in the city even if some internal pressure were put on him.

Be it as it may, it was in the design of Providence to save Jalāl al-Dīn from the immense destruction that Balkh and other cities of Khurasan were soon to face. Bahā' al-Dīn Walad set out with his whole family and a group of disciples towards the

West probably some time around 617/1220–1. It is said that in Nayshapur he met the renowned Farīd al-Dīn 'Aṭṭār, who was already a celebrated poet and saint, and presented Jalāl al-Dīn to him. In the words of Dawlatshāh, 'Aṭṭār 'came to visit Mawlānā Bahā' al-Dīn. At that time Mawlānā Jalāl al-Dīn was small. Shaykh 'Aṭṭār presented his *Asrār-nāmah* to Mawlānā Jalāl al-Dīn as a gift and told Mawlānā Bahā' al-Dīn, "soon this son of thine will set the spiritual aspirants of this world afire".'[4] There is no reason to doubt that such a meeting did take place. There is certainly a direct spiritual link between 'Aṭṭār and Rūmī, and more particularly the *Asrār-nāmah* was always held dear to Rūmī who made use of several of its stories in his *Mathnawī*.

From Nayshapur Bahā' al-Dīn Walad and his entourage set out for Baghdad, where they were held in high esteem, and met many of the scholars and Sufis of the city; from there they went to the Hejaz and performed the pilgrimage to Mecca. It was after this journey that most likely as a result of the invitation of 'Alā' al-Dīn Kayqubād, the ruler of Anatolia, Bahā' al-Dīn came to Asia Minor and finally settled in Qonya, a city associated with his family to this day.

The family of Bahā' al-Dīn Walad was welcomed warmly in Qonya, which was witness at this time to many immigrants from the eastern cities of Persia, since Anatolia offered a rare haven of peace and tranquility in the Islamic world during the turbulent years of the Mongol invasion. Bahā' al-Dīn rapidly gained fame as a religious scholar and Sufi and died with honour when Jalāl al-Dīn was 24 years of age.

Strangely enough although Jalāl al-Dīn was close to his father it was mostly in the exoteric sciences that his father had served him as a teacher. In fact, upon the death of his father Jalāl al-Dīn succeeded him as religious authority giving opinions (*fatwās*) on questions pertaining to the *Sharī'ah*. For a full year he devoted himself to this function until he met Burhān al-Dīn Muḥaqqiq Tirmidhī, a Sufi master of high quality who was himself a disciple of Bahā' al-Dīn Walad. It was through Burhān al-Dīn that Rūmī inherited the spiritual legacy of his father and became initiated into the mysteries of Sufism. For nine years Rūmī practiced Sufism as a disciple of

Burhān al-Dīn until the latter died in 638/1240–1. During this period Rūmī also continued to study the formal religious sciences in the Ḥalāwiyyah school in Aleppo until he became a perfect master in such disciplines as Quranic commentary, sciences of *Ḥadīth*, jurisprudence, theology, and even philosophy. Rūmī is one of those Sufi masters who was an authority in both the exoteric and the esoteric sciences and had mastered all the traditional sciences before transcending them in that supreme knowledge which means also union and which obliterates the traces of all knowledge that is derived from the separation of subject and object. During this period Rūmī also travelled to Damascus and is said to have spent some four years in this city which he knew well.[5]

Having become a master of both the *Sharī'ite* sciences and Sufism, Rūmī established a circle around him in Qonya and from 638/1240–1 to 642/1244–5 was occupied with teaching the religious sciences. It is said that he was a popular teacher and that as many as four hundred students attended his formal classes. Most likely, at this time, he also taught the esoteric sciences to a smaller circle of adepts for already he was an accomplished Sufi.

In 642/1244–5 the life of Rūmī was transformed through his encounter with that mysterious and powerful figure Shams al-Dīn Tabrīzī who had entered Qonya that year after spending some time in Baghdad where he had also met Awḥad al-Dīn Kirmānī, another of the outstanding Sufi poets of that remarkable age of saints and sages. The life of Shams is indeed shrouded in mystery. There is no doubt that there was such a human being although he appears in the writings of Rūmī as both a person and a spiritual function.[6] This man who was at once a learned Sufi, the author of the moving *Maqālāt*[7] and a wild *qalandar* who shunned any social connections, appeared like a sudden meteor in the heavens and disappeared with the same rapidity with which he had illuminated the sky of Rūmī's life. Even his death remains a mystery and he has several tombs which have remained sites of pilgrimage to this day.

There is no doubt that Shams al-Dīn Tabrīzī was not just a Sufi master for Rūmī. Jalāl al-Dīn had already practiced Sufism for many years before meeting Shams al-Dīn. It seems,

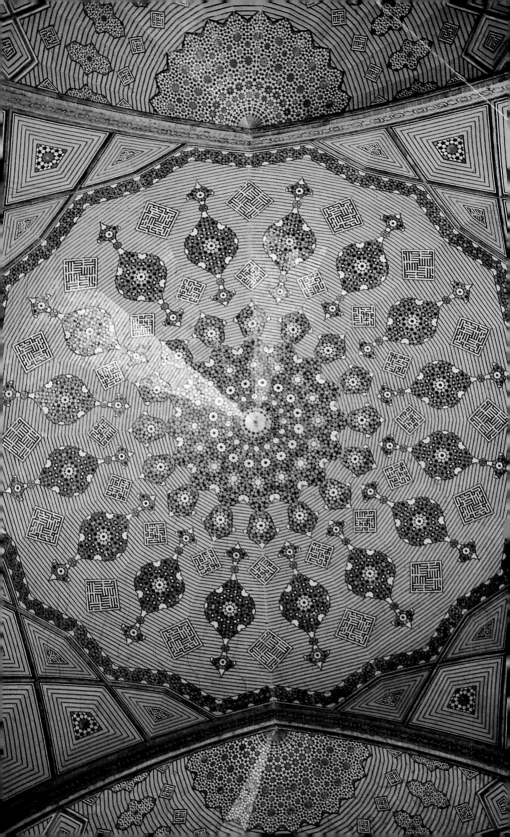

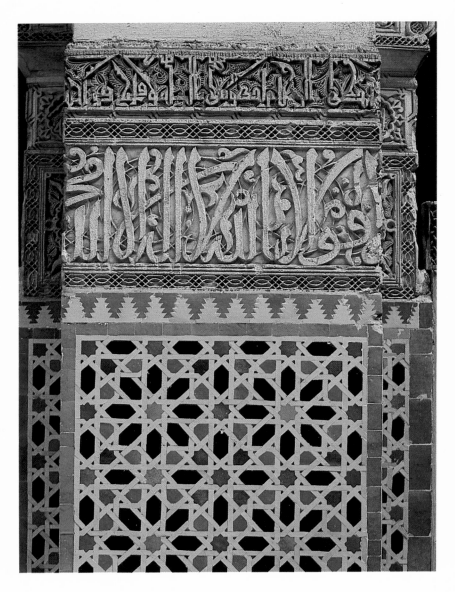

The traditional Islamic city reminds its dwellers at every turn of the presence of God and His Word as shown in this calligraphic frieze above ceramic patterned tiles from the 'Aṭṭārīn *madrasah* in Fez.

PREVIOUS PAGE The dome of a mosque is the symbol of the dome of Heaven. Here, under the cupola of the Chahār bāgh *madrasah*, one of the major monuments of Safavid Isfahan, one gains a sense of multiplicity issuing from Unity and the order in the cosmos which results from the metaphysical truth that all comes from the One and returns to Him.

rather, that Shams al-Dīn was a divinely sent spiritual influence which in a sense 'exteriorized' Rūmī's inner contemplative states in the form of poetry and set the ocean of his being into a motion which resulted in vast waves that transformed the history of Persian literature. One can say that Rūmī was the type of Sufi who needed spiritual companionship in order to express himself in words. The companionship provided by Shams al-Dīn was so powerful that it tranformed a sober teacher into an ecstatic poet bringing into actuality the poetic creativity within Rūmī's being. The first poem ever written by Rūmī is in a letter to Shams; and from the time of their encounter until Rūmī's death, the latter never ceased to compose poetry. There developed such a profound bond between the two that its effect upon Rūmī survived the disappearance of Shams. The spiritual friendship between these two towering figures is rare in the history of Sufism and has become proverbial in the East.

Harassed by some of the disciples who had become jealous of the fact that Jalāl al-Dīn spent all of his time with Shams, the latter left Qonya in 643/1245–6. Rūmī became so distressed that he sent him many letters and messages containing his first poems in Persian and Arabic and finally, having discovered that Shams was in Damascus, sent his own son Sulṭān Walad after him. Shams finally decided to return to Qonya, which he did in 644/1246–7, but after a short stay disappeared again, this time permanently. Jalāl al-Dīn searched two years for him and came to Damascus himself but to no avail. Shams al-Dīn had disappeared leaving Rūmī with the *shams*, or sun, of gnosis that shone at the centre of his heart. Rūmī returned to Qonya, began his open instruction of Sufism, and devised the spiritual dance (*samā'*) for which the Mawlawī order has been famous for the past seven centuries.

The rest of Jalāl al-Dīn's life from 647/1249–50 to 672/1273 was the period of dissemination of Sufism and the esoteric sciences related to it. He trained numerous disciples, some of whom like Salāḥ al-Dīn Zarkūb Qunyawī and Ḥusām al-Dīn Chalabī were themselves spiritual guides. The former was a simple goldsmith but of an exalted spiritual state who died in 657/1254 and was buried, according to his own will, to the

accompaniment of Sufi music. The latter was from Urmia, his father being a master of one of the orders of chivalry (*fatuwwah*). Ḥusām al-Dīn played the same role for Rūmī in the *Mathnawī* as Shams had done for him in the *Dīwān*. In the same way that Shams was the external cause for the composition of the *Dīwān-i Shams-i Tabrīzī* named after him, Ḥusām al-Dīn acted as the pole which attracted and brought into being that immense rhapsody of mystical poetry which is the *Mathnawī*.

In the month of Jumāda'l-ukhrā 672/December 1273, Jalāl al-Dīn fell ill. He knew that the moment of encounter with the Beloved was near, a moment which for him could not but be the most joyous moment of life. He predicted his own death and composed the well-known *ghazal* which begins with the verse:

چه دانـی تو که در باطـن چه شاهـی هم‌نـشین دارم رخ زرین من منگـر که پای آهنین دارم

*How doest thou know what sort of king I have
within me as companion?
Do not cast thy glance upon my golden face, for I have
iron legs.*

He died on the 5th of Jumāda 'l-ukhrā 672/16th of December 1273, in a state of joy and peace surrounded by his spiritual progeny, which also included his closest family. Ṣadr al-Dīn Qunyawī, the other great master of Sufism in Qonya at that time, read the prayer of the dead before the body and the earthly remains of the greatest Sufi poet of the Persian language was laid to rest in Qonya. His tomb remains one of the most important sites of pilgrimage in the Islamic world, a second Ka'bah for the Sufis and the spiritual centre of Turkey.

The writings of Rūmī are unique in the annals of Persian literature because of both their quality and the immense richness they possess. His achievement was never surpassed, being like a sea into which many rivers flowed and which was itself the source of innumerable tributaries. His works reflect nearly all earlier works of Islamic masters from Quranic commentaries to the Sufi treatises of Sanā'ī, 'Aṭṭār and Ibn 'Arabī. His writings

have found their echo in countless works written from Bengal to present day Turkey over the seven centuries that have passed since his death.

The most voluminous work of Rūmī is the *Dīwān-i Shams-i Tabrīzī* consisting of some thirty-six thousand verses of mostly *ghazals* in which Rūmī uses the name of Shams al-Dīn at the end instead of his own, as if Shams had written them. This fact displays the special relation that existed between the two men and the role that Shams played in the composition of this vast work. Most of these verses were written in the state of ecstasy and have a musical and rhythmic quality that is unique in Persian literature. The dance and music of the *Mawlawī* Order is in a sense crystallized in these verses of unmatched ecstatic power. The meaning dominates the form to such an extent that in many instances the *ghazals* break the laws of traditional prosody and metrics. It is a case of the spirit remoulding its material form and breathing into the formal order a new life, thereby creating a new yet totally traditional artistic form. This transformation from within is in sharp contrast to the breaking of forms from 'below' in modern poetry to which we have already alluded.

Since its composition the *Dīwān* has been celebrated throughout the eastern lands of Islam and several lithographed editions of it were printed in both India and Persia before a critical edition appeared under the care of B. Forouzanfar in ten volumes in Tehran.[8] It is also partially known in the West thanks to the selections translated by Nicholson, Arberry, and W. Chittick.[9] Much of its vast riches, however, continues to be inaccessible to those without a knowledge of Persian, and there remains the need to translate the whole into English. The musical and alchemical aspects of this symphony will, however, remain forever untranslatable. The *Dīwān-i Shams*, along with the *Dīwān* of Ḥāfiẓ, is perhaps the work that lends itself least to translation from the point of view of the orchestration of words and the harmony of sounds and the effect that its very rendition creates in the soul of a Persian speaker.

Rūmī's most famous work is without doubt the *Mathnawī*, that 'Quran of the Persian language' as Jāmī called it, which is indeed a vast esoteric commentary upon the Quran and

which was composed at the request of Ḥusām al-Dīn Chalabī, who asked the master to write a work on the mysteries of gnosis upon the model of the *Ḥadīqah* of Sanā'ī, a vast Sufi poem making use of many Quranic stories and themes, or the *Manṭiq al-ṭayr* of 'Aṭṭār. The *Mathnawī* is so celebrated that although the term means literally any poem consisting of rhyming couplets, it has come to mean the *Mathnawī* of Jalāl al-Dīn Rūmī. This unmatched masterpiece of Sufism is more didactic than the *Dīwān*. It consists of a preludium in Arabic or Persian for each volume, in the first of which the author calls his work the 'principles of the principles of the principles of religion' followed by six volumes of poems in Persian. It was begun between 657/ 1259 and 660/1262–3 and its composition continued to nearly the end of Rūmī's life. In fact it was never completed. Some have spoken of the seventh book of the *Mathnawī* and have even tried to 'complete' the work with a seventh volume, but the original work of the master is without doubt in six volumes, which have been published many times in Persia, India, and Turkey with the most critical edition to date being that established by Nicholson in his monumental eight volume text, translation, and commentary upon the work.[10]

In nearly twenty-six thousand verses of poetry, Rūmī unravels in the *Mathnawī* the vast ocean of the world of the spirit and man's journey to and through that world. Drawing from sacred history, simple tales, earlier Sufi writings, learned discourses of predecessors, lives of saints and many other sources, Rūmī discusses nearly every aspect of Islamic metaphysics, cosmology and traditional psychology, oscillating between the doctrinal and the initiatic points of view, that is between an objective presentation of the truth and the presentation of the subjective and operative aspects involved in the attainment of that truth. Few mystical works in any language combine such mastery of pure metaphysics with insight into the intricate structure of the human soul, the pitfalls which face the man who awakens through initiation to his own spiritual possibilities and who begins the journey towards the One.[11]

The third poetical work of Rūmī is the *Rubā'iyyāt*, whose Istanbul edition of 1312 (A.H. lunar) consists of 3318 verses,

most of which are probably by Rūmī.[12] Some of these quatrains are masterpieces matching the powerful verses of the *Dīwān* and the *Mathnawī*, but altogether the *Rubāʿiyyāt* has never gained the fame of Rūmī's other two poetical masterpieces. This work has again been made know to the English-speaking world thanks to the translation of a selection by Arberry.[13]

Of the prose works of Rūmī the most important is undoubtedly the *Fīhi mā fīhi*, literally 'In it what is in it', now usually referred to in English as *The Discourses*, a unique work reflecting Rūmī's most intimate discourses on various aspects of the spiritual life and assembled by his son and other disciples from his 'table talks' during Sufi gatherings. This work, whose critical edition appeared first under the care of B. Forouzanfar[14] and which is now well-known in the West thanks again to the selective translation of Arberry,[15] discusses with candour and in an intimate and direct manner many of the most subtle aspects of Sufism. It is a precious companion and practical guide to the 'Way' and reveals an aspect of Rūmī's personality not reflected so directly in his poetical works.

Closely related in content to *Fīhī mā fīhi* is the *Makātīb* or collection of letters of Rūmī written to his close associates such as Ṣalāḥ al-Dīn Zarkūb and his own daughter-in-law.[16] The letters, like the discourses in *Fīhī mā fīhi*, reveal the more personal and intimate aspects of the master's life, containing advice to disciples and even recommendations to various authorities on behalf of disciples while at the same time containing doctrinal passages and instruction concerning the practical aspects of the 'Way'.

Finally, one must mention the *Majālis-i sabʿah*, another prose work, which consists of a number of Rūmī's sermons and lectures delivered from the pulpit.[17] The sermons are mostly in the form of advice and counsel and reflect in style the background in which they were delivered.

These works are the written legacy of the 'master from Rum'. They complement the oral transmission and the particular type of grace or *barakah* which issued from the being of Rūmī and resulted in the foundation of the Mawlawī Order, that vastly extended Sufi order which still survives. Jalāl al-Dīn has remained alive through his works and his order to our own

times and his spirit continues to resurrect those who are capable of following the spiritual life and, on a more popular level, to intensify the religious fervour of those Muslims who live the life of faith. It is also said that Rūmī is one of those rare Sufi saints who can even mysteriously 'guide' certain people spiritually now, although he is no longer living. His works remain among the most outstanding and influential in all Islamic literature, and his teachings reflect the deepest aspects of Islamic spirituality. His message issues from the world of the Spirit and is as pertinent today as when it was first spoken, for his words come from a world which neither perishes nor withers away, which is ancient while being young and young while being ancient, a world which encompasses man in his journey from eternity to eternity.

PART II:
SOME REFLECTIONS ON RŪMĪ'S TEACHINGS

It is hardly possible to fit the ideas of Rūmī into a closed system and to give a systematic exposition of a metaphysical and initiatic teaching which, like the ocean, contains nearly everything and knows no limits or bounds.

گر بریزی بحـر را در کوزهای چنـد گنـجـد قسـمـت یك روزهای

If thou pour the sea into a pitcher,
One day's store, how much will it hold?[18]

There is hardly an important religious and spiritual subject of either a doctrinal or an operative nature with which Rūmī has not dealt in one way or another in his writings; hence, the *Mathnawi* is often called *daryā-yi ma'rifat*. But the treatment of these subjects has not been categorized in an orderly manner in any of his writings, even in the *Mathnawī*. This is in contrast to both the practical handbooks of Sufism such as *al-Risālat al-qushayriyyah* of Imām al-Qushayrī and the *Kitāb al-luma'* of Abū Naṣr al-Sarrāj and such doctrinal treatises as the *Fuṣūṣ al-ḥikam* of Ibn 'Arabī and *al-Insān al-kāmil* of 'Abd al-Karīm

al-Jīlī. Yet the *Mathnawī* partakes of the nature of both types of works. Also, although no outward orderly treatment of subject matter as found in the above mentioned treatises is to be detected in the *Mathnawī*, there is an inner harmony and structure which weaves the parts of the work together. The structure of Rūmī's didactic masterpiece is much like the Quran of which it is an esoteric commentary. Emulating the form of the Holy Book on the level of human inspiration, Rūmī interlaces stories and parables with direct formulations of Sufi doctrine and practice in such a way as to encompass the whole of human existence and all the different problems and obstacles that man faces in his quest after the Truth—a quest which also means a journey through the labyrinth of his own soul to its luminous Centre.

What made such a universal expression of the initiatic life and way possible was Rūmī's exalted spiritual station (*maqām*) combined with his remarkable knowledge of the whole of the Islamic tradition which preceded him, especially its religious and metaphysical aspects.[19] He was a master in the Islamic sciences such as jurisprudence (*fiqh*), tradition (*Ḥadīth*), and especially Quranic commentary. He must in fact be ranked among the foremost of Quranic commentators (*mufassirīn*). He was also thoroughly acquainted with various schools of theology (*kalām*) such as the Ashʻarite and the Muʻtazilite and refers often to such theologians as Fakhr al-Dīn al-Rāzī in his works. His own writings have been interpreted by some as masterpieces of Islamic theology,[20] although they are properly speaking metaphysical and initiatic rather than theological.

As far as the Sufi tradition is concerned, the writings of Rūmī, especially the two poetical masterpieces, the *Mathnāwī* and the *Dīwān*, are related in form and content to four types of Sufi writing: the practical treatises of early Sufism, Sufi hagiography, later doctrinal works and Persian Sufi poetry. Rūmī's writings contain major portions devoted to the description of the spiritual states and stations (*aḥwāl* and *maqāmāt*)[21] and practical advice about the spiritual journey. In this aspect the writings of Rūmī can be said to follow the path of such early masters of Sufism as al-Qushayrī, al-Makkī, al-Sarrāj, and Hujwīrī.

Other works of Rūmī, especially the *Mathnawī*, draw from

early biographies of saints, from the *Ḥilyat al-awliyā'* of Abū Nu'aym to the *Tadhkirat al-awliyā'* of 'Aṭṭār as well as from biographies of prophets and men of religion in general. The Quran itself has also served as a major source of inspiration in those sections dealing with sacred history and more particularly the history of the prophets. Rūmī draws from the lives of prophets and saints and from the episodes of sacred history not to describe the past, but to bring to light a spiritual struggle which continues within the souls of men here and now. The soul of man becomes the arena in which prophets and saints as well as Satan and his armies, each related to a force and an agent within man's own being, act out the drama of deliverance and sanctification.

Yet other sections of Rūmī's writings, especially the *Mathnawī*, are purely didactic and doctrinal, and in them Rūmī appears as the metaphysician and gnostic who describes the verities of gnosis in a 'theoretical' language. This aspect of Rūmī is closely akin to the works of al-Ghazzālī, 'Ayn al-Quḍāt Hamadānī, and especially Ibn 'Arabī, although as already mentioned Rūmī did not write a systematic metaphysical exposition. Still, he remains one of the greatest masters of Islamic gnosis and a peerless metaphysician who was able to express the most sublime truths in the most concrete and simple language.[22]

Finally it must be recalled that Rūmī follows directly upon the line of the greatest Persian Sufi poets, from Bābā Ṭāhir and Abū Sa'īd, who composed simple quatrains, to Sanā'ī and 'Aṭṭār, who brought Persian Sufi poetry to its maturity. The *Ḥadīqat al-ḥaqā'iq*, that rich but difficult and rather neglected masterpiece of Sanā'ī, as well as the *Manṭiq al-ṭayr* and *Asrārnāmah* of 'Aṭṭār and other works of the master from Nayshapur, must be studied as the immediate predecessors of the *Mathnawī* and the *Dīwān*. On the level of form the *Khamsah* of Niẓāmī is also of great significance as the predecessor of the *Mathnawī*. It is as if Rūmī breathed the spirit of Sufism into the beautiful body whose tissues were woven from so many threads by the poetic genius of Niẓāmī. Rūmī drew from all these sources in composing the vast synthesis of Sufism which is contained in his works.

What made the masterpieces of Rūmī possible, however, was not simply the reading of earlier works or historical borrowing. It was the illuminated soul and intellect of Rūmī combined with his poetic genius which were able to create such masterpieces of Sufi literature. By soaring across the vast horizons of Islamic esotericism and breathing a fresh spirit into the existing material, Rūmī created a new work of art in the most profound sense of the word 'creation', for the creative act is one which can only take place in its deepest sense in a traditional context where the artist has access to the world of the Spirit and where the most perfect artist is also the person with the highest degree of sanctity.

As one who was at once a saint and artist of unusual grandeur and universality, Rūmī was particularly sensitive to the spiritual efficacy of beauty, that 'splendor of the Truth' which for him was always the gateway to the inner courtyard of the Divine Mysteries. Rūmī saw beauty as the direct imprint of the Divine in this world of generation and corruption and the most immediate means of awakening in man the consciousness and awareness of the spiritual world. He saw in beauty the direct proof of God and His infinite Mercy and Power. One could say that for Rūmī the proof of the existence of God could be summarized in the statement, 'there is beauty, therefore God is'. Moreover, Rūmī saw beauty everywhere, in virgin nature, in the being of man, and in art. But it was most of all in poetry, music, and the sacred dance that Rūmī made use of the beauty of forms to reach the Formless.

Although not a poet by profession, Rūmī became a poet of unrivalled dimensions and grandeur after his encounter with Shams al-Dīn Tabrīzī. From that moment until the last days of his life, Rūmī poured forth the profoundest metaphysical truths into the mould of poetry and created some of the most beautiful verses of Persian poetry, even if, unlike some of the other masters of this language, he paid more attention to meaning than to form. Many verses, especially in the *Dīwān*, induce a state of ecstasy in the trained listener by the sheer beauty of their imagery and their rhymes and rhythms.

Rūmī also combined his poetical compositions with music and made of music a basic aspect of the spiritual gatherings

of the Sufi order founded by him. Of course, as we shall discuss in the following chapter, music has always been important in Sufism, and earlier Sufis such as al-Ghazzālī had already written extensively on this subject.[23] Sufism had made use of music both in the form of simple drumbeats and in more complicated compositions in which several instruments were used; and this continues to be the case to this day. But Rūmī placed particular emphasis upon the role of music as an aid and support for spiritual realization and made of music an integral part of the practices of the Mawlawī order. In his *Mathnawī* and *Dīwān* are to be found some of the most profound discussions of the spiritual significance of music. For Rūmī, man himself is an instrument in the hands of God, and his existence is the music issuing forth from this instrument. As Rūmī says,

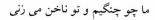

We are like the lyre, that Thou pluckest.

Likewise the sacred dance, the moving of the body in accordance with the inner rhythms and transformations of the soul, exists in nearly every Sufi order. But Rūmī again made of it a basic feature of the gatherings (*majālis*) of the Mawlawī Order to the extent that this Order has become known in the West as the Order of whirling dervishes. It is said that when Shams al-Dīn Tabrīzī disappeared from Rūmī's life, he began to dance in order to express his nostalgia for the Divine of which Shams was a direct theophany. The Mawlawī dance begins with the nostalgia for the Divine but develops into a gradual opening up towards the grace of Heaven, finally resulting in annihilation (*fanā'*) and absorption in the Truth.[24] Through this dance man journeys from the periphery to the Centre which is at once the Centre of the Universe and the Centre of man's own being. The dance also 'actualizes' the spirit in the body, making the body the temple of the spirit and a positive element in that spiritual alchemy which certain masters have described as the 'spiritualization of the body and the corporealization of the spirit'.

The whole of Rūmī's message can be interpreted through

the key which he provides himself in the distinction he makes between form (*ṣūrat*)[25] and meaning (*ma'nā*). According to Rūmī everything in the world of manifestation has a form and a meaning which is another way of describing the two aspects of exterior (*ẓāhir*) and interior (*bāṭin*) so characteristic of the esoteric teachings of Islam whether it be in Sufism or Shi'ism. No reality is exhausted by its appearance. Appearance is a manifestation of something, of an essence which is its *ma'nā*. Nothing can ever be fully understood if one remains on the level of *ṣūrat* and is oblivious to *ma'nā*. To understand the world of nature, of man, or of revelation, man must penetrate into the *ma'nā* of things in the manner of Rūmī himself, who was able to expound the Truth by having recourse to almost everything from simple actions of men or even animals to the most sublime passages from the Quran.[26]

It is by making this distinction between *ṣūrat* and *ma'nā* that Rūmī is able to offer a hermeneutical interpretation of all of reality, of both the 'cosmic Quran' and the 'revealed Quran'[27] and to unveil the transcendent unity of being and of religions. Jalāl al-Dīn is, along with Ibn 'Arabī, perhaps the foremost expositor of the transcendent unity of religions[28] in the annals of Sufism as well as one of the grand expositors of the cardinal doctrine of the unity of being (*waḥdat al-wujūd*). He has also expounded the most profound doctrines of cosmology, psychology and anthropology, as well as the philosophy of art, by having recourse to the distinction between *ṣūrat* and *ma'nā* and making use of *ṣūrat* or form not as a thing in itself but as a symbol which leads to *ma'nā*. For Rūmī, as for all contemplatives and gnostics, nothing is just itself except the Divine Self (*al-Dhāt*). Everything else is a symbol of the states that lie above it in the chain of being. For Rūmī all things are symbols revealing the spiritual worlds above; all forms are symbols which in his eyes, as in the eyes of all gnostics, become transparent, revealing the 'meaning' beyond.

Rūmī makes use of many types of symbolism drawn from numerous traditional sources. To understand fully the *Mathnawī* and the *Dīwān*, one must know the symbolism of the language of the Quran, of various traditional sciences ranging from the numerical symbolism of letters (*jafr*) to alchemy, as

well as various traditional cosmologies and the like. The rich-
ness of the symbolism employed by Rūmī corresponds to the
vastness of the spiritual vision he possessed and the universality
of his perspective. Through his magic pen the ṣūrat of nearly
every facet of human experience and science becomes the key
with which to open the door to the world of ma'nā. Rūmī was
able to create works that have become the life and soul of Per-
sian literature. May men succeed more than ever before in
benefiting from his message today when they are most in need
of it. Rūmī's message and his presence are a gift from Heaven
and a sign of Divine Mercy which remains accessible to men
whenever and wherever they are willing to open themselves
to its revivifying rays and to conform themselves to its immut-
able norms.

NOTES

1. Translation our own. See also, R. A. Nicholson, *Rumi, Poet and Mystic*, 1207–
1273, London, 1950, p. 32, where another rendition is given in English poetry.
2. For an account of the life of Rumi see B. Forouzanfar, *Risālah dar taḥqīq-i aḥwāl
wa zindigī-yi Mawlānā Jalāl al-Dīn Muḥammad mashhūr bi Mawlawī*, Tehran, 1315 (A.H.
solar); Aflākī, *Manāqib al-'ārifīn*, ed. by T. Yazici, 2 vols., Ankara, 1959–61, (trans.
by C. Huart as *Les Saints des derviches-tourneurs*, Paris, 2 vols., 1918–22); J. Homā'ī,
introduction to his *Tafsīr Mathnawī-yi Mawlawī*, *Dāstān-i qal 'ah-yi dizh al-ṣuwar yā
dizh-i hūsh-rubā*, Tehran, 1349; H. Ritter, 'Philologika XI: Maulānā Ǧalaluddīn Rūmī
und sein Kreis'', *Der Islam*, 1940, pp. 116–58 and 1942, pp. 221–49; introduction
of R. A. Nicholson, to his edition and translation of the *Mathnawī*, London, 1925–40;
M. Harry, *Djelale-Ddine Roumi, poète et danseur mystique*, Paris, 1947; E. Meyerovitch,
Mystique et poésie en Islam: Djalāl-ud Dīn Rūmī et l'ordre des derviches tourneurs, Paris,
1972; and A. M. Schimmel, *The Triumphal Sun: A Study of the Works of Jalaloddin Rumi*,
The Hague, 1978.
3. Many traditional sources mention that Rūmī descended from Abū Bakr, the
first caliph, on the father's side and from the royal family of the Khwārazmshāhīds
on the maternal side.
4. Dawlatshāh, *Tadhkirah*, Leiden, 1901, p. 193. Also quoted in Forouzanfar, *op.
cit.* p. 17.
5. Some sources have spoken of Rūmī's meeting with Ibn 'Arabī, who also lived
and died in Damascus. This, however, is not easy to substantiate historically. There
is no doubt, however, that these two towering masters of Sufism certainly 'met' in
the invisible world (*'ālam al-ghayb*) even if they never met in the flesh. The relation
between Ibn 'Arabī and Rūmī is a complex one deserving of extensive study.
6. See Chapter VIII of the present work.
7. Concerning Shams see Forouzanfar, *op. cit.*, chapter III; also the introduction
of Khushniwīs to his own edition of the *Maqālāt*, Tehran, 1349, (A.H. solar).
8. See Rūmī, *Kulliyyāt-i Shams*, ed. by B. Forouzanfar, Tehran, 10 vols, 1336–46,
of which the first seven volumes contain the *Dīwān*.
9. See R. A. Nicholson, *Selected Poems from the Divani Shamsi Tabriz*, Cambridge,
1898; A. J. Arberry, *Mystical Poems of Rumi*, Chicago, 1968; and W. Chittick, *The

Sufi Path of Love—The Spiritual Teachings of Rumi, Albany, 1983. This last work, which is a major study on Rūmī and the only one in a European language in which the master himself is allowed to speak through exact and meticulous translations of his words concerning various essential aspects of religion and the spiritual life, contains many *ghazals* from the *Dīwān* not available in the well-known Nicholson and Arberry translations.

10. See R. A. Nicholson, *The Mathnawī*, London, 1925–40, new edition, London 1982. The 'Alā' al-Dawlah and the Kulāla-yi Khāwar editions of Tehran are also valuable and trustworthy although not with the same degree of accuracy as the edition of Nicholson. There is still room for a new critical edition which would correct some of the inaccurate readings of Nicholson.

11. The *Mathnawī* is also well-known to the Western world thanks to the indefatigable efforts of Nicholson, who made the whole text available in English and also presented selections of it in a highly readable form. See R. A. Nicholson, *Rumi, Poet and Mystic*. Before Nicholson several other British scholars including Sir William Jones, E. H. Whinfield, J. Redhouse, and C. E. Wilson had rendered various parts of the *Mathnawī* into English. See especially Whinfield, *Masnavī-i ma'navī*, London, 1898. Students of the *Mathnawī* are also indebted to Arberry for his masterly translations of the stories of that book in lucid prose (see his *Tales from the Masnavi*, London, 1968), as well as other studies of the text.

The *Mathnawī* has received continuous attention since its composition. Several special musical forms have come into being in Sindh, Persia, Turkey and other regions simply for the chanting of the *Mathnawī* and numerous commentaries have been composed upon it in Persian, Turkish, Arabic and some of the languages of the Indo-Pakistani sub-continent. Some of the best known of these commentaries include the commentary of Aḥmad Rūmī, *Jawāhir al-asrār*; of Kamāl al-Dīn Khwārazmī, *Asrār al-ghuyūb*; and the commentary of 'Abd al-'Alī Muḥammad known as *Baḥr al-'ulūm* all in Persian: *Fātiḥ al-abyāt* of Ismā'īl Anqurawī in Turkish: and *al-Minhaj al-qawiy* of Yūsuf ibn Aḥmad Rūmī in Arabic. There are also commentaries in Sindhi, Urdu and several other languages. Moreover, commentaries continue to be written on this work to this day as witnessed by the recent Persian works of such scholars as J. Homā'ī, *Tafsir-i Mathnawī-yi Mawlawī*; B. Forouzanfar, *Sharḥ-i Mathnawī-yi sharīf*, 3 vols., Tehran, 1346–8; and M. T. Ja'farī, *Tafsir wa naqd wa taḥlīl-i Mathnawī-yi Jalāl al-Dīn Balkhī*, Tehran, 1349, (A.H. solar) onward. Concerning the commentators upon the *Mathnawī* see A. Ḥakīmiyān, 'Shārihān wa muqallidān-i Mathnawī-yi ma'nawī' *Nigīn* vol. 9 no. 105, Bahman, 1353 (A.H. solar), pp. 41ff.

12. The *Rubā'iyyāt* of Rūmī has also been edited by B. Forouzanfar in his *Kulliyyāt-i Shams*, vol. 8. In this edition there are 3,966 verses.

13. Arberry, *The Rubā'īyāt of Jalāl al-Dīn Rūmī*, London, 1949.

14. *Fīhī mā fīhi*, ed. by B. Forouzanfar, Tehran, 1330 (A.H. solar).

15. A. J. Arberry, *Discourses of Rūmī*, London, 1961.

16. Ed. by H. Ahmed Remzi Akyurek and published by M. Nafiz Uzluk, Istanbul, 1937.

17. The text of the *Majālis* appears at the beginning of the Kulāla-yi Khāwar edition of the *Mathnawī*, Tehran, 1315–1319 (A.H. solar). The text was originally edited by H. Ahmed Remzi Akyurek and published by M. Nafiz Uzluk, Istanbul, 1937.

18. Trans. by R. A. Nicholson, *Mathnawī*, I, 20.

19. This theme will be dealt with more fully in the next chapter.

20. See M. Shibli Nu'mānī, *Sawāniḥ-i Mawlawī-yi Rūmī*, originally in Urdu, trans. into Persian by M. T. Fakhridā'ī-yi Gīlānī, Tehran, 1332 (A.H. solar).

21. On the states and stations in Sufism see S. H. Nasr, *Sufi Essays*, London, 1972, chapter V.

22. On Rūmī's metaphysical teachings see W. Chittick, *The Sufi Doctrine of Rumi: An Introduction*, Tehran, 1974.

23. In both his *Iḥyā' 'ulūm al-dīn* and *Kīmīyā-yi sa'ādat*, al-Ghazzālī devotes a separate section to the Sufi concert (*samā'*).

24. On the spiritual significance of the Sufi dance and music see J. L. Michon, 'Sacred Music and Dance in Islam', in the *World Spirituality: An Encyclopedic History of the Religious Quest*, Vol. xx, (in press).

25. It is important to repeat this basic fact that the use of the term *ṣūrat* in the context of Sufism must be clearly distinguished from its usage in philosophy where it corresponds to the Aristotelian *forma* and not to the external aspect of a thing.

26. Concerning Rūmī's use of *ṣūrat* and *ma'nā* in actual poems and in different contexts see Chittick, *op. cit.* pp. 15 and 61ff.

27. On the cosmic Quran (*al-Qur'ān al-takwīnī*) and the revealed Quran (*al-Qur'ān al-tadwīnī*) see S. H. Nasr. *Ideals and Realities of Islam*, London, 1971, chapter 11.

28. See F. Schuon, *The Transcendent Unity of Religions*.

VIII
Rūmī and the Sufi Tradition

Wine in ferment is a beggar suing for our ferment, Heaven in
revolution is a beggar suing for our consciousness.
Wine became intoxicated with us, not we with it;
the body came into being from us, not we from it.

(*Mathnawī*, I, 1811, trans. by Nicholson)

T
O UNDERSTAND more fully the significance of Rūmī as
a perfect example of the rapport between Islamic art and
spirituality in the domain of literature, it is necessary to
consider him not only in his own majestic personality, but also
in relation to the tree of the Sufi tradition of which he was one
of the most dazzling flowers. The elucidation of this relationship
will not only illustrate the rapport between literature and
spirituality as it pertains to the whole of Sufism rather than
to the few figures with whom we are dealing in this book, but
will also make far easier the comprehension of some of the
pertinent features of Rūmī's message either not mentioned or
not sufficiently elaborated in the last chapter. A further study
of Rūmī, concentrating upon him rather than upon certain
other major figures of Persian literature—Ḥāfiz, Shabistarī, and
Jāmī, for instance, in whom the union between art and spiritu-
ality is also to be observed to an eminent degree—is neces-
sitated by the fact that Rūmī marks the peak of mystical poetry
in Islam and is fast becoming one of the major figures to whom
those in the contemporary world in search of traditional truth,
and what the contemporary traditionalist school calls the
philosophia perennis, are turning.[1]

Rūmī is indeed a major peak in the tradition of Sufism, but
like every peak which is related to a mountain chain of which

133

it is a part, Rūmī is inextricably linked to that tradition which, because of the sacred teachings and the grace (*barakah*) present within its spiritual means, was able to produce a saint and poet of this dimension. He appeared at a moment when six centuries of Islamic spirituality had already moulded a tradition of immense richness. And he lived during a century which was like a return to the spiritual intensity at the moment of genesis of Islam; a century which produced remarkable saints and sages throughout the Islamic world, from Ibn 'Arabī, who hailed from Andalusia, to Najm al-Dīn Kubrā from Samarqand. Rūmī came at the end of this period of immense spiritual activity and rejuvenation which shaped the subsequent spiritual history of the Islamic peoples.

By the time Rūmī appeared upon the stage of history, the Islamic tradition, of which Sufism is like the heart or marrow, had already crystallized into its classical form.[2] The various Islamic sciences from Quranic commentary to philosophy and theology had already produced their Fakhr al-Dīn al-Rāzīs, Ibn Sīnās, and Ghazzālīs while the major schemes of Islamic cosmology to which Rūmī often refers were already formulated. Sufism itself had also left its early period of relative silence and heroic asceticism to enter into the phase of eloquent expression of love and gnosis. The cycle of fear, love and knowledge (*makhāfah, maḥabbah* and *ma'rifah*) which is present in every religion and in a sense is to be seen within the Abrahamic tradition itself in the successive appearance of Judaism, Christianity, and Islam,[3] had already become manifest within the Sufi tradition. The early Mesopotamian ascetics had emphasized above all else that reverential fear before the Divine Majesty which is the origin of wisdom according to the famous prophetic saying (*ra's al-ḥikmah makhāfat Allāh* 'the origin of wisdom is the fear of God'), and which is itself the source of majesty and nobility within men. The era of these saints, such as Dā'ūd al-Anṭākī, who spoke of the fear of God, had in turn led to the period in which the love of God was openly expressed, most of all in exquisite poetry by such Sufi masters as al-Ḥallāj and Abū Sa'īd Abi'l-Khayr. And finally the explicit formulation of *ma'rifah* or gnosis, to a certain extent begun by al-Ghazzālī and 'Ayn al-Quḍāt Hamadānī, had reached its peak with Ibn

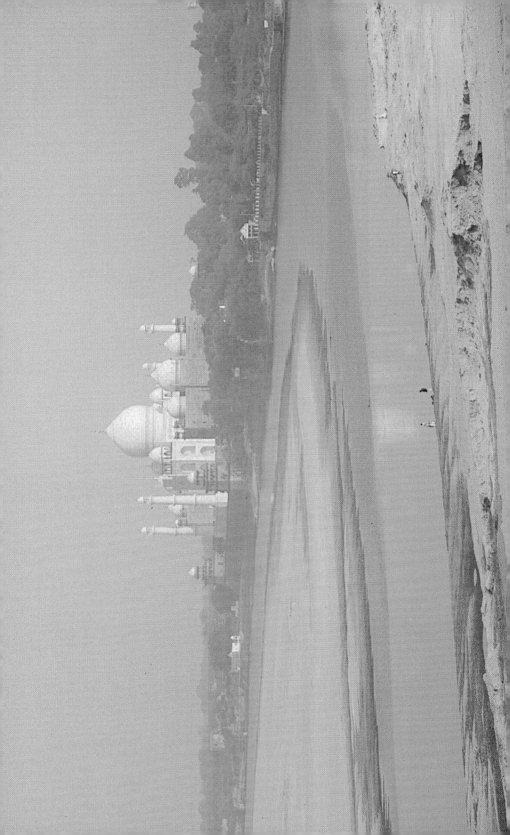

One of the earliest and most perfect works of Islamic architecture, the Dome of the Rock in Jerusalem displays that harmonious wedding between Heaven and earth, the circle and the square, and that stability, peace and immutability which characterize Islamic architecture as such. The Dome of the Rock is also of special significance for it was from its sacred ground that the Prophet's nocturnal ascent (*al-miʿrāj*) to the Divine Presence took place.

PREVIOUS PAGE The Taj Mahal represents a peak of Moghul Islamic architecture, its crystallic and pure geometric forms symbolizing directly the spiritual and intelligible world whose realities are reflected in such a blinding fashion in the geometric perfection and harmony of such masterpieces of Islamic architecture as the Taj Mahal.

'Arabī, that supreme master of Islamic gnosis whose formulation of Islamic metaphysics has dominated all later Sufism.[4]

Rūmī, who had undergone a long period of training, both formal and initiatic, was fully acquainted with the long tradition before him both in Sufism and in other Islamic sciences. He was deeply immersed in the Quranic sciences and the numerous Quranic commentaries that had come before him. Careful study of his works reveals not only the truth of his own assertion that his *Mathnawī* is a commentary upon the Quran but that even his *Dīwān* flows like a vast river which has come into being from the mountain springs of the Quranic revelation.[5]

Likewise, in the case of the *Ḥadīth* literature and the early sacred history of Islam, Rūmī shows his full mastery of his subject by repeatedly citing various traditions as the source for his doctrines and his inspiration. One of the most sublime and profound descriptions of the personality of the Prophet of Islam is to be found both in the *Mathnawī* and the *Dīwān*. If one were to assemble those parts of Rūmī's works which deal with the Blessed Prophet one would possess an incomparable spiritual biography, such as is sorely needed today especially in a European language.[6] Moreover, the stories connected with such patriarchs and prophets as Abraham, Solomon, David, Moses, Joseph and Christ as well as the Virgin Mary are interpreted esoterically to reveal the spiritual personality of these figures not only in history but also in the ever-living firmament through which the spiritual man journeys on his way to ultimate beatitude and union.

All of Rūmī's works are in the profoundest sense what he considers his own *Mathnawī* to be, namely, 'The principles of the principles of the principles of religion concerning the unveiling of the mysteries of union and certitude'.[7]

Rūmī was intimately associated with the Sufi tradition both through formal and external contact with earlier Sufi writings and as a result of the vastness of his own spiritual personality and the breadth of his spiritual experience, which in a sense embraced all that had come before him. He had already experienced and lived the reverential fear of a Dā'ūd al-Anṭākī, the

Divine Love of a Rābi'ah and the gnosis of an Ibn 'Arabī. In a sense he contained within himself the earlier Sufi tradition because he had lived and experienced the various spiritual possibilities inherent in Sufism within himself.

As far as the early Sufis are concerned, Rūmī was well acquainted with the spiritual personality of nearly all the well-known masters and must have made an intimate study of their writings and their biographies.[8] Moreover, he had an intimate inner knowledge of these figures which can only be the result of his vision of their celestial reality beyond their earthly form. The early saints of Islam, particularly Bāyazīd Basṭāmī, Ḥallāj, Dhu'l-Nūn al-Miṣrī, Ma'rūf Karkhī, and Abu'l-Ḥasan Kharraqānī, gain such transparency and shine with such luminosity in the *Dīwān* and the *Mathnawī* that one might say that through Rūmī they re-enter upon the stage of Islamic history. Like the prophets whom they follow, both in time and in the spiritual hierarchy, the saints of Sufism shine through the writings of Rūmī as so many living poles of spirituality, as so many living norms and prototypes which concern the seeker of the truth here and now. Even the concrete *barakah* of some of these earlier saints can be felt in various poetical utterances of Jalāl al-Dīn, while their spiritual experiences are invoked by him to resuscitate within the soul of the reader an awareness of the ever present landscape of the world of the spirit. In a sense Rūmī played a providential role in that he made accessible the thoughts and teachings of these earlier masters by interpreting them into his own synthesis for later generations for whom drawing the full meaning of many of the earlier works directly is very difficult if not well nigh impossible.

The following *ghazal* from the *Dīwān-i Shams* is a clear example of how Rūmī makes use of various incidents of sacred history (here the story of the taking of refuge of the Prophet and Abū Bakr during the night of the *hijrah* in the cave) and episodes in the life of earlier Sufi saints (here Manṣūr Ḥallāj and Farīd al-Dīn 'Aṭṭār) to re-awaken in man the nostalgia for the Divine.[9]

بی وصـل اوازخویشتن ، بیزارشوبیزارشو بیدارشوهین وقت شد ، بیدارشوبیدارشو

خواهی که آیــدنزدتو، بیمـارشوبیمـارشو آمـدنـدا از آسمان ، آمد طبیب عاشقان

بیچون ترا بیچون کند ، روی ترا گلگون کند خار از کفت بیرون کند ، گلزار شو گلزار شو

این سینه را چون غاردان ، خلوتگه آن یاردان گر یار غاری تویقین ، در غار شو در غار شو

ویران چو کردت این زمان ، سودی نمیدار دفغان خواهی که معمورت کند ، معمار شو معمار شو

عالم همه پر شور بین ، وآن دولت منصور بین خواهی که منصورت کند ، بردار شو بردار شو

چون زلف او هر صبحدم ، باد صبا بر هم زند خواهی کز و بوئی بری ، عطار شو عطار شو

Awake, the time hath arrived, awake, awake!
Without union with Him, detest thyself, detest thyself!
The heavenly proclamation hath arrived, the healer of
lovers hath arrived,
If thou wilt that He visiteth thee, become ill, become ill!
In an inexplicable way He shall purify thee, and make
thee rosy-faced,
He shall remove the thorn from thy hand; become a
garden of roses, become a garden of roses!
Consider thy breast as a cave, the place for the spiritual
retreat of the Friend;
If thou art really the 'companion of the cave', then enter
the cave, enter the cave!
Once time hath brought ruin upon thee, laments will be
of no avail,
If thou wilt that he restore thee, become a restorer,
become a restorer!
See the world filled with tumult, see the dominion of the
victorious (Manṣūr).
If thou wilt to become victorious (Manṣūr), hang on the
gallows, hang on the gallows!
In as much as each early morn the zephyr entangles Her
hair,
If thou wilt to benefit from its scent, become a druggist,
('Aṭṭār), become a druggist.

As far as later Sufism is concerned, especially of the school of Ibn 'Arabī, there is again an intimate relation between this form of gnosis and Rūmī. There is still a great deal to be said concerning the rapport between Ibn 'Arabī and Rūmī, these two giants of Sufism who were destined to live within a generation of each other and in each other's proximity. There is no doubt that Rūmī knew directly of the teachings of the master

from Murcia through Ṣadr al-Dīn Qunyawī, who was at once the foremost expositor of Ibn ʿArabī's doctrines in the East and Rūmī's most intimate friend, and behind whom Rūmī performed his daily prayers. Some have in fact called the *Mathnawī*, the *Futūḥāt al-mukkiyyah* in Persian verse.

No doubt Rūmī accepted Ibn ʿArabī's fundamental doctrine of *waḥdat al-wujūd*, the transcendent unity of Being, which is the central axis of all Sufi doctrine. In several poems of exquisite beauty Rūmī describes this doctrine, for example in the well-known verses of the *Mathnawī*:

ماعـدمـهـائـیـم و هستـی های ما تو وجـود مطلقـی فانـی نمـا
(مـاعـدمـائـیـم هستـی ها نمـا تو وجـود مطلق و هسـتـی ما)
بادمـا و بود ما از داد تسـت هسـتـی ما جمـله از ایجـاد تست
لـذت هسـتـی نمـودی نیـسـت را عاشـق خودکـرده بودی نیـسـت را
لـذت انـعـام خود را وا مگـیـر نقـل و باده و جام خود را وامـگـیـر
ور بگیـری کیست جست و جو کنـد نقش با نقـاش چون نیـرو کند
منـگـر انـدر ما مکـن درمـا نظر انـدر اکـرام و سخـای خود نگـر
ما نبـودیـم و تقـاضـامـان نبـود لطف تو ناگـفـتـهٔ ما می شنـود

We and our existences are non-existent: Thou are the
absolute appearing in the guise of mortality.
That which moves us is thy Gift: our whole being is of
thy creation.
Thou didst show the beauty of Being unto not-being:
after Thou hadst caused not-being to fall in love
with Thee.
Take not away the delight of Thy Bounty: take not away
Thy dessert and wine and wine-cup!
But if Thou takest it away, who will question Thee?
Does the picture quarrel with the painter?
Look not on us, look on Thine own Loving-kindness and
Generosity!
We were not; there was no demand on our part: yet Thy
Grace heard our silent prayer and called us into
existence.[10]

No poet could depict in more moving words the utter nothingness of all existing things before the One who alone

is. Here is the doctrine of *waḥdat al-wujūd* shrouded by the theophany of its own beauty.

Likewise Rūmī follows Ibn 'Arabī in believing that the existence of everything is identical with the relation of that particular being to Being Itself, that existents are nothing but the relation they possess to the Absolute. This fundamental metaphysical doctrine whose intricacies and implications were later developed by such theosophers as Mullā Ṣadrā is summarized in a deceivingly simple couplet by Rūmī when he states, referring to the relation between beings and Being Itself:

اتّــصـــالــی بی تکـیّــف بی قیــاس هســـت ربّ الــنـــاس را با جان ناس

There is a link beyond all description and comparison:
between the Lord of creatures and their inner being.

As for the complementary doctrine of the universal man (*al-insān al-kāmil*), which, like the doctrine of *waḥat al-wujūd*, was also formulated for the first time by Ibn 'Arabī,[11] its meaning is reflected throughout Rūmī's writings, but he does not use the term *insān-i kāmil*. Rather, when referring to the idea he uses such terms as the macrocosm (*'ālam-i akbar*) which he considers the spiritual man to be in contrast to 'profane man', who is the microcosm. For example he addresses the man whom he wishes to awaken to his own spiritual possibilities in these terms:

پس به صورت عالــم اصــغــر توئــی پس به معــنــی عالــم اکـبــر توئــی

Therefore in outward form thou art the microcosm,
While in inward meaning thou art the macrocosm.

Rūmī, however, did not simply continue the school of Ibn 'Arabī, as did such masters as Ṣadr al-Dīn al-Qunyawī, 'Abd al-Razzāq Kāshānī and Dā'ūd al-Qayṣarī.[12] In certain matters, such as the meaning of evil he departed from Ibn 'Arabī and his followers. Rather, Rūmī must be considered as another peak of Sufism, as the perfection of a type of spirituality that is akin but distinct from that of Ibn 'Arabī. Throughout the later

history of Sufism, the type of spirituality represented by each master has remained distinct, each with its own fragrance and form of radiance, while at the same time some like Jāmī and Ḥājjī Mullā Hādī Sabziwārī have sought to bridge the gap between the two types of spirituality in question.

As far as Rūmī's rapport with the Persian Sufi poets before him is concerned, we have had the occasion to discuss it in the last chapter. It is, however, of interest for the understanding of Rūmī's art and his role in Persian culture to say a few words about his relation to Firdawsī, whose *Shāh-nāmah* is in a sense the complement of the *Mathnawī*. Firdawsī's *Shāh-nāmah* is the surpreme epic poem of the Persian language emphasizing the glory of the Persian people in the pre-Islamic period. The *Mathnawī* is the supreme epic of the Islamic period, but an epic whose field of battle has now become transformed to the world within the soul of man. The *Shāh-nāmah* is in a sense an account of the 'lesser holy war' (*al-jihād al-aṣghar*) while the *Mathnawī* is the tale of the 'greater holy war' (*al-jihād al-akbar*), to use the terminology of the well-known prophetic *ḥadīth*. In the same way that Suhrawardī sought, through esoteric interpretation, to interiorize the heroic tales of the *Shāh-nāmah*,[13] Rūmī on a much larger scale sought to create a vast canvas upon which the supreme epic of the spiritual hero in quest of the Fountain of Life was depicted with the finest detail.

To achieve this end, Rūmī drew from all the resources of the Persian language and benefited from all the literary masters who preceded him. He was at once an excellent story teller, sacred historian, lyricist and above all poet. Yet, he was not a poet like other poets, even the great Sufi poets before him. While being an unparalleled master of mystical poetry, he often claimed not to be a poet at all.[14] It is indeed strange that this supreme poet whose tongue was touched by the wing of the angels should write in the *Dīwān*:

شعـــر چه باشــــد بر من تاکه از آن لاف زنـــم هست مرا فنّ دگــر غیـــر فنـون شعـرا

شعـر چو ابـری است سیـه، من پس آن پرده چو مه ابر سیـه را تو مخوان ماه منوّر به سما

What is poetry that I should boast of it,
I possess an art other than the art of the poets.

*Poetry is like a black cloud; I am like the moon hidden behind
 its veil.*
Do not call the black cloud the luminous moon in the sky.

Rūmī, like Shabistarī after him, was an oustanding poet in
spite of himself. The beauty of his verses is like the beauty of
a sanctuary which is there of necessity as the 'existential' condi-
tion for all authentic manifestations of the sacred. But despite
this disregard for poetry, Rūmī could not cease to compose
poetry. The ocean within his being could not spew forth its
waves except in the rhythms and rhymes which have made
of Rūmī perhaps the greatest mystical poet the world has ever
seen.

The poetry of Rūmī is a celebration of not only life in its
spiritual aspect but also death which alone makes the realiza-
tion of the spiritual dimension of life possible. Rūmī saw in
death the supreme ecstatic moment of life, for he had already
died before dying according to the famous prophetic saying,
'Die before you die'.

«موتوا قبل ان تموتوا . »

For him death could only be an entrance into the world of light,
according to his own well-known poem:

تا نبـاشـد زحـمـت جان دادنت رو بمیـر ای خواجـه قبـل از مردنت
نی چنـان مرگـی که در گوری روی آن چنـان مرگـی که در نوری روی

Go die, sire, before thy death,
So that thou wilt not suffer the pain of dying.
Die the kind of death which is entrance into light,
Not the death which signifies entrance into the grave.[15]

Rūmī had already entered the world of light before
encountering physical death. Consequently physical death
could not but be the moment of celebration when the last
obstacle was lifted and he was able to return fully to the ocean
of light from which he had become momentarily separated.
Rūmī had already realized that *amor est mors*; through the love

of God he had tasted death while physically alive and was a resurrected being shrouded in the light of Divine Knowledge when still discoursing and walking among men.

What had made it possible for Rūmī to look upon the encounter with death as a moment of supreme ecstasy was of course the kind of life he had led in this world, a life which had already led him into the state of sanctity before passing through the gate of death. This life was to be witness to the remarkable encounter with Shams and the *sympathia* (*hamdamī* to use Rūmī's own words) between them which brought about the creation of the *Dīwān*, causing Rūmī to leave the world of silence and to have recourse to poetry to explain that which cannot but issue from holy silence.[16] In a sense Ḥusām al-Dīn Chalabī played the same role for Rūmī *vis-à-vis* the *Mathnawī*. In the same way that if there is no appropriate disciple, the initiatic function retires within the being of a master, the lack of spiritual companionship and discourse can lead the most artistically creative of Sufis into silence. To quote the well-known verse of Saʿdī:

گر نبودی گل نخواندی بلبلی بر شاخساری

*If there were no rose the nightingale would not be
singing in the grove.*

But the poetic masterpieces of Rūmī could not *not* have come into being, for such a perfect wedding between wisdom and beauty, and art and spirituality was a possibility that had to be realized. Rūmī was one of those rare beings who possessed a kind of 'sensual awareness' of spiritual beauty, a person for whom things appeared as transparent forms reflecting the eternal essences. For him the very existence of beauty was the most direct proof of the existence of God.[17] It can also be said that for the perceptive reader the beauty of Rūmī's poetry itself is the most powerful proof of the reality of the world of the Spirit. Rūmī bathed in beauty like an eagle soaring in the light of the sun and he left in his poetry as well as in the spiritual music and dance of the Mawlawī Order something of this beauty for posterity. The beauty of Rūmī's poetry, music and

dance is a way of bringing about recollection and of awakening within man an awareness of that supreme Beauty of which all terrestrial beauty is but a pale reflection, for as Rūmī says:

بر زمـیــن خاك من كأس الــكــرام جرعــهای بر ریـخـتـی زآن خُفیــه جام
خاك را شاهــان همـی لیـسـنــد از آن هست بر زلف و رخ از جرعهاش نشان
كه به صد دل روز و شب می بوسـیش جرعـهٔ حسـنـسـت انــدر خاك گش
مرتـرا تا صاف او خود چون كنــد جرعــه خاك آمیــز چون مجنـون كند

> *Kings lick the earth whereof the fair are made,*
> *For God hath mingled in the dusty earth*
> *A draught of Beauty from His choicest cup.*
> *'Tis that, fond lover—not these lips of clay—*
> *Thou art kissing with a hundred ecstasies,*
> *Think, then, what must it be when undefiled!*[18]

Complementary to Rūmī's sensitivity to beauty is his awareness of the sacred in all things and his ability to provide keys for the spiritual solution of practically every problem man faces in any age or situation. The Prophet of Islam was given the possibility of experiencing everything that a human being can experience, from losing his only son to uniting all of Arabia under the banner of Islam. He was given this mission in order to be able to sanctify all of human life. Rūmī, who is one of the outstanding fruits of the tree of 'Muḥammadan poverty' (*al-faqr al-muḥammadī*), was able to accomplish this same task on of course a smaller, yet nonetheless vast, scale. He was able to express the fullness and diversity of human existence in such a way as to reveal the fact that behind every possible kind of experience there lies a door towards the Invisible.

During the seven centuries that have passed since his death, Rūmī has left such an immense impact upon the Persian, Turkish and Indian worlds that volumes would be needed to track down the visible traces of his influences. In the Turkish world the Mawlawī Order founded by him has played such a dominant role in the history of the Ottoman Empire that even from an external point of view no account of Ottoman and even modern Turkish history would be complete without mention of it. Moreover, the Turks extended the influence of Rūmī to

the Balkans as far as Albania as well as to Cyprus, Syria, and Lebanon where Mawlawī centres are still to be found. Even in Republican Turkey his tomb continues to radiate its *barakah* and commentaries continue to be written upon his works following the long tradition going back to Rūmī's own family and to Aḥmad Rūmī.

In Persia, likewise, numerous commentaries have been and continue to be written on the *Mathnawī*, from the *Jawāhir al-asrār* of Kamāl al-Dīn Khwārazmī to the present day commentaries of Jalāl Homā'ī, Badī' al-Zamān Farouzanfar and Muḥammad Taqī Ja'farī.[19] There is practically no Persian speaker who does not know some verses of the *Mathnawī* by heart, while the art of singing the *Mathnawī* has become a recognized musical form of a most delicate and profound nature whose continuing influence upon the cultural and artistic life of the Persians is immense.

In the Indian subcontinent Rūmī was appreciated among the Naqshbandiyyah Order already in the ninth/fifteenth century and his influence has grown ever since. Not only have numerous commentaries been written upon him, such as those of 'Abd al-Laṭīf 'Abbāsī and Shāh Mīr Muḥammad Nūrallāh Aḥrārī, but also there developed in the subcontinent, as well as in Persia and the Ottoman worlds, a particular musical *genre* which is associated solely with the singing of the *Mathnawī*, a form that again remains popular to this day. More particularly certain of the Sufis of that region, especially Shāh 'Abd al-Laṭīf, the great Sindhi poet and mystic who was also an outstanding musician, may be said to be direct emanations of Rūmī's spirituality in the Indian world.[20] It is not without reason that many have compared Shāh 'Abd al-Laṭīf's *Risālo* with the *Mathnawī*.

In the modern world, impoverished of spirituality and suffocating in an ambience where ugliness has become the norm and where beauty is a luxury, Rūmī is discovered by many to be the antidote to the ills from which the modern world suffers. Indeed he is a most powerful antidote provided his teachings are followed, however bitter might be the medicine he proposes. In order to draw aid from Rūmī in the spiritual battle at hand one must read him not as a *mere* poet but as the *porte-parole*

of the Divine Mysteries who like the birds could not but sing in melodies that move the spirit. The works of Rūmī and his ever living spiritual presence stand as a strong beacon to guide men by means of beauty to that Truth which alone can liberate them from the illusory prison of deprivation and ugliness that they have created around themselves, and whose confines cannot be eradicated save by means of the message of men like Rūmī in whom the vision of the Truth and its expression in the most perfect human form, the experience of spirituality and its formulation in an artistic manner are combined. Verily it must be said of the works of Rūmī that:

نردبـان آسـمـان اسـت ایـن کلام هرکـه زان بر می رود آیــد به بام
نی به بام چرخ کو اخــضــر بود بل به بامـی کز فلك برتـر بود

These words are the ladder to the firmament.
Whoever ascends them reaches the roof—
Not the roof of the sphere that is azure.
But the roof which transcends all the visible heavens.

NOTES

1. Concerning the *philosophia perennis* see F. Schuon, *Light on the Ancient World*, trans. Lord Northbourne, London, 1965 pp. 136–144; and Nasr, *Knowledge and the Sacred*, pp. 68ff. It is of interest to note that already the selection of the poetry of Rūmī translated by R. A. Nicholson as *Rumi, Poet and Mystic*, London, 1950, has sold many more copies than works of most European 'thinkers' who were supposed to be very progressive and timely when they first appeared.

2. In the strict sense one should refer to the Islamic tradition and not to the Sufi tradition, because the first is an integral tradition and the second a part of the first and inseparable from it. In using the term 'Sufi tradition', therefore, the more limited sense of the word is intended yet without wishing in any way to imply that Sufism can be practiced in itself without reference to the Islamic tradition of which it is a part.

3. In the Abrahamic family the dominant aspect of Judaism can be said to be related to the fear of God, of Christianity to the love of God, and of Islam to the knowledge of God, although of necessity in every integral tradition all three elements must be present. See F. Schuon, 'Images d'Islam', *Etudes traditionnelles*, vol. 73, Nov–Dec. 1972, pp. 241–43.

4. See T. Burckhardt, *La Sagesse des prophètes*, Paris, 1955; and Ibn al-'Arabī, *The Bezels of Wisdom*, trans. R. W. J. Austin, New York, 1980; Nasr, *Three Muslim Sages*, chapter III, and *Sufi Essays*, chapter VIII.

5. One of the greatest authorities on Rūmī in contemporary Persia who died only recently, Hādī Hā'irī, has shown in an unpublished work that some six thousand verses of the *Dīwān* and the *Mathnawī* are practically direct translations of Quranic verses into Persian poetry.

6. Despite numerous biographies of the Prophet in Western languages very few

145

succeed in underlining his spiritual grandeur. One remarkable and exceptional work in a European language which does succeed in illuminating the contours of the Prophet's spiritual personality is F. Schuon's, *Understanding Islam*, chapter III. The recent work of M. Lings, *Muhammad*, London, 1983, is a unique work in the English language which deals with the biography of the Prophet on the basis of traditional Islamic sources and from a traditional point of view. The elegant English, mastery of recitation and devotion to the subject bestow a special spiritual significance to this work even if this biography is of the life of the Blessed Prophet in general and not solely concerned with his spiritual nature. See also Nasr, *Ideals and Realities of Islam*, chapter III, with an annotated bibliography.

7. This is the statement with which the preludium of the *Mathnawī* begins. Like many of the greatest spiritual poles of Islam, such as al-Ghazzālī, 'Abd al-Qādir al-Jīlānī and Ibn 'Arabī before him and Shaykh al-'Alawī after him, Rūmī was a master and authority in both the exoteric and the esoteric sciences.

8. On the early Sufis, especially those in Persia who were directly connected to the line of Rūmī, see L. Massignon, *Essai sur les origines du lexique technique de la mystique musulman*, Paris, 1954, chapter III–V; and A. M. Schimmel, *Mystical Dimensions of Islam*, Chapel Hill, 1975, pp. 23ff.; S. H. Nasr, 'Sufism' in the *Cambridge History of Iran*, vol. IV, Cambridge, 1975, pp. 442–463; also A. J. Arberry, *Sufism*, London, 1950; and J. Spencer Trimingham, *The Sufi Orders in Islam*, Oxford, 1971.

9. Rūmī, *Dīwān-i Shams-i Tabrīzī*, ed. by B. Forouzanfar, vol. 5, Tehran, 1339, *ghazal*, No. 2133. In this *ghazal* Rūmī plays upon the names of Ḥallāj and 'Aṭṭār. The first name of Ḥallāj was Manṣūr, which means 'victorious', while 'Aṭṭār means 'druggist' in the traditional sense of one who sells both drugs and perfumes.

10. *Mathnawī*, I. 602ff. English translation by Nicholson, *Rumi, Poet and Mystic*, p. 107.

11. For an analysis of Sufi doctrine upon the basis of the two fundamental doctrines of *waḥdat al-wujūd* and *al-insān al-kāmil*, see S. H. Nasr, *Science and Civilization in Islam*, Cambridge, U.S.A., New York 1970, chapter XIII. For an exposition of the meaning of *al-insān al-kāmil*, see the introduction of T. Burckhardt to al-Jīlī, *Universal Man*.

12. On these and other figures who belong to the school of Ibn 'Arabī see W. Chittick, 'Ibn 'Arabī and His School' in *World Spirituality: An Encyclopedic History of the Religious Quest*, vol. XX, (in press).

13. See H. Corbin, *En Islam iranien*, pp. 82ff.

14. In accordance with the Islamic tradition the Quran, although highly poetical, is not considered poetry or *shi'r*, and the Prophet admonished the poets of his day because they would compose poetry about any subject without moral scruple or spiritual discernment. Rūmī, like many other Muslim saints, disclaimed to be a poet while composing poetry. The meaning of such an assertion must be understood in the context of the sacred history of Islam and not be confused with that indifference and even opposition to beauty which emanates today from certain quarters in the Islamic world in the name of a 'purified' Islam.

15. This is a universal theme to be found also in Hindu and Buddhist as well as Jewish and Christian mysticism. In Christian sources some of the verses of Angelus Silesius are almost a verbatim repetition of these and similar lines of Rūmī. See Nasr, *Knowledge and the Sacred*, pp. 29–30.

16. It is of interest to note that Rūmī's pen-name (*takhalluṣ*) was 'silent' (*khāmūsh*).

17. 'The teleological proof also embraces the aesthetic proof, in the profoundest sense of that term. Under this aspect it is perhaps even less accessible than under the cosmological or moral aspects; for to be sensitive to the metaphysical transparency of beauty, to the radiation of forms and sounds, is already to possess—in common with a Rūmī or a Ramakrishna—a visual and auditative intuition capable of ascending through phenomena right up to the essences and the eternal melodies.' F. Schuon, 'Concerning the Proofs of God', *Studies in Comparative Religion*, Winter, 1973, p. 8.

18. *Mathnawī*, v. 372–5. English translation by Nicholson, *Rumi, Poet and Mystic*, p. 45.

19. The immense commentary of Ja'farī which despite its size is a popular work, shows to what extent Rūmī is still alive for the Persians.

20. See N. A. Baloch, *Maulana Jalaluddin Rumi's Influence on Shah Abdul Latif*, International Mevlana Seminar, Ankara, 1973.

MUSIC

IX

Islam and Music: The Views of Rūzbahān Baqlī, the Patron Saint of Shiraz

NO DISCUSSION about Islamic art and spirituality could take place without considering music, which is of great significance from a spiritual point of view not only in itself but also in its relation to poetry as exemplified by the case of Jalāl al-Dīn Rūmī. Even the Quran itself in its traditional prosody is at once music and poetry, although traditionally it has not been classified as either but, being the Word of God, belongs to a category above all categories of human art. One need only study the Islamic world in various stages of its history or in the present day to become aware of the presence of music in many of the most fundamental aspects of that tradition. The call to prayer (al-adhān) is almost always sung,[1] as is the Noble Quran whose chanting is the most nourishing of all music for the soul of the people of faith (mu'minūn) although the chanting has never been technically called 'music', that is mūsīqā or ghinā'.[2] Even now, during Ramaḍān, in some Islamic cities, one can observe the age old tradition of waking people in time to eat before dawn and the beginning of the fast by means of chants, and sometimes trumpets. Moreover, funeral orations performed under the most strict religious canons are usually sung melodies and in some holy sanctuaries music accompanies religious ceremonies as it does in Mashhad in Persia at the tomb of Imam 'Alī al-Riḍā where drums and an instrument resembling the oboe welcome the rising sun every morning at the earliest moment of the day. Finally, it might be mentioned that the Muslim armies performing the holy war (al-jihād) were accompanied from the earliest times by a type of music which intensified the qualities of bravery and courage within the

hearts of the soldiers. The first military band was, in fact, created by the Ottomans and later copied all over Europe.

Besides these specifically religious instances from the *Sharī'ite* point of view,[3] there is of course that ocean of celestial music connected with Sufism, music varying from the simple playing of drums in the Senegal to elaborate performances by large numbers of musicians on a wide range of instruments in Turkey and the Indo-Pakistan sub-continent, primarily among the Malawīs and Chishtīs. This music is also of a directly religious character, although here the esoteric rather than the exoteric dimension of the religion is involved. Furthermore, this type of music overflows to embrace nearly the whole community of believers on certain occasions such as the anniversary of the birth or death of great saints.

There is also the more popular form of music, or folk music as it is called today, which has existed as an integral part of the life pattern of various groups, especially in the countryside and among the nomads throughout the Islamic world and which has been sung or played by peoples who have adhered most strictly to the *Sharī'ah*. Sometimes this type of music has served as inspiration for various Sufi masters who have adopted it for strictly spiritual ends in their gatherings. Even Jalāl al-Dīn Rūmī often took songs from the taverns of Anatolia and converted them into vehicles for the expression of the most profound yearning for God.

Besides all these forms of music, one must mention the major classical traditions of music in the Islamic world such as the Persian, Andalusian, Arabic of the Near East, Turkish, and North Indian traditions which have survived to this day. Although the origin of these musical traditions goes back to ancient civilizations, they became fully integrated into the Islamic universe and took their place among the central expressions of Islamic art. These classical traditions were supported mostly by the courts of various caliphs and sultans or the nobility and, as mentioned earlier at the beginning of this book, were more of an aristocratic and knightly art than anything else—as far as patronage was concerned—although the content of this art remained highly contemplative and spiritual. Often the musicians supported by the court or the aristocracy

were themselves members of the Sufi orders as can be seen so clearly in Persia and India during the past three centuries.[4] This classical tradition was in any case closely related to Sufism and in certain instances, such as that of the Mawlawī Order, the cultivation and preservation of the classical tradition was directly due to a Sufi order.[5]

Many of the outstanding Islamic men of learning, especially philosophers, mathematicians and physicians, were well-versed in music and its theories and some like al-Fārābī, Ibn Sīnā and Urmawī were notable authorities in musical theory.[6] Certain Muslim physicians used music to cure ailments of both body and soul and several treatises were written concerning the therapeutic view of music.[7] Men of letters were also usually acquainted with music. Poetry in particular has been almost inseparable from music throughout Islamic history as the *Kitāb al-aghānī* of Abu'l-Faraj al-Iṣfahānī illustrates for the early Islamic period. In both Arabic and Persian literature, the close wedding between masterpieces of poetry such as the *Burdah* or the *ghazals* of Ḥāfiẓ and their musical rendition is to be observed in almost all periods and climes. The same holds true for Turkish, Urdu, and other Islamic languages. One can hardly conceive of Urdu, Bengali, and Sindhi poetry, to cite a few languages of the Indian sub-continent, without recalling the sessions of poetry (*mushā'arah*) which are usually combined with the singing of poems and the *qawwālīs* which are vocal musical performances with instrumental accompaniment in which the chanting of poetry plays the central role.[8]

With all these considerations in mind, it might be asked why many people, including not only orientalists but also some modern Muslims, claim that music is forbidden, or *ḥarām*, from the legal point of view in Islam and question the significance of this ban upon music, if indeed there is such a ban. What domain of musical activity does the ban involve and what kind of music falls under the *Sharī'ite* injunctions concerning music? There is no doubt that this question was debated by noted jurists and theologians including such eminent authorities as Ibn Ḥazm and al-Ghazzālī.[9] The question of the significance and legitimacy of music in the total structure of the Islamic tradition is not, however, merely juridical or theological. It involves most

of all the inner and spiritual aspect of Islam, and therefore whatever ambiguities exist on the juridical level, the ultimate answer, especially as far as the relation of music to Islamic spirituality is concerned, must be sought above all in Sufism. Numerous Sufis have written on this subject and some have themselves been both accomplished musicians and authorities on the psychological and spiritual effect of music upon the human soul.[10] One such figure is Rūzbahān Baqlī of Shiraz[11] who was a master of both Sufism and the *Sharī'ah* as well as of music itself. The words of the patron saint of Shiraz in his *Risalat al-quds* are a most telling witness to the significance of music, the conditions under which it is legitimate, the kinds of people who may listen to music, and the kind of music which is worthy of being performed and listened to.[12]

On the Meaning of 'Spiritual Music' (samā')
'Know O Brothers—may God increase the best of joys for you in listening to spiritual music—that for the lovers of the Truth there are several principles concerning listening to spiritual music, and these have a beginning and an end. Also the enjoyment of this music by various spirits is different. It can be enjoyed according to the station of the Sacred Spirit (*rūḥ-i muqaddas*). However, no one, save he who is among those who reign in the domain of gnosis (*ma'rifat*), can be prepared for it, for spiritual qualities are mingled with corporeal natures. Until the listener becomes purified from that filth, he cannot become a listener in the gatherings (*majālis*) of spiritual familiarity (*uns*). Verily, all the creatures among the animals have an inclination toward spiritual music, for each possesses in its own right a spirit. This spiritual music keeps alive thanks to that spirit and that spirit keeps alive thanks to music.

'Music is in the coming to rest of all thoughts from the burdens of the human state (*bashariyyat*), and it excites the temperament of men. It is the stimulant of seigneurial mysteries (*asrār-i rabbānī*). To some, it is a temptation because they are imperfect. For others, it is an exhortation (*'ibrat*) for they have reached perfection. It is not proper for those who are alive on the natural plane, but whose heart is dead, to listen to music, for it will cause their destruction. It is, however, incumbent

upon him whose heart is joyous, whether he discovers or fails to discover the soul, to listen to music. For in music there are a hundred thousand joys of which, with the help of one of which, one can cut across a thousand years of the path of attaining gnosis in a way that cannot be achieved by any gnostic through any form of worship.

'It is necessary that the passions in all the veins of the seeker after music become diluted (as far as the passions are concerned) and that the veins become filled with light as a result of the purity of worship. In his soul he must be present before the Divine and in the state of audition so as to remain free, while listening to music, from the temptations of the carnal soul. And this cannot be achieved with certainty except by the strongest in the path of Divine Love. For spiritual music is the music of the Truth (*al-Ḥaqq*). Spiritual music comes from God (the Truth—*Ḥaqq*); it stands before God; it is in God; it is with God. If someone were to conceive one of these relations with something other than God, he would be an infidel. Such a person would not have found the path and would not have drunk the wine of union in the spiritual concert.

'The disciples of love (*maḥabbat*) listen to music without recourse to their carnal soul. Those who walk upon the path of yearning (*shawq*) listen to spiritual music without recourse to reason. The possessed followers of intense love (*'ishq*) listen to spiritual music without recourse to the heart. Those agitated by spiritual familiarity listen to music without recourse to the spirit. If they were to listen to music with these means they would become veiled from God. And if they were to listen to it with the carnal soul they would become impious (*zindīq*). And if they were to listen to it with the power of reason (*'aql*) they would become creditable. And if they would hear with the heart they would become contemplative (*murāqib*). And if they were to listen with the spirit they would become totally present. Spiritual music is the audition and vision of Divine Presence (*ḥuḍūr*). It is terror and sorrow. It is wonder in wonder. In that world canons cease to exist. The man of knowledge becomes ignorant and the lover is annihilated.

'In the feast of Divine Love, the listener and the performer are both one. The truth of the path of lovers is accompanied

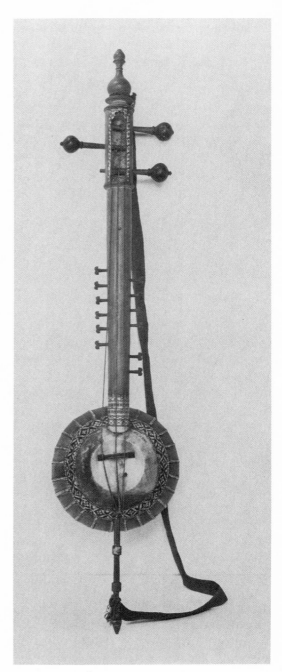

Muslim craftsmen usually took the greatest care in making musical instruments as is seen in this Kamanchah made in the 13th/19th century in Kashmir. The beauty of the visible form of the instrument is to complement the sonoral beauty it produces through its interiorizing and inebriating music.

156

by music but the truth of its truth is without music. Spiritual music comes from discourse (*khaṭāb*) and the lack of it from beauty (*jamāl*). If there is speech, there is distance, and if there is silence there is proximity. As long as there is audition, there is ignorance (*bīkhabar*) and the ignorant dwell in duality. In hearing spiritual music, reason is dethroned; command becomes prohibition and the abrogator (*nāsikh*) the abrogated (*mansūkh*). In the first stage of the spiritual concert, all the abrogators become abrogated, and all the abrogated abrogators.

'Spiritual music is the key to the treasury of Divine Verities. The gnostics are divided: some listen with the help of the stations (*maqāmāt*); some with the help of the states (*ḥālāt*); some with the help of spiritual unveiling (*mukāshifāt*); some with the help of vision (*mushāhidāt*). When they listen according to the stations, they are in reproach. When they listen according to the states, they are in a state of return. When they listen according to spiritual unveiling they are in union (*wiṣāl*); when they listen according to vision they are immersed in the Divine Beauty.

'From the beginning to the end of the stations (*maqāmāt*), there are thousands upon thousands of stations each of which possesses thousands upon thousands of pieces of spiritual music, and in each piece of music there are thousands upon thousands of qualities, such as change, warning, elongation, union, proximity, distance, ardour, anxiety, hunger, thirst, fear, hope, melancholy, victory, sorrow, fright, purity, chastity, servitude and lordship. If any of these qualities were to reach the soul of the ascetics of the world, their soul would involuntarily depart from their bodies.

'Likewise, from the beginning to the end of the states (*aḥwāl*), there are thousands upon thousands of *maqāms* in each of which there are a thousand allusions (*ishārāt*) within spiritual music. And in each allusion there are many kinds of pain such as love (*maḥabbat*), yearning, intensive love ('*ishq*), ardor, purity, aridity, and power. If one of them were to pass within the heart of all the disciples, the heads of all of them would become separated from their bodies.

'Also from the beginning of spiritual unveiling to its end during the hearing of spiritual music, there is one theophanic dis-

play after another. If the lovers of God were to see one of these displays they would all melt away like quicksilver. Likewise, in mystical vision during the spiritual concert hundreds of thousands of qualities become revealed, each of which prepares a thousand subtleties (*laṭā'if*) within the being of the gnostic. Such qualities as knowledge, truth, calamities, flashes and gleamings of the Divine Lights, awe, strength, inconstancy, contraction, expansion, nobility and serenity, will cast him to the Invisible beyond the invisible world, and reveal to him the mysteries of his origins.

'From each leaf in the paradise of spiritual vision and from the trees of the qualities, the birds of light will sing the eternal song with uncreated notes before the soul of his soul. One syllable of that song will annihilate the gnostic from the state of servitude and make him subsistent in the state of Divinity. It will seize the foundations of his being and bestow another foundation upon him. It will familiarize him with himself and make him a stranger to himself. It will make him know himself, audacious *vis-a-vis* himself and fearful of himself. While he is amidst the assembly, it will transform him into its own colour. It will speak of the Mystery of Mysteries with him and enable him to listen to the discourse on Divine Love from its tongue.

'Sometimes it says "thou art I", and sometimes 'I am thou'. Sometimes it makes him annihilated in subsistance and sometimes subsistent in annihilation. Sometimes it will draw him near; at other times provide peace for him through familiarity. Sometimes it fatigues him with the scorching of Unity; at other times it brings his soul to life through perplexity. At times it makes him listen; at other moments to flee or to recite. Sometimes it casts him into the state of pure servitude; at other times into the essence of lordship. Sometimes it makes him inebriated with beauty; at other times humbled by majesty. Sometimes it makes him sober, or strengthens him or makes him inconstant. Sometimes it takes his soul through the langour of spiritual music. At other times, through the eradication of the calamities caused by the unceasing light shining from the dawn of Unity upon the roof of Majesty, it will place him upon the throne of Kingship. Sometimes it will make him fly with the aid of the mystery of blessedness through the space of pre-

eternity. At other times, by means of the shears of transcendence, it will cut the wing of resolution in the space of self-identity.

'All these are to be found in spiritual music and still more. He knows this truth who, at the moment of spiritual vision and through the beauty of this vision in the presence of the Divine Presence, acquires from the eternal *saki* without the toil of non-existence the wine of spiritual familiarity; one who is able to hear the sublime words issuing from the blessed dawn within the invisible dimensions of the "rational spirit" (*rūḥ-i nāṭiqah*). He will know who is there. Those who are here do not know its exposition. These teachings are neither for the unripe who would fall into a state of doubt through them, nor for strangers who would become stranded by them. For this is the heritage of Moses, the secret of Jesus, the ardour of Adam, the sincere friendship of Abraham, the lamentation of Jacob, the suffering of Isaac, the consolation of Ishmael, the sons of David, the familiarity of Noah, the flight of Jonas, the chastity of Joseph, the calamity of Jacob, the remedies of John, the fear of Zacharias, the yearning of Jethro and the spiritual unveiling and vision of the friend, Ahmad (Prophet of Islam)—May the blessings of God the Merciful be upon all of them.

'These words are the secret of "I am the Truth" (*ana'l-Ḥaqq*); they are the truths which glorify God. The reality of spiritual music belongs to Sarī Saqaṭī; the speech of this music to Abū Bakr Wāsiṭī; and the pain of this music to Shiblī.[13] The spiritual concert is permissible (*mubāḥ*) for the lovers of God; it is forbidden (*ḥaram*) for the ignorant.[14]

'Spiritual music is of three kinds: one for the common people, one for the elite and one for the elite among the elite. The common people listen through nature and that is destitution.[15] The elite listen with the heart, and that is being in quest. The elite among the elite listen with the soul, and that is being in love. If I comment upon music, I fear that it will cause constraint in the world of those with large ears. For I come from the ruins of annihilation and I have brought the mystery of subsistence. If I speak, I speak without foundation.[16] I speak according to the foundation of the listener. My musician is God and I speak of Him. My witness is God and I see Him. My words are the

159

song of the nightingale of the eternal covenant.[17] I hold discourse with the birds in the pre-eternal nest.'

My case has become strange to all strangers,
And I have become 'wonder among all that is wonderous'.

* * *

The very sobriety of Islam prevented music from becoming an externalized profanation. While on the exoteric level it remained confined to special occasions and situations such as those already mentioned in which music is governed strictly by canons to prevent it from arousing animal passions, esoterically music became the means of transmuting the sentiments and transforming the soul. But then it was played under conditions that guaranteed the subjugation of the carnal soul before the transmuting effect of music was allowed to take place within the being of the listener.

Islamic civilization has not preserved and developed several great musical traditions *in spite of* Islam but *because* of it. It has prevented the creation of a music, like the post-classical music of the West, in which an 'expansion'[18] takes place without the previous 'contraction' which must of necessity preceed expansion in the process of spiritual realization. Islam has banned music which leads to the forgetfulness of God and has forbidden those Muslims from hearing it who would become distracted from the spiritual world and become immersed in worldliness through listening to music. But Islam has preserved for the whole community music in its most exalting and yet sober aspect. In its psalmody of the Quran and its religious songs related to the Blessed Prophet and the sacred litany of Islam and through its inner dimension it has made of music a ladder to the Divine Presence. It has lent music a contemplative quality which is an echo of paradise and in which are combined the sensuous and the ascetic, the otherworldly and the beauty of the here and now. It has made of spiritual music, a vibration and echo of the Reality which is at once transcendent and immanent.

The *samā'* or spiritual music of which Baqlī speaks, and which

represents one of the most essential aspects of Islamic art in its relation to spirituality is the voice of God calling man unto Himself as well as a means whereby man is led back to his spiritual origin. It is an adjunct to the Path (*ṭarīqah*) to God, and only he who is willing to undertake the necessary discipline to become worthy of traversing this Path has the right to listen to this music. As for others, they should not disdain the path which they are not meant to follow, for to negate or deny any of God's gifts is to commit a sin for which man must ask the forgiveness of Him who alone can forgive. Ultimately man is himself God's music and Islam, as an integral tradition, could not but include this reality and provide the possibility for those with the right qualifications to hear the music of the lyre of their own existence being plucked by the Divine Hand.

NOTES

1. In some regions of the Islamic world such as Indonesia, the *adhān* is accompanied by drum beats which carry through the jungle much farther than the voice of the muezzin.

2. See L. al-Fārūqī, 'Al-Ghazali on *samāʿ*', in I. al-Fārūqī (ed.), *Essays in Islamic and Comparative Studies*, Herndon, Virginia, 1982, p. 44–45.

3. The religious view of course encompasses the inner dimensions of religion as well, if religion is understood in its most universal sense. Therefore, the *Sharīʿite* point of view is not synonymous with the religious view in Islam but comprises one of its most important and indispensable elements.

4. See J. During, 'Elements spirituels dans la musique traditionelle iranienne contemporaine', in *Sophia Perennis*, vol. 1, no. 2, Autumn 1975.

5. To this day the best performers of classical Turkish music are connected with the Mawlawī Order despite the eclipse of this order in recent times in Turkey.

6. See R. d'Erlanger, *La Musique arabe*, 5 vols., Paris, 1930–1939; the numerous works of H. G. Farmer, on both the theory and practice of Arabic music; N. Caron and D. Safvat, *Iran* (collection *Les traditions musicales*), vol. 2, Paris, 1972; and A. Shiloah, 'L'épitre sur la musique des Ikhwān al-Ṣafāʾ', *Revue des Etudes Islamiques*, 1965, pp. 125–162; 1967, pp. 159–193, which includes the translation of the important treatise of the Ikhwān al-Ṣafāʾ on music.

7. Al-Fārābī wrote a treatise entitled *al-ʿIlāj fiʾl-mūsīqā* (*Cure through Music*) and the Ikhwān al-Ṣafāʾ dealt with the effect of music upon the soul in their *Epistles*. See Shiloah, *op. cit.*

8. Traditional treatises on music often contain a section devoted to the relation between music and poetry and to those letters whose sounds are melodies, the (*ḥurūf al-muṣawwatah*). See for example, al-Hasan ibn Ahmad al-Kātib, *La Perfection des connaissances musicales*, trans. by A. Shiloah, Paris, 1972, pp. 99ff.

9. Al-Ghazzālī has dealt with the question in his capacity as authority in both exotericism and esotericism. There is, however, no unanimity of opinion concerning this subject among the most eminent jurists, both Sunni and Shiʿite. It seems as if God did not want a definite legal view to be established on this matter, considering the double nature of music as both means of interiorization and recollection and dis-

sipation and diversion. See J. L. Michon, *op. cit.*, and L. al-Fārūqī, 'Music, Musicians and Muslim Law', (in press).

10. While some Sufis like Rūmī, 'Irāqī, Ibn al-Fāriḍ and Awḥad al-Dīn Kirmānī have referred to the spiritual significance of music in their poetry, others including al-Ghazzālī have written separate treatises or sections of books on the subject usually under the title of *samāʿ*. As the most recent example of this type of work see J. Nour-bakhsh, *Samāʿ in Sufism*, New York, 1976.

11. Rūzbahān Baqlī Shīrāzī was born in Fasa near Shiraz in 522/1128 and died in Shiraz in 606/1209, where his tomb is still a centre of pilgrimage. He was a master of both the exoteric and the esoteric sciences and the author of numerous works including a monumental commentary upon the Noble Quran. His most famous works, however, are the *'Abhar al-ʿāshiqīn*, edited by H. Corbin as *Le Jasmin des fidèles d'amour*, Tehran-Paris, 1958, and again by J. Nourbakhsh, Tehran, 1349 (A.H. solar); and *Sharḥ-i shaṭaḥiyyāt*, edited by H. Corbin as *Commentaire sur les paradoxes soufis*, Tehran-Paris, 1966. A *shaṭḥ* is a paradoxical or ecstatic saying which contains a pro-found esoteric significance. Rūzbahān assembled the early sayings of Sufis which belong to this category and commented upon them. He thereby gained the title of 'Sultān al-shaṭṭāḥīn', the king of those who express paradoxical utterances. He has also been aptly called by Corbin one of the foremost among the *fedeli d'amore* of Islam. On his life and doctrines see the French prolegomena of Corbin to the above cited editions of Rūzbahān and also H. Corbin, *En Islam iranien*, vol. 11, pp. 9–146.

12. *Risālat al-quds*, ed. by J. Nourbakhsh, Tehran, 1351 (A.H. solar), pp. 50–54, 'Fī bayān al-samāʿ'.

13. These are among the most famous of the early Sufis whose inner spiritual states and outward utterances have been echoed in later chapters of the history of Sufism over the ages.

14. This is in reference to the *Sharīʿite* division of human actions into the obliga-tory (*wājib*), permissible, (*mubāḥ*) and unlawful or forbidden (*ḥarām*). For example, the eating of pork is forbidden, choosing a certain colour of one's everyday dress is permissible, and performing the daily prayers obligatory.

15. By 'nature' is meant the imperfect nature of most men dominated by the passions (*ṭabīʿat*) and not the primordial nature (*fiṭrah*) which lies also within the heart of every man but which is hidden and veiled in most cases by the state of negligence, ignorance, and passion or by that condition which is interpreted by Sufis as the state of *ṭabīʿat*.

16. By 'without foundation', Baqlī means in an absolute sense independent of the audience and not without principles.

17. This is in reference to the pre-eternal covenant between man and God men-tioned in the Quran, 'Am I not your Lord?' (VII: 172)

18. For an explanation of these terms see the next chapter, especially p. 167.

X

The Influence of Sufism
on Traditional Persian Music[1]

HE RELATION between spirituality and Islamic art in its
musical form can be seen with great intensity and clarity
in classical Persian music, which is one of the most
important and enduring musical traditions of the Islamic
peoples. Traditional Persian music like all art´ of a spiritual
nature arises from silence. Its peace and calm manifest the
eternal Truth in the framework of sounds belonging to the
world of forms and appearances, although that Truth itself is
beyond every kind of form, determination, and particulariza-
tion. The quiet and serenity of this music is the seal of the world
of the Spirit impressed upon the countenance of the world of
form. The root of every melodious sound takes shape within
the depths of this vast world of silence, a world which
transcends every kind of sound although all sounds draw their
existence from its life-giving power.

Man himself is situated between two worlds of silence, which
in a certain respect are ambiguous and unknown for him. The
first is the period before birth, and the second that after death.
Between them human life is an instant which like a sudden
cry shatters this infinite silence for a brief moment, only to
become united with it. But a deeper study shows that what
appears to man as nothingness or silence, that is, the stage
beyond the life of this world, is pure Being, and what is appar-
ently being—the fleeting instants of life in this material
universe—is only the reflection and shadow of that tran-
scendent Being. Man's life also is no more than noise and
clamour in the face of that eternal silence which is the most
profound of all music. The life of this world comes to possess

meaning only when it joins that silence and transforms the noise and uproar of the external world into the enchanting song of the world of man's inner dimension.

Sufism is a way that provides access to the silence hidden at the centre of man's being, that silence which is the most beautiful form of music heard only by the sages and the source of all meaningful activities and actions, itself the origin of life and of man's existence. Sufism is a Divine Trust originating in the Mercy of God and placed within the Islamic revelation as its heart. It is a key given to man with which he can unlock the secret of his own existence and come to possess the forgotten and neglected treasure hidden within his being. Sufism gives to man the means to know himself and thus to know God, to listen to the music of silence. With the help of the doctrines and methods of the spiritual path man is able to understand who he is, to die to what he is in an illusory manner in order to come alive to what he is in reality. Sufism is able to lead man to that quiet and peace which is hidden at the centre of his being and whose attainment is possible at all times and all places. It can deliver him from the crushing storm of events in this life and the uproar of the external world— without it being necessary that he abandon that world. In Sufism man is delivered by means of an inner transformation which takes place here and now, within the framework of his normal life. As a result he is enabled to hear the inward music of all beings and, above the noise of everyday life, to listen to the music of the Silence of Eternity.

In order to express its truth Sufism can make use, and has in fact made use, of every legitimate means, from weaving to archery, from architecture to music, and from logic to traditional theosophy (*ḥikmat-i ilāhī*). The goal of Sufism is to lead man from the world of form to the world of the Spirit; but since he lives in the world of form and at the beginning of the spiritual path is not detached from it, by means of this very world of form Sufism turns man's attention towards the spiritual world.

Form is the veil of the spiritual world; but at the same time it is its symbol and the ladder by means of which union with it can be attained. As the poet Awḥadī Kirmānī has said;

<div dir="rtl">

زان می نگــرم به چشم سر درصورت زیــرا که زمعنی است اثــر درصــورت

این عالم صورت است و ما درصوریم معـنی نتــوان دیــد مگــر درصــورت

</div>

*I gaze upon form (ṣūrat) with my physical eye because
there is in form the trace of the Spirit (maʿnā).
This is the world of form and we live in forms; the spirit
cannot be seen save by means of form.*

A limited few can reach the stage of complete detachment
from the material world (*tajarrud*) without need of material and
formal support. But most of those who possess the necessary
qualifications for the spiritual life can only reach the world of
the Spirit through form, albeit a form so polished and refined
by traditional art that the darkness and opacity of multiplicity
has been lifted from it so that, like a mirror, it reflects the beauty
of the spiritual world. This form, as we have already seen, can
be a geometrical figure in architecture, a design in painting
or calligraphy, or a melody in music. For this very reason Suf-
ism has made use of all of these possibilities and has had such
a profound effect upon nearly all aspects of Islamic art.

But among the traditional arts music has a special place, for
it deals less with material forms and shapes than do all the
other arts and is connected more directly to the world of
spiritual essences (*mujarradāt*). It is not without reason that
the Hindus consider the first art sent from Heaven for men to
have been music, and that the Muslim gnostics (*'urafā'*) con-
sider music to be the best means to express the subtlest of divine
mysteries. To restate the words of Jalāl al-Dīn Rūmī, traditional
music expresses the mysteries of the eternal covenant between
God and man (*asrār-i alast*) behind the veil of melody.

Although its origin is the transcendent world, man's spirit
became joined to the earthly body through a talisman, whose
secret is known only to God and thus his life in the lower world
came into being. But the spirit always retains a memory of its
original dwelling and first homeland, and all of man's efforts
to reach perfection, even if limited to the material world, have
their roots in this remembrance. In the transcendent world the
spirit of man listened perpetually to a never ending concert
from whose harmony and beauty it benefited and in which it

participated. By means of traditional music the spirit in its bodily prison once again remembers its original homeland. The talisman through which it has been joined to the body may even be broken, thus allowing the bird of the spirit, even if only for a few moments, to spread its wings and fly in the unlimited expanse of the spiritual world and to participate in the joy and ecstasy which is an essential aspect of this world. In the words of Sa'd al-Dīn Ḥamūyah:

دل وقــت سمــاع بوی دلــدار برد جان را به سراپــردهٔ اســرار برد

این زمــزمــه مرکبی است مر روح ترا بردارد و خوش به عالــم یار برد

When the heart attends the spiritual concert (samā')
It perceives the Beloved and lifts the soul to the abode
of the Divine Mysteries.
The melody is the steed of thy soul;
It raises it up and takes it joyfully to the world of the
Friend.

The man who has reached the state of spiritual perfection has of course no need for any kind of steed or vehicle, for he himself possesses the power of flight. But until this stage is reached, music of a spiritual nature, such as the traditional music of Persia, can be one of the most powerful means for awakening the qualified person from the sleep of forgetfulness (*ghaflah*). Sufism took the music of ancient Persia and like so many other forms polished and perfected it until it became a vehicle sufficient for its purposes. That is why, from the point of view of the effect that this music leaves upon the soul of man, it matters little what its origin might have been, whether it was of the Barbad school or whether it reaches back to the Achaemenian period. What is important is that it was able to come under the influence of Sufism and be transformed by it in such a way that an inward and spiritual dimension came into being within it, thus bringing the spirit of the person quali-fied for spiritual ascent into union with the Beloved.

The relationship of traditional Persian music with Sufism is not accidental, nor is it merely historical. Rather, it has the nature of a profound reality which has left a considerable influ-

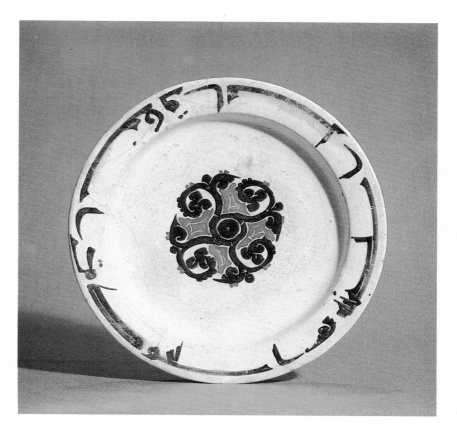

Even the utensils of daily life were adorned with Quranic calligraphy as shown in this 4th/10th century Persian plate from Khurasan. In this way the Muslim was forever reminded of God's presence in his life and in all his acts, whether great or small.

OVERLEAF This Safavid miniature of the *Conference of the Birds* of the Persian poet Farīd al-Dīn 'Aṭṭār is not a depiction of the natural world as usually understood, but rather of the imaginal world (*'ālam al-mithāl*) wherein the tale of 'Aṭṭār itself takes place.

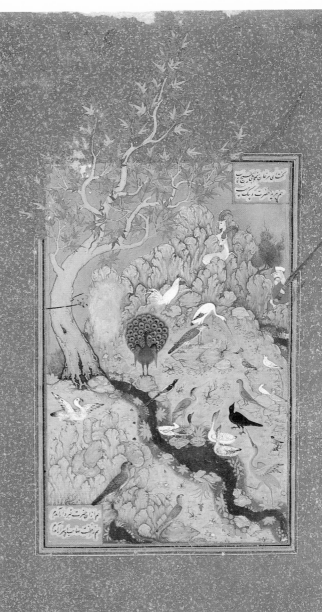

ence upon the way this music affects the soul of the listener.
In order for this point to be fully understood, it is necessary
to take into consideration the stages of the spiritual path (*sayr
wa sulūk*). Although there are various ways of describing and
explaining the way toward union with God in Sufism, these
can be summarized in three main stages: the first is that of
'contraction' (*qabḍ*). In this stage a certain aspect of the human
soul must die; this stage is connected with asceticism and piety
and with the manifestation or theophany (*tajallī*) of the Divine
Names of Justice and Majesty. The second stage is 'expansion'
(*basṭ*), in which an aspect of the human soul is expanded so
that man's existence passes beyond its own limits until it
embraces the whole Universe, and man can say with Saʿdī:

به جهان خرم از آنم که جهان خرم از اوست

I am joyful in the world because the world is joyful in Him.

This stage is accompanied by happiness and ecstasy and is
the manifestation of the Divine Names of Beauty and Mercy.
The third stage is union with the Truth (*wiṣāl bi'l-Ḥaqq*) by
means of reaching the stations of extinction (*fanā'*) and perma-
nence (*baqā'*). At this level the gnostic has passed beyond all
other stations (*maqāmāt*) and has attained to contemplation
of the Face of the Beloved. He sees with manifest clarity that,
in the words of Hātif of Isfahan:

که یکی هست و هیـچ نیست جز او وحـــده لا الـه الّا هـــو

He is one and there is naught but He:
There is no God save Him alone.[2]

Music is concerned with the second and third stages and not
with the first. That is why in Islam, the Divine Law or *Sharīʿah*
discourages listening to music unless it be for special occasions
such as those mentioned above or, of course, that highest and
purest form of musical melody, the recitation of the verses of
the Quran, for the injunctions of the *Sharīʿah* are concerned
with religious commands and prohibitions and with Divine

Justice. But in Sufism, which is concerned with the spiritual path, music has been permitted and in some orders, like the Mawlawiyyah and the Chishtiyyah, it has even possessed considerable importance.

The spiritual profundity of present-day traditional Persian music has its origin in the Islamic teachings themselves, which turned music toward the world of the Spirit. While Western music during the past two centuries has been for the most part an attempt to reach the second of the above three stages—causing the soul to undergo an expansion which is not always connected with a spiritual influence nor in itself of a spiritual nature and without the listener passing initially through asceticism, piety, and detachment from the world—the traditional music of Persia and of the other Islamic countries has been based on consideration of the reality of the first stage and its effect upon the soul and mind of the listener. This is also true of the music of North India, which has been composed and performed to a large extent by Sufis and many of whose greatest masters down to the present day, such as Riḍā Qulī Khān, 'Ala'uddīn Khān and Bismillāh Khān, have been Muslims. The profundity of traditional Islamic music, which pulls man away from the material world and plunges the roots of the tree of his existence into the world of the Spirit, is due to the fact that the men who have composed and performed this music have themselves reached the stage of detachment and possess spiritual states (ḥāl) in the truly gnostic ('irfānī) meaning of the term.

As the words of Ruzbahān Baqlī already cited demonstrate, the Sufis have been completely aware of the above facts and have considered listening to music and 'spiritual concerts' (samā') as permissible only for those who have gone beyond the first stage in the development and perfection of the soul, this stage being none other than the subjugation of the animal passions. Ghazzālī in his book *Alchemy of Happiness* (*Kīmiyā-yi sa'ādat*) has written the following in the chapter called 'On Discussions of Listening to Music (*samā'*) and the Explanation of What is Permitted of it and What is Forbidden':

'Know that God, the Exalted, possesses a secret in the heart of man which is hidden like fire in iron. Just as the secret of

fire becomes manifest and apparent when iron is struck with a stone, so listening to pleasing and harmonious music brings man's essence into movement and causes something to come into being within man without his having a choice in the matter. The reason for this is the relationship that exists between the essence of man's heart and the transcendent world, which is called the world of spirits (*arwāḥ*). The transcendent world is the world of loveliness and beauty, and the source of loveliness and beauty is harmony (*tanāsub*). All that is harmonious manifests the beauty of that world, for all loveliness, beauty and harmony that is observable in this world is the result of the loveliness and beauty of that world.

'Therefore pleasing and harmonious songs have a certain resemblance to the wonders of that world, and hence an awareness appears in the heart, as well as a movement (*ḥarakat*) and a desire, and it may be that man himself does not know what it is. Now this is true of a heart that is simple, that is free of the various loves and desires which can affect it. But if it is not free of them, and it is occupied with something, that thing comes into movement and becomes influenced like a fire which is blown upon. Listening to music (*samā'*) is important for him whose heart is dominated by the love of God, for the fire is made stronger, but for him in whose heart is full of love for vanity, listening to music is a deadly poison, and it is forbidden to him.'[3]

The Sufis have allowed participation in the spiritual concert to only those individuals who are spiritually prepared and qualified, that is, those who have escaped from the abyss of the material world and its attractions. Thus, in the words of Sa'dī:

نگـویم سمـاع ای برادر که چیست مگـر مستـمـع را بدانـم که کیست

گر از برج معنـی پرد طیـر او فرشتـه فرو مانـد از سیـر او

وگـر مرد سهـو اسـت و بازی ولاغ قویـتـر شود دیـوش انـدر دمـاغ

چویـشـان شود گل به باده سحـر نه هیـزم که نشـکـافـدش جز تبـر

جهـان بر سمـاع است و مستی و شور ولـیـکـن چه بیـنـد در آئـیـنـه کور

I will not say, O Brother, what the spiritual
concert is,
Until I know who is listening to it.
If he begins his flight from the tower of the Spirit.

169

The angels will not keep up with his soaring.
But if he be a man of error, vanity and play,
The devil in his brain will grow more powerful.
The rose is torn apart by the morning breeze,
But not the log; for it can only be split by an axe.
The world subsists on music, intoxication and
ardour,
But what does the blind man see in a mirror?

The influence of Sufism on traditional Persian music derives more than anything else from the fact that Sufism has made of music a vehicle for the ascent of the spirit to the transcendent world, but only for those who have taken upon themselves the difficulties of asceticism and spiritual discipline, the first stage of which is piety and fear of God. For the same reason those who enjoy this music without having passed through the first stage of the spiritual path will never attain to the unlimited expanse of the transcendent world, and if their soul takes to flight in that world for a few moments with the help of this celestial music, it will immediately fall back when the music ends and they will not be able to maintain their spiritual state.

Then again, the musician who plays this music, precisely because it was composed by men who themselves possessed spiritual stations, who were empty of themselves and who played this music in a state of spiritual ecstasy, can only perform it well if in turn he first forgets himself. Traditional Persian music is too profound for a person to be continually in its intimacy and to play it well without there first being some kind of spiritual transformation and forgetfulness of his ordinary, profane state. Many people ask why today a number of those who perform traditional Persian music are addicted to narcotics. The probable reason is that many of them do not benefit from the grace which derives from Sufism and gnosis nor possess the means to reach spiritual states and stations through genuine Sufi and gnostic ways; therefore they resort to the only way which they have to forget themselves for a few moments. In any case, what is certain from the point of view of Sufism is that spiritual profit from music is only possible through the polishing of the soul and the slaying of the dragon

within ourselves. This alone can deliver the bird of the spirit and prepare it for the ascent which music of a spiritual nature can make possible.

The spiritual ascent which is accomplished by means of traditional Persian music is of several kinds. One kind is reached through the melody, which takes man step by step from one spiritual state to another, and finally to the state of spiritual joy and ecstasy. Also the system begins with a particular note which is its principle and the melody always returns to that note never leaving the Centre to which the music returns throughout the duration of the performance. The total experience of the music is therefore one of living in a cosmos of sound with a Centre to which the musical composition leads the listener, the reaching of the Centre being of course none other than the musical counterpart of spiritual ascent. Another way of attaining this goal is through the rhythm and metre of the music, which changes the relationship of man with ordinary time—the most important characteristic of the life of this world. Persian music possesses extremely fast and regular rhythms, and moments in which there are no beats or any form of temporal determination. In the first instance man is united with the pulsation of cosmic life, which in the human individual is always present in the form of the beating of the heart. Man's life and the life of the cosmos become one, the microcosm is united to the macrocosm, and thus man's spirit undergoes expansion and participates in the joy and ecstasy which encompass the world and which man fails to perceive only because of his state of forgetfulness of God (*ghaflah*). In the second case, which transcends all rhythm and temporal distinction, man is suddenly cut off from the world of time; he feels himself situated face to face with Eternity and for a moment benefits from the joy of extinction (*fanā'*) and permanence (*baqā'*).

The perfect gnostic has no need of music or any other traditional art, for he and his life are themselves works of art. Nevertheless, since his inward senses have been awakened, it can be said that he is constantly in the state of listening to the spiritual concert. The whole world is for him an eternal song. He sees existence forever accompanied by harmony and

beauty. In the same way that through his vision he sees this beauty in the form of the colours and shapes of the world of nature and of creation, through his hearing he hears it in the form of music. His life is never separated from music, its happiness and joy. If he listens to and enjoys a traditional musical composition, it is only because this music, which has originated in the silence of the Spirit, confirms his own inward states. And if he seeks to keep away from what some people today call music, but which is no more than noise and cacophony devoid of any meaning or spiritual value, it is because listening to it disturbs his inner spiritual state; its lack of harmony disrupts and dissipates the song at the centre of his being. At the same time, if this individual is talented in the composition and performance of music, as many of the Sufis have been—and the majority of the great masters of traditional Persian music have been connected with Sufism—what he composes and performs will be a reflection of his spiritual states covered by a veil of sounds, the combination of which will result in a melody which can guide the listener towards these states.

It can also be said that the Sufi is himself an instrument in the hands of the Creator, and what he produces is a song played by the celestial Musician and heard within his being. The world itself is like a song composed of harmonious sounds, the combination of which results in a melody which can guide the listener towards those states. Since the gnostic has torn apart the veils of separative existence and become united with his original state and primordial nature, he also, like the world, echoes a melody which his being produces in as much as he is an instrument upon which God plays what He wills. What joy could be greater than that a man not only listen to the Divine Concert, but also be himself the means for playing its music? That man, through submitting his own volition to the Divine Will, places himself completely in God's hands and becomes the source of melodies which spread joy and felicity and guide man towards his primordial home and ultimate abode.

In today's world when access to genuine spirituality becomes more difficult every day, and when that beauty which at one time was everywhere has come to be considered a luxury, tradi-

tional music possesses an extraordinary value, for it is like a refuge amidst a terrifying storm and a fresh and luxuriant oasis in the midst of a burning desert. Today many are interested in this music without themselves knowing the profound reason for it. In reality these people are searching for the spiritual life and that quiet and peace which is hidden in the substance of music of a spiritual nature. They are seeking 'the mysteries of the eternal covenant between man and God, within the veil of melody', the beauty of which attracts them to itself; its apparent sorrowful exterior is but the preface to the indescribable joy hidden within it.

Today, for Persians as well as other Muslims and traditionally oriented people in general, traditional Persian music, which is one of the finest art forms of Islam in its wedding to spirituality, can be a spring full of grace for satisfying the lost and thirsty soul, a place of refuge from the negative influences of the times and, for some at least, a guide from its own wondrous beauty to the beauty of the Absolute. Since this music is the song of the eternal world in the world of time and space, it undergoes no degeneration or corruption. Like the sun at dawn its message is always fresh and alive. It is for us to open our eyes and ears so that with the help of its melodies and of course with Divine Succour we can be delivered from that death which is falsely called life, and attain that true life which knows no eclipse. It is for us to realize the worth of this valuable heritage, which, like the other aspects of the extremely rich culture of Islam, we are in need of now more than at any other time in history.

مطرب بگو که کار جهان شد به کام ما ساقـی بەنـور باده برافـروز جام ما

ای بیـخـبـر زلـذت شرب مدام ما ما در پیـالـه عکس رخ یار دیـدەایـم

ثبـت اسـت در جریـدهٔ عالـم دوام ما هرگز نمیرد آنکه دلش زنده شد بەعشق

O cup-bearer, brighten our goblet with the light of
wine!
O minstrel, tell how the world has succumbed to our
desires!
We have seen in the cup the reflection of the face
of the Friend,

173

O you who know nothing of the joy of our eternal
wine-drinking!
He whose heart has been made living by love never
dies;
Our permanence is recorded within the pages of the
cosmic text.

(Ḥāfiẓ)

NOTES

1. Written originally in Persian, this essay was first translated by W. Chittick into English and later revised by the author for this book.

2. This verse is the 'refrain' of Hātif's celebrated *tarjī'band*, one of the most famous poems in Persian Sufism, which was translated by E. G. Browne in his *Literary History of Persia*, vol. IV, Cambridge, 1924, pp. 292–297.

3. Ghazzālī, *Kīmiyā-yi saʿādat*, edited by Aḥmad Ārām, Tehran, 1345, p. 370.

THE PLASTIC ARTS

XI

'The World of Imagination' and the Concept of Space in the Persian Miniature

THE RAPPORT between Islamic art and spirituality can of course also be observed in the plastic arts ranging from decorations on vases to stucco ceilings. The patterns and forms of Islamic art are all related to those spiritual and intellectual principles which we have had occasion to mention in earlier chapters of this work. To make an exhaustive study of this subject in fact would require delving into the symbolic meaning of calligraphic styles, the arabesque, geometric patterns, colour symbolism, and many other facets of Islamic art. Here, since our purpose is not to carry out an exhaustive survey but to provide illustrations for the principles involved in the relation between Islamic art and spirituality, we shall turn our attention to the subject of space in the Persian miniature. Like so many other facets of Islamic art much has been written on the Persian miniature, but save for a few in-depth studies,[1] little attention has been paid to the spiritual significance of this dazzling art form and its relation to the concept of time, space, form and more generally reality as such in the culture which produced this art form. The concept of space in Islamic art and especially in the Persian miniature remains, then, a relatively unexplored field which deserves to be studied in greater depth.

The Cartesian dualistic view of reality left European science and philosophy, and through them the general view of Western men, with but two alternative domains of reality: the world of the mind and the world of extension or space which became identified exclusively with the material world. When we speak of space today, whether it be the linear space of Newtonian

physics or the 'curved space' of relativity, we are exclusively concerned with the spatio-temporal domain of reality which we identify with reality as such. We can hardly conceive of a 'non-physical' space, which is not the creation of man's whims and fancies but possesses an ontological reality of its own. Yet, it is precisely with such a space that sacred art, and more particularly Persian art deals.

To conceive of space which is more than physical space and whose experience certain types of sacred art seek to make possible through their techniques and symbolism, there must exist a discontinuity between the space created by this art and the physical space in which man lives in his profane life. As long as there is mere continuity with profane space, it is not possible to experience the transcendent dimension which leads *beyond* physical space and the physical world. As we have seen in the sacred art *par excellence* of Islam, namely the mosque, space is not meant to be 'supernatural' as opposed to 'natural'. Rather, it is a space which recreates the peace and harmony of virgin nature by dissolving the tensions and disequilibria of the mundane world. But by this very fact it creates in its own way a differentiated and qualitative space which places man in the presence of the Eternal by removing the tensions and stresses that characterize man's terrestrial and temporal life.[2]

As for the Persian miniature, it is also based on the heterogeneous division of the two-dimensional space involved, for only in this way can each horizon of the two-dimensional surface come to symbolize a state of being as well as a degree of consciousness. And even in those miniatures where there is an integration of space and the creation of a homogeneous space, this whole space is clearly distinguished by its 'non-three-dimensional' character from the natural space around it. It is therefore itself a recapitulation of the space of another world and concerns another mode of consciousness. The law of perspective followed in the Persian miniature, before influences of Renaissance art along with internal factors brought about its decay, is one based on natural perspective, the *perspectiva naturalis*, whose geometric laws were developed by Euclid and later by Muslim geometers and opticians such as Ibn al-Haytham and Kamāl al-Dīn al-Fārsī. The miniature remained

178

faithful to the law of this science, and in conformity with the 'realism' of the Islamic view did not betray the two-dimensional nature of the surface by making it *appear* as three-dimensional, as was to happen through the application of rules of 'artificial perspective', the *perspectiva artificialis*, during the European Renaissance.[3] By conforming strictly to the non-homogeneous (or heterogeneous) and qualitative conception of space, the Persian miniature succeeded in transforming the plane surface of the miniature to a canvas depicting grades of reality, and was able to guide man from the horizon of material existence, and also profane and mundane consciousness, to higher states of being and consciousness, to an intermediate world with its own space, time, movement, colours and forms,[4] where events occur in a real but not necessarily physical manner. This world the Muslim philosophers of Persia have called the 'imaginal world' (*mundus imaginalis*) or the *'ālam al-khayāl*.

Before turning to analyse the features of the 'imaginal' world—almost unknown to the modern topography of the real—we must pause to answer a possible objection to our spiritual and symbolic interpretation of the Persian miniature. It will be said that mosque architecture and Quranic calligraphy are sacred arts connected directly with the religious life, but the Persian miniature is a courtly art that flourished in the worldly environment of Persian court life and made use of romantic and epic themes having no direct religious significance.

To answer this objection, with which we dealt in more general terms at the beginning of this book, it must be recalled that in a traditional civilization, especially one like Islam where religion dominates all spheres of life, no aspect of human activity is left outside the authority of the spiritual principles least of all that which deals with what would correspond in Western parlance to temporal authority. In terms of Western language it could be said that the purely sacred art of Islam, such as mosque architecture and calligraphy, correspond to 'sacerdotal initiation' and the 'Greater Mysteries' while the miniature and other courtly arts belong to 'knightly and royal initiation' and the 'Lesser Mysteries'. More specifically, in Persia, through the extension of the organization of Sufi orders,

many functions connected with chivalry were directly integrated into Sufism and many of the courtly arts such as miniature painting and music were cultivated by Sufis. There are so many examples of this in the Safavid or even Qajar periods as to make it unnecessary to elaborate here.

The themes chosen for miniatures bear out this point. For the most part they are either epic scenes, depicting battles of ancient Persian heroes as recorded mostly in the *Shāh-nāmah* or tales of moral and spiritual significance drawn from such works as the *Kalīlah wa Dimnah* or the writings of Niẓāmī and Saʿdī. In the first case the heroic scene is transposed above history to a 'transhistorical world' where it also acquires a gnostic (*'irfānī*) and mystical significance in the same way that Suhrawardī was to give a gnostic interpretation to the ancient epics of Iran in his theosophical and mystical narratives.[5] In the second case also, the artistic treatment of the themes takes place in a world above ordinary temporality where it gains a non-temporal and permanent significance. Even the plants and animals that are drawn are not simply those of physical nature but of primordial nature, of the paradisal environment which remains actualized even now in the *'ālam al-khayāl* or *'ālam al-mithāl*. Likewise, the colour of each mountain, cloud or sky is unique unto itself and different from natural colours, the uniqueness pointing to the angelic world where, according to the well known theological doctrine also confirmed by St. Thomas, each angel is unique and comprises its own species. The majority of Persian miniatures depict not a profane world but this intermediary world which stands above the physical and which is the gateway to all higher states of being. Like the 'Lesser Mysteries', which prepare the adept for entrance into the abode of the 'Greater Mysteries', the miniature, along with similar so called 'courtly' arts, is a traditional art of the intermediate world in its positive angelic aspect and by virtue of this character has for its subject what we might call the earthly paradise whose joys and beauties it seeks to recreate.

We must now make clear the meaning and ontological status of this 'world of imagination', the *'ālam al-mithāl*, which has its correspondence in other traditional cosmologies, including those of ancient Persia.[6] The multiple states of being can be

summarized in five principal states which the Sufis call the five 'Divine Presences' (*al-ḥaḍarāt al-ilāhiyyah*),[7] and which Islamic philosophers from Suhrawardī onward have accepted fully as the ground pattern and 'plan' of reality, although they have used other terminologies to describe it.[8] These worlds of presences include the physical world (*mulk*), the intermediate world (*malakūt*), the archangelic world (*jabarūt*), the world of the Divine Names and Qualities (*lāhūt*), and the Divine Essence or Ipseity itself (*Dhāt*), which is sometimes called *hāhūt*.

The *jabarūt* and the states beyond it are above forms and formal manifestation, whereas the *malakūt*, which corresponds to the world of imagination (*'ālam al-khayāl* or *mithāl*), possesses form but not matter in the ordinary Peripatetic sense. That is why in fact this world is also called the world of 'hanging forms' (*ṣuwar al-mu'allaqah*), and later Persian philosophers like Mullā Ṣadra have devoted many pages to its description and the proof of its existence. But from another point of view this world possesses its own matter (*jism-i laṭīf*), which in fact is the 'body of resurrection', for in this world is located both paradise in its formal aspect and the inferno. This world possesses, likewise, its own space, time, and movement, its own bodies, shapes, and colours. In its negative aspect this world is the cosmic labyrinth of veils which separate man from the Divine, but in its positive aspect it is the state of paradise wherein are contained the original forms, colours, smells, and tastes of all that gives joy to man upon the earth. The space of the Persian miniature is a recapitulation of this space and its forms and colours are a replica of this world. The colours, especially the gold and lapis lazuli, are not just subjective whims of 'artistic taste'. Rather, they are the fruit of vision of an 'objective' reality which is that of the imaginal world. The space is depicted in such a way that the eye roves from one plane to another, moving always between the two-dimensional and the three-dimensional. But the miniature does not allow the eye to 'fall' into the three-dimensional pure and simple. If it were to do so it would cease to be a depiction of the *malakūt* and would become simply a replica of the *mulk*. By remaining on another plane, and yet possessing a life and movement of its own, the miniature is able to have a contemplative dimension and to create

an aspect of joy, so characteristic of the Persian spirit, which is an echo of the joy of paradise. Like the good Persian rug and the genuine Persian garden, the miniature serves as a reminder of a reality which transcends the mundane surroundings of human life. The space of the miniature is the space of that 'imaginal world' where the forms of nature, the trees, the flowers, and the birds, as well as the events within the human soul, have their origin. This world itself is in fact both beyond this external world and within the soul of man. It is a world that is often depicted and described in Persian Sufi poetry, as in these verses of the *Mathnawī*, where Mawlānā Jalāl al-Dīn says:

> In the orchard a certain Sufi laid his face in Sufi fashion
> upon his knee for the sake of (mystical) revelation;
> Then he sank deep into himself. An impertinent fellow
> was annoyed by his semblance of slumber.
> 'Why', said he, 'dost thou sleep? Nay look at the rivers,
> behold these trees and the marks (of Divine mercy)
> and green plants.
> 'Harken to the command of God, for He hath said, "Look
> ye": Turn thy face towards these marks of
> (Divine) mercy.'
> He replied, 'O Man of vanity, its marks are (within) the
> heart: that (which) is without is only the marks
> of the marks.
> 'The (real) orchards and verdure are in the very essence
> of the soul: the reflection thereof upon (that which
> is) without is as (the reflection) in running water.
> 'In the water there is (only) the phantom (reflected
> image) of the orchard, which quivers on account
> of the subtle quality of the water.
> 'The (real) orchards and fruits are within the heart: the
> reflection of their beauty is (falling) upon this
> water and earth (the external world).
> 'If it were not the reflection of that delectable cypress,
> then God would not have called it the abode of
> deception.'[9]

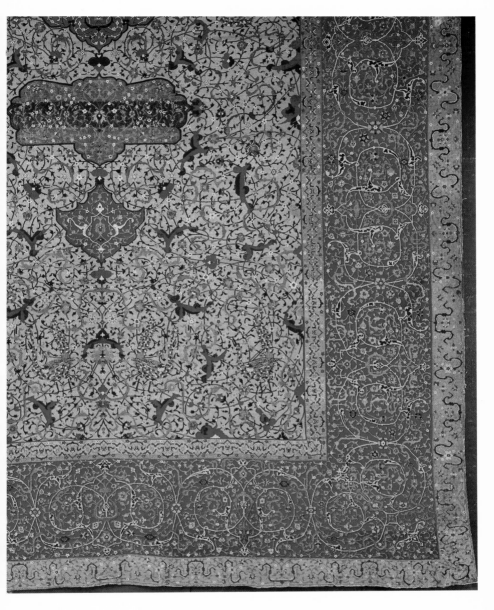

The traditional carpet is the earthly reflection of the cosmos itself. To sit upon it is to be located within a sacred precinct protected by its borders and often looking inward towards the centre where all the patterns meet as in this Safavid carpet from Tabriz known as the 'Anhalt' carpet.

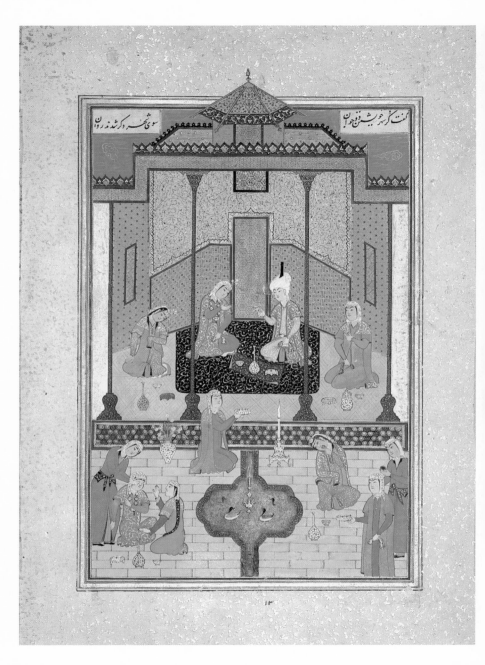

This Safavid miniature of Bahrām-i Gūr and the Chinese Princess from the *Khamsah* is not a depiction of material reality but of that 'intermediate world' whose space and forms have their own norms and laws above and beyond those of physical existence. The treatment of space and the colour symbolism reveal the symbolic nature of the classical Persian miniature and its relation to the imaginal world.

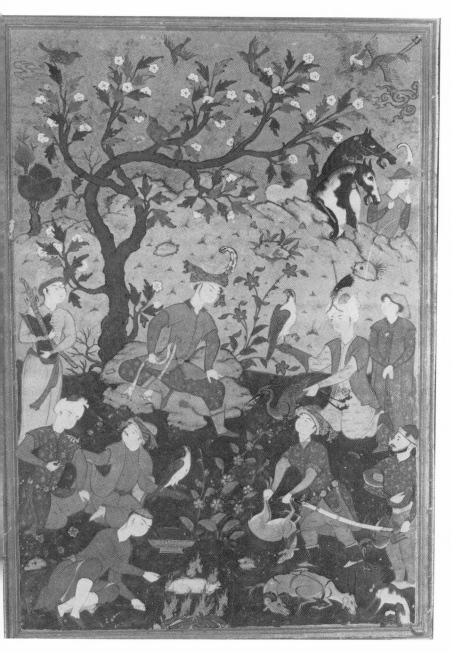

This scene of a hunt from a 10th/16th century Persian miniature from Qazwin depicts not the natural world as usually understood, but that paradisal abode of which virgin nature is a direct reflection.

The function of the genuine Persian miniature, as all sacred and traditional art, is to reflect through symbolism something of that delectable garden in a world which without this reflection would be mere deception.

NOTES

1. The descriptive and historical study of the Persian miniature has been carried out extensively in the West and numerous fine works are to be found dedicated to this aspect of the subject. It is the symbolic and spiritual aspect of the Persian miniature that has been treated seriously much more rarely, only a few essays by such men as T. Arnold, A. U. Pope, R. Ettinghausen, and L. Bronstein being concerned in depth with this subject.

2. Concerning qualified space see chapter 3; also R. Guénon, *The Reign of Quantity and the Signs of the Times*, trans. by Lord Northbourne, London, 1953.

3. See H. Corbin, 'La configuration du temple de la Ka'ba comme secret de la vie spirituelle', *Eranos Jahrbuch* xxxiv, 1963, pp. 83ff.

4. It must be remembered that time, space, matter, form and number are not only aspects of the reality of the physical world but have a universal import for all the levels of the hierarchy of cosmic existence and have their principle even beyond the cosmos in the metacosmic Reality. See F. Schuon, *From the Divine to the Human*, pp. 57–71.

5. See H. Corbin, 'Actualité de la philosophie traditionnelle en Iran', *Acta Iranica* i, Jan.–Mar. 1968, pp. 1–11. This transposition of the epic to the mystical is best seen in the Persian works of Suhrawardī such as *Alwāḥ-i 'imādī* and *'Aql-i surkh*, all of which we have edited in Suhrawardī, *Opera Metaphysica et Mystica*, vol. III, Tehran 1977. For an English translation see W. M. Thackston, *The Mystical and Visionary Treatises of Suhrawardī*, London, 1982.

6. The theme of the intermediary world has been dealt with extensively by Corbin in many of his writings for example, *Spiritual Body and Celestial Earth*, Princeton, 1977; *En Islam iranien*, vol. I, pp. 120ff., *Creative Imagination in the Sufism of Ibn 'Arabī*, Princeton, 1969 and *Mundus Imaginalis – or the Imaginary and the Imaginal*, Ipswich, 1976.

7. See F. Schuon, *Dimensions of Islam*, trans. London, 1970, pp. 142ff.; also W. Chittick, 'The Five Divine Presences: From al-Qunawī to al-Qayṣarī', *The Muslim World*, April 1982, pp. 107–128.

8. See S. H. Nasr, 'The School of Ispahan' and 'Ṣadr al-Dīn Shīrāzi', in *A History of Muslim Philosophy*, ed. M. M. Sharif, Wiesbaden, vol. II, 1966, pp. 904–932, and 932–961.

9. *The Mathnawī of Jalālu'ddīn Rūmī*, trans. by R. A. Nicholson, London, 1930, vol. IV, p. 347.

XII

The Significance of the Void
in Islamic Art

O NE OF THE consequences of the intimate and profound
relation between the spiritual and metaphysical prin-
ciples of Islam and Islamic art in all its aspects, and one
of the results of the influence of the metaphysical principle of
Unity (al-tawḥīd) is the spiritual significance of the void. The
use of the void in Islamic art is one of the most important direct
consequences for art of the metaphysical principle of Unity
(although it is not the sole effect of this principle), for nearly
every facet of Islamic art is in one way or another related to
this principle and its ramifications in the world of multiplicity.[1]

The doctrine of Unity is contained most directly in the
testimony of faith of Islam or the shahādah, Lā ilāha illa'Llāh,
'There is no divinity but the Divine'. This most profound of
metaphysical formulations possesses many aspects and levels
of meaning, two of which concern us here most directly. The
first is the emphasis upon the transient and insubstantial char-
acter of all that is other than God (mā siwa'Llāh) and therefore
the whole of the created order—of which the material is the
most impermanent of all. The second is the emphasis upon the
'otherness' of that which is Ultimate Reality, that is, emphasis
upon the truth that God is completely beyond all that the ordi-
nary mind and the senses can conceive as reality in the usual
meaning of the term, which corresponds to the word 'ilāh' in
the above formulation. According to the first interpretation, if
we consider God as the Ultimate Substance[2] or Pure Being,
remembering that in the terminology of Islamic metaphysics
it is possible to refer to Being as 'thing' (al-shay'), then there
is an aspect of nothingness or void which lies in the very nature
of the whole created order and which is a direct consequence

185

of the fact that, in an absolute sense, only God is real. According to the second interpretation, if we look upon objects as things in the ordinary sense, then the void, or that which is empty of things becomes a trace and an echo of God in the created order, for through its very negation of 'things' it points to that which is above and beyond all things. The void, therefore, is the symbol of both the transcendence of God and His presence in all things. This basic metaphysical principle founded upon the *shahādah*, and also the refusal of Islam to base its perspective upon the concept of the God-man—a refusal which is itself closely allied to the Islamic emphasis upon Unity—are the profound reasons for the important role played by the void in Islamic art and explain the spiritual significance it possesses as a powerful symbol in both art and architecture.

Islamic art has always sought to create an ambience in which the transient and temporal character of material things is emphasized and in which the vacuity of objects is accentuated. But if objects were to be completely unreal and absolutely nothing, there would be no existing objects to start with and no art about which to speak. The reality of the situation in all its fullness, however, encompasses both the illusory aspect of things and their being reflections and positive symbols of the higher orders of reality and finally of the Ultimate Reality Itself. Both aspects have to be emphasized. To the one corresponds the void, and to the other the 'positive' material, form, colour, and so forth, employed in a work of art. Together they depict the full reality of an object, chiselling away its unreality and illuminating its essential reality as a positive symbol and harmonious whole. The combining of these two aspects is seen clearly in the case of the arabesque, so characteristic of Islamic art, where both the negative space and the positive 'form' play an equally central role. The arabesque enables the void to enter into the very heart of matter, to remove its opacity and to make it transparent before the Divine Light. Through the use of the arabesque in its many forms, the void enters into the different facets of Islamic art, lifting from material objects their suffocating heaviness and enabling the spirit to breathe and expand.

Likewise, the arabesque, through its extension and repetition of forms interlaced with the void, removes from the eye the

possibility of fixing itself in one place and from the mind the possibility of becoming imprisoned in any particular solidification and crystallization of matter. This refusal to identify, even symbolically, any concrete form with the Divinity stems, of course, as much from the Islamic insistence upon Divine Unity as does the absence of an icon which would symbolize the God-man or the incarnation found in other traditions. Because there is no sacred image in the Christian sense in Islam, man does not project himself outwardly by identifying himself in one way or another with the image of the God-man. The painting of the image of the Universal Man (*al-insān al-kāmil*), which is the closest concept in Islam to the God-man in other religions, is as much forbidden in Islam as is depiction of the Divinity. Therefore, man must concentrate his mind within himself and remain collected inwardly, for only through this inward collectedness and contemplation can he gain an awareness of the Divinity.

Islamic aniconism,[3] which removes the possibility of the concretization of the Divine Presence (*ḥuḍūr*) in an icon or image, is a powerful factor in intensifying the spiritual significance of the void in the Muslim mind. Through it as well as the metaphysical principle of Unity the void has been made into a sacred element in Islamic art.[4] God and His revelation are not identified with any particular place, time, or object. Hence His Presence is ubiquitous. He is everywhere, in whichever direction one turns, as the Quranic verse, 'Whithersoever ye turn, there is the Face of God' (11; 115), affirms. Hence emptiness in art becomes synonymous with the manifestation of the sacred. The mosque, whether it be a simple construction as in the early period such as that of Damghan or the recently destroyed one of Damavand, or the most ornate such as those of Fez, Isfahan, Mashhad, or Lahore, conveys the sense of the Divine Presence through its emptiness. As mentioned already, this is achieved in the case of the first type of mosque through the actual absence of diverse forms and colours and in the second through geometrical and floral designs, through the use of colours, through the arabesque in all its variety, and also by means of calligraphy. In the case of calligraphy the negative patterns are nearly as important as the positive, especially in

187

the *Kufic* and, at the other extreme, the *shikastih* forms. Many calligraphic designs are justly famous as much for the patterns created from empty spaces as for the lines traced by the script itself. Examples of this positive use of the void in calligraphic patterns abound, from Seljuq minaret designs in Persia to windowpanes in palaces in the Maghrib.

It can be said that through calligraphy as well as the arabesque and geometric patterns an awareness of the relation between the void and the Divine Presence is achieved in Islamic art, an awareness which is also closely related to the spiritual attitude of poverty (*faqr*). All Islamic art, of which Persian art contains some of the most remarkable examples, contains an affirmation, even through material objects, of the Quranic verse 'Allah is the rich and ye are the poor (*fuqarā'*)' (XLVII: 38, Pickthall trans.). Even the luxurious and ornate art of Safavid Persia or Umayyad Andalusia is able to realize this 'poverty' and to remain faithful to the principle that the void symbolizes the sacred and the gate through which the Divine Presence enters into the material order which encompasses man in his terrestrial journey.

The void thus removes the constricting effect of the cosmic environment upon man, for whenever and wherever the veil of matter is removed the Divine Light shines through. To be in a room uncluttered by furniture, to sit on a carpet of traditional design woven of arabesque patterns and stylized forms, to stand in a mosque that is empty and depicts Unity either through its simplicity or its ornament yet whose very ornamentation is based on the importance of emptiness and the void and which depicts multiplicity in Unity, is to gain a spiritual experience of the void through art. And this experience leads to an expansion (*inshirāḥ*) which breaks the effect of the cosmic contraction upon the soul and places man before the Divinity, making him aware of the ubiquitous Divine Presence.

The positive significance of the void is also to be seen in the role that space plays in Islamic architecture and city-planning. In Western architecture of either the classical, medieval, or modern periods space is defined by a positive form such as a building or a statue. It is the object that determines the space around it and gives this space its meaning and determination.

188

In Islamic architecture space possesses a negative sense. Space is not determined by a positive object but is defined by the absence of corporeality. It is once again an aspect of the void and is what, for want of a better term, one could call 'negative space'.[5] The close rapport existing between traditional art and cosmology enables us to understand this concept of space in Islamic art and architecture by appealing to the definition of space found in Islamic cosmological works.[6]

In most schools of Islamic cosmology the highest heaven defines the space below it and is therefore referred to as 'that which limits and defines (*muḥaddid*) space'. Cosmic space is defined in relation to the inner surface of the outermost sphere rather than by any positive object such as the earth or planets. Space is, as it were, carved out from the plenum of cosmic creation and is conceived with respect to a surface that surrounds it rather than an object which it surrounds. There are, of course, other possible cosmological definitions of space and the Muslim authors have been far from unanimous in the way they have defined space. But the viewpoint just mentioned predominates and it is precisely this view which finds its correspondence and application in art.

In Islamic architecture and city-planning space is defined in exactly the same way by the inner surface of surrounding forms rather than by a positive, concrete object. It is in itself negative and is directly connected to the spiritual symbol of the void. The inner walls of the garden define the space of the Persian garden and not any object such as a building or a pool in the middle of it. It is likewise the walls of the surrounding structures that define the space of the bazaar in the traditional city where, in walking through narrow streets, the space, which is the absence of corporeality and therefore appears identified with the void, is like a path cut through the density of material forms so as to enable the spirit to breathe in a world which would otherwise suffocate it. Hence the special significance of the expansion of this negative space which occurs most often in the mosque courtyard into which the narrower space of the bazaar or street opens and also in the courtyard of private houses to which the narrow spaces of streets and alleys lead.

For anyone who has experienced fully the sense of space in

the streets of Fez or the bazaar of Isfahan, the sudden opening of this space into a large courtyard of a mosque, a private house or a traditionally constructed square generates an immediate sense of expansion and joy. For the Muslim this sense is always combined with an intensification of the awareness of the Divine Presence which is invariably accompanied by the experience of joy. It is not accidental that the term *inbisāṭ* in Arabic and Persian means both expansion and joy, or that the intensification of faith and spiritual experience are related in Islam, following the language of the Quran, to the expansion of the breast (*inshirāḥ al-ṣadr*).[7] The skilful use of negative space by Muslim architects and city-planners, basing themselves on the positive significance of the void in the Islamic religious consciousness, was thus able to create a space in which the very absence of corporeality led to inwardness and contemplation, as in the garden, and expansion and spiritual joy, as in the large mosque spaces adjoined to the enclosed and negative space of the bazaar and the streets of traditional Islamic cities.

The void then plays a positive role in both Islamic art and architecture by making matter transparent and revealing its impermanent nature and at the same time by infusing even material forms with the Divine Presence. Because in Islam the Divinity was never identified with any descent or concrete manifestation or incarnated in a specific form, it has remained always in the Islamic consciousness as absolute and infinite so that while being fullness and complete richness in Itself It appears from the point of view of men living in the domain of corporeality as a reality so transcendent and beyond the material that its presence can be felt in the corporeal world only with the help of the void. The use of the void in Islamic art thus became, along with the use of geometric and other forms of abstract symbolism, the only way to indicate through the means of art and architecture the Unity which is at once everywhere and beyond all things. Through its use in the plastic arts, not unrelated to the use of silence in music and poetry, Islamic art became the vehicle for the expression of that spirituality which lies at the heart of Islam, that Unity which is the alpha and omega of faith itself, according to the saying of the Master Sufi Maḥmūd Shabistarī who sang:

The Significance of the Void in Islamic Art

یکـی بیـن و یکـی گوی و یکـی دان بدین ختم آمـد اصــل و فرع ایمـان

See unity, utter unity, know unity,
In this is to be summarized the trunk and branches of
the tree of faith (īmān).

(*Gulshan-i rāz*)

NOTES

1. See T. Burckhardt, *Sacred Art in East and West*, chap. IV; T. Burckhardt, 'Perennial Values in Islamic Art', in Ch. Malik (ed.), *God and Man in Contemporary Islamic Thought*, Beirut, 1972, pp. 122–31; F. Schuon, *Spiritual Perspectives and Human Facts*, trans. D. M. Matheson, London, 1953.

2. This is not of course in the sense given to the term 'substance' by Islamic philosophers who define substance (*jawhar*) in such a way that God remains above the category of substance. In using the term substance we mean rather that which is itself, and which relies only upon itself as its source of reality. Seen in this light, ultimately only God is Substance in the absolute sense. There is in fact a *ḥadīth* in Shi'ite sources in which God is referred to as *shay'*. It states, 'Verily the Exalted (Allah) is *shay'* but not like things (*ashyā'*). And He is *shay'* according to the true meaning of "thingness" (*shay'iyyah*)'. (*Innahᵘ taʿāla shay'ᵘⁿ lā ka'l-ashyā' wa-innahᵘ shay'ᵘⁿ biḥaqīqat al-shay'iyyah.*) See chapter 9 of Part III of *Biḥār al-anwār*, Majlisī's compilation of Shi'ite *Ḥadīth*, entitled 'Prohibition of speculation concerning God's Essence and investigation of questions of Divine Unity and of the use of the term "thing" concerning Him', where several similar *ḥadīths* are cited, Tehran, 1376, (A.H. lunar), pp. 257–67.

3. Aniconism must not be confused with the prohibition of the painting of living beings. The first is a basic aspect of Islam practised by all Muslims and the second an injunction to avoid the danger of a type of idolatry existing especially among the Semites and therefore not applied in the Persian, Turkish and Indian worlds except of course where it concerns images of the Divinity or the Universal Man identified in Islam with the Prophet.

4. 'Aniconism to some extent becomes co-extensive with the sacred; it is even one of the bases, if not the basis, of the sacred art of Islam.' T. Burckhardt, 'The Void in Islamic Art', *Studies in Comparative Religion*, IV (1970), p. 97. In this essay Burckhardt has discussed the reasons for the use of the term aniconism rather than iconoclasm.

5. The subject as it pertains specifically to the art of Islamic Persia has been dealt with extensively in N. Ardalan and L. Bakhtiar.

6. For discussion of space in Islamic cosmological doctrines see Nasr, *An Introduction to Islamic Cosmological Doctrines*, particularly p. 63 and pp. 222–5.

7. The Quranic *Sūrah* entitled *Inshirāḥ* states, 'Did We not expand [*nashraḥ*, from the same root as *inshirāḥ*], thy breast for thee and lift from thee thy burden, the burden that weighed down thy back?' (XCIV: 1–3, Arberry trans.)

191

POSTSCRIPT

The Spiritual Message of Islamic Art

THE SACRED ART of Islam is, like all veritable sacred art, a descent of heavenly reality upon the earth. It is the crystallization of the spirit and form of the Islamic revelation dressed in the robe of a perfection which is not of this world of corruption and death. It is an echo of the other world (*al-ākhirah*) in the matrix of the temporal existence in which men live (*al-dunyā*). And in the same way that, according to the Quran, 'The *ākhirah* is better for you than this world', this art is more precious than all the material and social causes and ideals at whose altar so much has been and is being sacrificed and destroyed today. If one were to ask what is Islam, one could in answer point to the *miḥrāb* of the Cordova Mosque, the courtyard of the Sulṭān Ḥassan Mosque in Cairo or the cupola of the Shah Mosque of Isfahan if the questioner were only capable of reading the message which these structures convey. One could of course also point to a Mamlūk or Īl-Khānid frontal piece of the Quran or its illumination, not to speak of the calligraphy of the Sacred Text itself. Or, on the most inward level one could point to the Sufi *samā'* wherein man stands directly before God celebrating His Blessed Name in spirit, mind and body.

Traditional Islamic art conveys the spirituality and quintessential message of Islam through a timeless language which, precisely because of its timelessness as well as its direct symbolism, is more effective and less problematic than most of the theological explanations of Islam. One of the most pertinent aspects of the spiritual message of Islamic art today is its ability to present the heart of Islam in a much more direct and intelligible manner than many a purportedly scholarly exposition. A piece of traditional calligraphy or an arabesque can speak much more eloquently of the intelligence and nobility which characterize the Islamic message than many an apologetic

195

work of Islamic modernists or so-called activists. It is the serene, intelligible, structured and highly spiritual character of Islamic art which more than any other element has helped to combat and off-set the very negative effect produced by that type of currently popular literature about Islam which would depict it as a violent, irrational and fanatical force.

There are of course those who would deny such a function to Islamic art by simply denying its Islamicity and claiming that such an art, no matter how beautiful, intelligible, or harmonious has in fact little to do with the spirit or form of the Islamic revelation. This group includes not only many a Western historian of art but a larger number of modern Muslims whether they consider themselves as modernists or reformers of one kind or another. The latter group helps to confirm the views of those Western scholars in question who belittle the spiritual significance of Islamic art and brush aside the whole tradition as an historical accident no different from, or of no greater value than the ugliest products of industrialized civilization. Moreover, this group then proceeds to adopt these products in good conscience, while forgetting that in so doing it is depriving the Islamic religion of one of its most important supports in this world, and cutting the Islamic community off from one of the most tangible testimonies to the spiritual dimension of its revelation.

Despite such views, however, works of Islamic art continue to emanate their *barakah* (*barakah* being like the grace or divine influx which flows in the arteries of the Universe), as a result of their inner nexus to Islamic spirituality. Even a modernized Muslim experiences deep down in his heart the sense of peace and joy, even a kind of psychological 'assurance', when sitting on a traditional carpet, viewing a piece of calligraphy, or hearing classical poetry of his or her language, not to speak of hearing the Quranic psalmody or praying within the confines of one of the masterpieces of Islamic architecture which dot the Islamic world from the Pacific to the Atlantic. To the extent that the ugliness of the modern world spreads within the traditional Islamic ambience, this sense of the spiritual preciousness of objects of Islamic art continues to grow much like the prices of those objects which were common possessions only one or

two generations ago. All the attacks of the modernists and the reformers either directly against this art itself or as a challenge against its importance have not been able to destroy its spiritual significance which, issuing from the inner sources of the Islamic revelation, is as abiding as the historical life of the revelation in this world.

One could perhaps understand or at least try to discern certain logical reasons why most Western historians of art have either remained indifferent to the spiritual message of Islamic art or have failed to delve into its inner meaning, symbolism, metaphysical and cosmological significance, and organic relation to the religion which gave birth to it. It is much more difficult to comprehend the argument of those Muslims who in the name of social justice belittle Islamic art and reduce it to the category of luxury. These groups forget that despite all their anger and vituperations against the West they are unwittingly expressing a characteristically modern Western idea when they consider art and beauty as a luxury. They forget that their attitude has nothing to do with the Islamic one which considers beauty to be a Divine Quality (one of God's Names being *al-Jamīl*, the beautiful) and teaches that God loves beauty.

Those who are affected by this type of modern mentality, whether they are called reformist, activist or fundamentalist, and who must be distinguished from traditional Muslims, emphasize the *Sharī'ite* dimension of Islam at the expense of everything else. Now, no Muslim could oppose this emphasis upon the application of the *Sharī'ah* any more than he could oppose the thesis that an Islamic society is one in which the *Sharī'ah* is promulgated and practiced. But if the *Sharī'ah* as law governing the external actions of human society—as well as the rites which man must perform as part of his duties towards God—were the only aspect of Islam, why was such care taken throughout Islamic history, even going back to the very beginning, in the psalmody of the Quran, in the building of beautiful mosques, and in beautifying all that concerns God and his religion? Why was so much effort spent in bringing Islamic values into the lives of men and women through all kinds of means from story telling and literature to weaving all of which are concerned with art? The answer is clear

enough. Putting aside the saints of God, those who are themselves works of art, being occupied at every moment of life with the remembrance of God and of whom it might be said that they do not 'need' art—although as we have seen in this book they are for the most part the sources of various kinds of Islamic art—human beings have more hours in the day than directly religious injunctions of the *Sharī'ah* can fill. These injunctions include prayer, fasting, pilgrimage, and so on, while other activities such as earning a living or caring for the family are also a religious duty as long as they are performed in accordance with the *Sharī'ah*. But human nature being what it is, man tends to forget God in those other activities ranging from economic transactions to what is now called 'leisure'. Islamic art was the means whereby the spirit of Islam penetrated into all these types and modes of activity, into all the moments of man's life reminding him wherever he was of the Divine Presence. As for the contemplative, Islamic art was and continues to be for him a most precious support for the spiritual life and an occasion for the recollection of the Divine Realities (*al-ḥaqā'iq*). To destroy this art is to empty the soul and mind of the Muslim to a large extent of its Islamic content leaving a vacuum which is then rapidly filled by the worst clutter, noise and banality of the modern world as is the case of many a Muslim today. As a result of this loss of a part of their soul to the claims of the false and the ugly there are those who have lost their faith altogether.

The soul and mind of the traditional Muslim was woven—and continues to be woven to the extent that traditional Islam survives—first of all of attitudes drawn from verses of the Quran, and secondly of proverbs and poems, visual images and forms all of which reflect the ethos of Islam in its most profound aspects. When a traditional Muslim spoke, poems which always confirmed Islamic values flowed from his lips. When he wrote it was often in calligraphy of beauty. He appreciated a fine carpet whose forms and colours symbolized for him the Islamic image of paradise. His soul felt intensely the soothing effect of the serenity of a mosque or traditional home while his ear, trained in the celestial beauty of Quranic psalmody, could distinguish between a music which came on the one

hand from the 'other' shore of existence and, on the other, the cacophany that today in the name of music emanates from the lower regions of the psyche. A whole civilization and culture deeply impregnated by the spiritual values of Islam surrounded the Muslim and aided him in his living Islamically.

During the past century both the modernizing and so-called reforming movements in the Islamic world have joined hands—despite their severe opposition in legal and theological matters—to destroy this art and culture and to create a desert in the soul of the Muslim which has made it possible during the past few decades for the ugliest manifestations of the modern industrial world to annihilate with remarkable ease much of the precious Islamic artistic heritage. The vilification, for instance, of many of the most beautiful Islamic cities, including some of the most sacred, through architectural and urban planning and interior decoration totally alien to the spirit of Islam is certainly due to a large extent to human greed in the shape of Western companies interested in making the maximum profit joined by their Muslim collaborators who usually add a few arches and facades to their architecture to have their work appear Islamic. But the rapidity with which this process has taken place—without great resistance until very recently—is the result of a neglect of the spiritual significance of Islamic art by those who have either tried to modernize the Islamic world according to a Western model or who would 'reform' it by returning to a supposedly 'pure' Islam. But this conception of a 'pure' Islam of necessity creates a vacuum in the soul of Muslims and destroys the very forces which could resist the debilitating effect of an alien culture.

At long last, however, even in those regions of the Islamic world where the withering away of Islamic art and culture has been most noticeable, there is a desire to re-discover Islamic art. Young Muslim architects are again becoming interested in the principles of Islamic architecture, city planning and gardening. Some of the crafts have been revived in at least certain countries. There is an attempt on the part of the few to preserve the classical traditions of music, and a new wave of interest in the classics of Arabic and Persian literature is clearly discernible. In the present struggles for the presentation

of the identity of Islam, this movement is of great significance. In the long run it may prove to be more effective from a religious point of view than many of the political, social and economic movements which begin with such grandiose goals but rarely succeed in achieving anything which is authentically Islamic since they do not begin from within the heart and mind of the Muslim believer. This renewed attention towards traditional Islamic art cannot but have a major significance from the point of view of the Islamic religion itself, seeing that art is inextricably bound to the very heart of the Islamic message. The sacred art of Islam is a gift from Heaven full of *barakah*. In every sense this art is a blessing issuing ultimately from the Divine Mercy, *al-Raḥmah*.

There is, moreover, another function which traditional Islamic art can play today, one which is itself also a great boon and blessing if fully understood. In a world replete with deception and counterfeit, this art can play the role, along with doctrinal truth, of determining the Islamicity of all that claims to be Islamic. It can serve as a criterion for deciding what social, cultural, or even political manifestation or movement is authentically Islamic and not just making use of Islamic symbols and images as slogans or means for the achievement of other ends. Islam throughout its history and within the depth and breadth of all its authentic manifestations, from architecture to the art of dress, has emphasized beauty and been inseparable from it. Have those who claim to speak in the name of Islam today created any form of beauty? Can the qualities of serenity, peace, harmony and equilibrium which characterize both the Islamic religion and the artistic and cultural manifestations of Islam be seen in what these present day groups in question create and produce? It must be remembered that even the armies of the traditional Islamic world, from those of the battle of Badr to the armies of Saladin or the Janissaries, possessed a nobility and beauty reflected in their dress, weaponry, and music. It might of course be claimed that in the old days armies of Christian, Hindu, and Buddhist nations also possessed artistic beauty and that it is the modern world which has made that impossible. This assertion is of course true but it must be remembered that in the modern world there are

not any notable powers claiming to possess Christian, Hindu, or Buddhist armies and acting on the politico-military scene in the name of these religions. They do not therefore carry the same burden as do those who speak and act in the name of Islam. In their case the criterion of Islamic art remains a powerful one in deciding the real nature of the forces involved in their movement.

The same can be said about the intellectual and religious life. There is today much talk of Islamization of education, of the economic system, and of society itself, and many are spending valiant efforts to achieve these ends. But to speak in the name of Islam, as in the name of any other of God's religions, carries with it a great deal of responsibility. Are those who wish to carry out these tasks fully aware of what determines Islamicity outside the *Sharī'ite* injunctions clearly defined by the Quran and *Ḥadīth?* Again, Islamic art in its universal sense can act as a powerful criterion with which to judge the nature of these processes, as well as their success, for nothing authentically Islamic can be devoid of those inner qualities discussed earlier in this book, qualities which have emerged from Islamic spirituality and have manifested themselves over the ages in many different climes in the various traditional arts of Islam from pottery to literature and music.

What remains intact today of the traditional arts of Islam —especially their sacred centre which is Islamic sacred art—is a most precious gift of God for Muslims as well as for all men and women sensitive to the revivifying power of beauty as it is wedded to truth. This art provides a shelter from the storm of the modern world; it acts as a spring of life to rejuvenate body and soul and is a support for contemplation of the highest realities leading to Ultimate Reality Itself. The principles of this art, grounded in the inner dimension of the Islamic revelation and its spirituality, can certainly be re-discovered and applied by those Muslim artists whose vocation it is to make and create contemporary forms, objects and manifestations of Islamic art. It should also be studied in the light of its spiritual significance rather than as a mere historical development by those who wish to gain a better understanding of Islam itself, whether they be non-Muslims or Muslims in search of the re-discovery

of their own tradition. Meanwhile, this art stands in its very reality as witness to the manifestation of the One in the many, its resultant harmony creating a soul-releasing effect which frees man from the bondage of the many and enables him to experience the infinite joy of proximity to the One. Islamic art fulfills its goal and function as ancilliary and aid to the Quranic revelation itself by acting as support to attaining the end for which Islam was revealed. That end is the realization of the One through the inebriating beauty of those forms, colours, and sounds which as theophanies manifest themselves outwardly as limited forms while opening inwardly onto the Infinite and serve as vehicles for the attainment of that Truth (*al-Ḥaqq*) which is at once Majesty (*al-Jalāl*) and Beauty (*al-Jamāl*).

wa'Llāh^u a'lam

LIST OF MONOCHROME PLATES

Title page: *Wāhid*, 'One', inscription on the wall of the Eski Cami, Edihe. *Courtesy of E. J. Brill, Lieden.*

Page 30: Brass Pen box, Iran, made by Shāzī for Majd al-mulk al-Muẓaffar, dated 607 AH (1210–11). *Courtesy of the Freer Gallery of Art, Smithsonian Institution, Washington D.C.*

Page 20: Platter, shallow, wide-rimmed, on low ring-foot, 10th Century. *Courtesy of the Freer Gallery of Art, Smithsonian Institution, Washington D.C.*

Page 22: Ewer, hammered brass, damascened silver and copper. Persian, late 13th Century. *Courtesy of the Board of Trustees of the Victoria and Albert Museum, London.*

Page 23: Bowl, white earthenware with decoration in colours and gilt on white enamel, Persian (Rayy) 13th Century. *Courtesy of the Board of Trustees of the Victoria and Albert Museum, London.*

Page 42: View of the Ibn Ṭūlūn Mosque, Cairo. *Jill Brown.*

Page 43: View of the Ka'bah, Mecca. *Courtesy of Middle East Archive.*

Page 52: View of the Great Mosque, Kairouan, Tunisia, 9th Century. *Nicholas Stone.*

Page 53: Detailed view of stalactite ornament in the Court of Lions in the Alhambra, Granada. *Katherine O'Brien.*

Page 156: 'Kamanchah', spike fiddle, wood inlaid with ivory, Kashmir, 19th Century. *Courtesy of the Board of Trustees of the Victoria and Albert Museum, London.*

Page 183: Scene after a hunt, illustration from a Persian Manuscript, Qazwin style, late 16th Century. *Courtesy of the Board of Trustees of the Victoria and Albert Museum, London.*

LIST OF COLOURED PLATES

Between pages 30 and 31

Opening of the Quran in Oriental *Kufic*, written and illuminated by 'Uthmān ibn Ḥusayn Warrāq, 466/1073–4, Iraq or Persia. *World of Islam Festival Trust, London.*

Quran page in *Maghribī* script, probably Spanish, 12th Century. *The Metropolitan Museum of Art, Rogers Fund 1946.*

Quran page in *Naskhī* with *Sūrah* headings, anonymous. 828/1425, Cairo. *World of Islam Festival Trust, London.*

Patterns and calligraphic frieze in ceramic tiles in the Buyuk Karatay *madrasah*, Qonya, 13th Century, Turkey. *Jill Brown.*

Between pages 78 and 79

View of columns and stalactite ornaments of the Court of Lions in the Alhambra, Granada. *Nicholas Stone.*

Main entrance to the Shaykh Luṭfallāh mosque, Isphahan. *Keith Critchlow.*

Courtyard of Moulay Idris II mosque in Fez. *Courtesy of William Stoddart.*

Detail of *Miḥrāb*, Shaykh Luṭfallāh mosque, Isphahan. *Keith Critchlow.*

Between pages 118 and 119

View of inside of dome of the Chahār Bāgh *madrasah*, Isphahan. *Jill Brown.*

Calligraphic frieze in stone above ceramic patterned tiles in the 'Aṭṭārīn *madrasah*, Fez. *Jill Brown.*

Between pages 134 and 135

The Tāj Mahal from Agra Fort, 17th Century, India. *Jill Brown.*

View of the Dome of the Rock, 688 to 692 A.D. Jerusalem. *Jill Brown.*

Between pages 166 and 167

Small platter, with slip decoration of central black floral swastica, Samanid period 10th Century. *Courtesy of the Freer Gallery of Art, Smithsonian Institution, Washington, D.C.*

Concourse of the Birds painted by Ḥabīb Allāh illustrating *Manṭiq al-ṭayr (Language of the Birds)* by Farīd-al-dīn 'Aṭṭār (1111–1230). Safavid Period, Isphahan, c. 1600. *The Metropolitan Museum of Art, Fletcher Fund, 1963.*

204

List of coloured plates

205

INDEX

Index

Index

Index

Index

DATE DUE

HIGHSMITH 45-220